Temperaments

Temperaments

Memoirs of Henri Cartier-Bresson and Other Artists

DAN HOFSTADTER

All rights reserved, including without limitation the right to reproduce this book or any portion thereof in any form or by any means, whether electronic or mechanical, now known or hereinafter invented, without the express written permission of the publisher.

The essays in this work were originally published in slightly different form in *The New Yorker*.

Copyright © 1992 by Daniel Hofstadter

ISBN: 978-1-5040-0812-9

Distributed by Open Road Distribution 345 Hudson Street New York, NY 10014 www.openroadmedia.com

Contents

Prefacevii
Breakout: Jean Hélion
Stealing a March on the World: Henri Cartier-Bresson 21
A Painting Dervish: Avigdor Arikha99
Dungeon Masters: R. B. Kitaj, Leon Kossoff, and Others125
Mark Rothko, Talker: Richard Diebenkorn169
Acknowledgments176

Preface

I was struck recently, in rereading the 1992 edition of this book, by the changes that the intervening years had seemingly wrought in its meaning and its very texture. Like an old house surrounded by new constructions, it had assumed an unexpected appearance, and some of these new aspects I scarcely recognized. For one, I now doubted whether the reader would be wholly convinced that my intentions were descriptive rather than critical; and I also saw, quite suddenly, that though I'd had no intention of favoring any particular artist or artists, I had indeed espoused a particular approach to art, and one that really did merit capturing because it stood on the verge of extinction. (I might add that of all the people I wrote about, only two, Leon Kossoff and Dennis Creffield, are with us today.)

It may be useful to bear in mind that the material in that original edition consisted exclusively of profiles commissioned by the *New Yorker*. (The postscript about Henri Cartier-Bresson and the memory of Mark Rothko to be found here are recent additions.) As such, all were intended as literary portraits, not critical evaluations, although certain truant judgments and an impish tendency to cock an affectionate snook at my subjects do creep into the prose (the latter being, I

PREFACE

admit, a typical *New Yorker*-esque failing of the period). By and large, however, as indicated in the original preface, I was merely keen to explore the sensibilities of the generation of my grandparents and that of my parents, a natural interest for anyone.

Why, then, does it now seem as though I was favoring a special aesthetic attitude? It is simply because that attitude, once common, scarcely exists any longer. It was already starting to disappear by the late 1970s, and though I do not believe that in writing about it I was consciously defending it, I was certainly basking in it to the fullest. I wanted to inhabit, and in fact did for a spell inhabit, a social lagoon in which artists worked alone, at a remove from bourgeois society and with a frankly adversarial relation to it. To be a cultivated person, in those days, was to be an outsider, or, as Robert Motherwell perhaps too hopefully put it, one in whom there was "no knowing, only faith." Pictures were created in rough congruence with the emotions that had inspired them, without predetermined conclusions, set ways of solving problems, bombastic sizes, or presentational effects.

The bygone form of artistic ambience I am describing was of course called the avant-garde. It has vanished completely, and vanished with it is the psychological excitement that sophisticated people used to feel on first seeing adventurous pictorial work on display. Some critics have felt that it germinated the seeds of its own destruction, others that its armor was too fragile to withstand the onslaught of the market, still others that it was simply coopted by consumer society. Any or all of these postmortems may be accurate, but I had no desire, in writing this book, to offer an analysis of a doomed way of life. I wanted merely to vivify it—to see how some people lived and worked, and to offer what I found to the reader.

Daniel Hofstadter, 2014

Temperaments

Breakout

Jean Hélion

Jean Hélion was eighty when I met him, one of the two major living representatives of the classic prewar School of Paris. Like Balthus, who was the other, he had never conformed to fashion; and, perhaps for that reason, he had received inconsistent attention in New York. This, I felt, was a pity, for Hélion had worked in the United States off and on for about five years in the late thirties and early forties, and few French painters had played so important a part in the history of the New York avant-garde. Nonetheless, even his most devoted American admirers had found it hard, down the decades, to keep track of his many successive interests and achievements.

Jean Hélion died in 1988. Because he lived so long yet showed only intermittently in this country, every generation of American viewers had practically to discover him for itself. His style was constantly changing, so every generation had its own Hélion, and his lifework still remains out of focus. As if to complicate matters, his images are often too dense with meaning to be emotionally grasped without a lengthy acquaintance. The masses of derelict objects he painted in the past few decades—threadbare hats, eviscerated pumpkins, wilting plants—inevitably remind you of flux and decay, and his sketchy

figures can often seem, like parvenus at a party, only memorandums for an impossible version of themselves. Yet the "difficulty" of his pictures lies not primarily in their subject but in their style: Hélion has frequently incorporated into his depictions of things the very qualms—embodied in peculiarities of color or line—aroused by the act of depiction. His drift into a mannerism of execution put one artistic crowd off his work in the forties and attracted another in the sixties, yet the question remains whether this sort of mannerism, by now an accepted resource of art, is really at the center of his contribution. The undertow pulls hard, but it is not the surf. Looking today at his best pictures, you may well feel that they retain their interest because of their sheer sensuous beauty: that whatever stratagems lie buried within them are only a residue of something else—something as simple as a passion for taking the act of painting in a thoroughly free and personal way.

This passion has led Hélion to paint many kinds of pictures, from severe abstractions to highly realistic interiors. He spoke of them all with equal indulgence, probably because he sensed that he could not foster the strong unless he cared for the weak, but also, I suspect, out of loyalty to his vision of his work as an ensemble. Through the years, this vision remained remarkably fixed, and that is one reason that a comprehensive exhibition is the only good way to see Hélion. Another is that his sensibility was steeped in memories of itself, charged with what a French critic called "Proustian unease." Some of his pictures seem, in the oddest way, to depict two different moments at once, while others update or commemorate earlier statements. Notes for projects suddenly become projects; reworkings of forsaken themes change the perception of forty-year-old canvases. Some time ago, Hélion did a big picture of a reversible plow, and, scrutinizing his image of this strange implement, you feel that it might well stand for that quality in his work which invites the backward glance.

In the late sixties, before redevelopment had robbed Montparnasse of its musty, mildly Bohemian allure, Hélion worked in a sort of aerial cottage perched high above the rue Michelet. He showed his pictures not far away, in a gallery in the rue du Dragon, near Saint-Germain-des-Prés. As I daily traversed the same territory, I often

found myself walking in the rue du Dragon, heading for a student restaurant or a cheap cinema, and several times I poked into the gallery to have a look at his work. I wasn't alone, for a whole new crop of French painters was discovering Jean Hélion. He was the most famous unknown painter in the world—famous, that is, among artists and the art-obsessed, unknown for all practical purposes to the general public. Strange to say, he was old even then, with terrible eyesight and a troublesome heart, but to judge by the pictures he still swung his brush with undiminished vigor. I knew that he'd made his name as an author of austere geometrical abstractions, but later had turned to representation—an unusual and intriguing progression in those days. The broadly brushed canvases in the rue du Dragon revealed a feel for the economics of form, and there was something in his style akin to good muscle tone—a readiness of response to whatever was developing on the canvas. He was bold, too: he seemed to take on subjects on a dare. Sometimes he'd set his easel up before a window that looked out over the wilderness of chimney flues above the rue Michelet, and in the colors he chose I recognized the light of the neighborhood sky, which in its cool clarity often reminded me of a glass of water. In other images I recognized places and things I'd never seen, for many of Hélion's pictures had the feverish compulsion of a dream.

When, some twenty years later, I finally met him, he told me a little about his life. The whole thing still astonished him. "How could I, the grandson of peasants and the son of a coachman, actually have become a painter?" he would ask. Because his parents were so poor, his grandparents had helped to bring him up, and one of their few interesting possessions was a Victrola. They had only one record, or only one that caught his fancy enough for him to remember it as an adult. It was a seventy-eight of the song called "Les Trois Roses," and on its circular label was a picture of the three roses, with the legend "Les Trois Roses chanté par Vaguet de l'Opéra." Decades later, on a trip to the Soviet Union, Hélion was poking about in a street market in Kiev—he always loved such markets—when he came upon a copy of the very same record. Like so many of the things that he ferreted out and later put into his paintings, it seemed a portent of some sort—a sign from the world of coincidence, the hidden web that André Breton

called "objective chance." It came as a confirmation that he had chosen the right path.

The elderly Hélion had the habit of wrapping his Burberry scarf around his neck and pulling his porkpie hat down over his nose and dozing off. Well, he seemed to be dozing off; but when somebody said something that caught his interest, he would suddenly perk up and offer an impromptu *mot*. "Poverty has this advantage, that it teaches you economy in art," he said once—it was a true Norman remark. Another time, when I mentioned something that had got burnt up by mistake, he said, "One must burn what one loves, my boy—it happens in life anyway." His remarks about painting were shrewd and liberal-minded.

I liked to picture him in earlier days, in his former studio in the avenue de l'Observatoire, with its stagy portico and loggia, its deck chairs and coal-burning stove, its walls covered with the umbrellas and gloves and hats that he'd found at flea markets. Or I'd imagine him in that other place, that light-filled studio-cottage with its view of a celestial, crystalline Paris of rooftops, skylights, and chimney pots. He seemed to me warm and insightful, which is how younger people would prefer to feel about older people; yet I knew that not everyone felt that way about him. Some Americans who'd known him in the thirties and forties hinted that he had virtually abandoned his first wife, the American Jean Blair, and their two sons, and that he had been terribly envious of those of his contemporaries who had gained a larger reputation than his; other critics found him cold or overly cerebral. It was clear that I would never be able to measure the truth of such disparagements. One of his friends, the writer Pierre Bruguière, told me that Hélion had virtually lived on the money of his second wife, Pegeen, the daughter of Peggy Guggenheim, who was mentally unstable and a flirt; he also told me that Hélion had made heroic efforts to hold his second family together, and he showed me two touching, terribly sad oil sketches that Hélion had made of Pegeen. It seemed to me in the end that even if Hélion had at one time had all the character flaws that his rather priggish detractors attributed to him, he had nonetheless outgrown them and passed into a rich and generous maturity. He'd retained a host of friends from the thirties and forties,

and had even cemented fresh bonds with some of the people he'd misplaced, so to speak, along the way. He welcomed me into his world as he had welcomed so many other Americans; and he was happy to serve as a guide back into the salad days of the School of Paris.

During the winter of 1985, the Museum of Modern Art of the City of Paris offered a major retrospective of Hélion's paintings and drawings. The museum's exhibition space isn't ideal for a review of anyone's career—originally designed for the 1937 World's Fair, it's about as easy to find your way through as a sunken ship—and although the selection included almost two hundred pictures, Hélion's accomplishment was unevenly represented. The early, Mondrian-influenced abstractions were out in force, and the bizarre, sparkling figure compositions of the forties and the still-life intricacies of the fifties populated several big rooms. But many of the powerful, loosely brushed pictures of the past two decades—notably a pair of important triptychs depicting marketplaces—were absent, and the few recent canvases on display were poorly hung. Anyone already familiar with Hélion was left with the impression that his late paintings were still crying for an exhibition.

Whatever the shortcomings of the retrospective, it did serve to demonstrate the stylistic cohesion of Hélion's work. This was interesting, for his controversial shift from abstraction to representation during the war years left him a virtual outcast in the international avant-garde. The story of his exclusion is also the story of a signal failure of judgment, and it has been told and retold in studios and art magazines: how the artist, widely regarded in 1940 as the hope of French modernism, joined his country's Army and was captured by the Germans; how he daringly broke out of a prison ship and made his way to New York; and how, upon returning to Paris in 1946, he found himself branded by "advanced" critics and dealers as a traitor to the modernist cause. One can imagine his bewilderment, for his deepest stylistic impulses never had much to do with whether or not he happened, at any given moment, to be painting recognizable objects. Almost from the beginning, for example, he enlisted a stock of shapes similar to those found in dress patterns and architectural blueprints: some of his finest abstractions of the thirties suggest a neighborhood

built by a tailor or a sportswear line designed by an architect. These shapes he carried over into his representational work, where he often attended to the music of his linear "phrases" well before indicating the identity of the objects in question. There is much, in fact, to suggest that Hélion was the first thoroughly modern artist for whom the degree of a picture's resemblance to nature implied nothing either positive or negative about its value. And it was precisely this spirit of pragmatic independence that set him at odds with one aesthetic doctrine after another.

"I can't stand orthodoxies," he told me one afternoon as we were going through his Paris retrospective. Small, trim, and white-haired, he radiated a sort of puckish bonhomie. "Form has its own sort of wisdom, and it won't put up with rules. In my early abstract painting I tried to convey a certain harmony or balance, and when I turned to nature I sought the same thing. I've never renounced any of my work—only continued to build."

Hélion spoke in well-formed paragraphs, often scarcely moving his lips, and this rather ventriloquial delivery sometimes made it seem as if his thoughts were simply airing themselves, without benefit of vocal apparatus. Companionable without being familiar, wary of false emotional pitch, he used gestures only to mark a really important point. But if you searched his expression for the fluent ocular pantomime that usually accompanies speech you were pulled up short: his eyes could scarcely be found behind a pair of enormously thick glasses. It was overwhelming how much you expected someone who had offered so many images for contemplation, in so imaginative a light, to *see*; yet in the past year or so Hélion had not seen well enough to paint. He was also obliged to walk with a cane, but on entering the exhibition he had tucked it under his arm. He seemed perfectly able to find his way forward, presumably orienting himself by the bigger shapes in his well-remembered abstractions.

"Of all orthodoxies, the only one I've ever found useful was that of Mondrian," he said. "In my early work, I took it as a reference point, because I shared his conviction that abstract art could yield great paintings—I mean paintings on a level with Poussin or Seurat.

I showed those two to Mondrian"—he peered through his glasses toward a pair of small rectilinear compositions—"and he approved of them, though with certain reservations. He was then living in Paris in something like seclusion—quite a warm person, really, but also distant. He looked terribly ascetic and seldom said anything. He was trying to make his life like his painting, and it didn't work. In retrospect, I wonder if he didn't have a sort of foreknowledge that he would soon be dying, because his painting was turning into a funerary monument to himself. I admired him unreservedly—I, too, was making abstractions—but he wanted to shut the world out, and I wanted to let it in."

As we moved slowly forward, examining Hélion's early work, I was struck by how many of his compositions played variations on the theme of near-symmetry. At length, I observed to him that he often seemed, in a manner of speaking, to be balancing visual equations.

"Yes, there is always this equipoise," he replied. "But that is not all there is. Each one of these compositions is also a sign, a meaningful gesture, like somebody waving. Mondrian didn't want anybody waving; I did. I showed him my *Equilibrium*, of 1933—it's over there, I think—and he was utterly shocked. He stared at it, and he said, 'These *curves*, these *diagonals*—this is not abstraction, Hélion, this is naturalism.' Then he looked me full in the face and said to me—very kindly, for he was incapable of being unkind—'Hélion, you are a sinner."

The sinner smiled. It was cold even indoors that day, and, in his camel's-hair coat and Burberry scarf and porkpie hat, he looked a pretty jolly delinquent. Yet there was, I reflected, a certain aptness to Mondrian's phrase. Artistic taste has an unyielding hardness, and won't descend to common, sociable assent. Rightly or wrongly, Hélion had offended this taste in Mondrian, for his abstractions, with their incipient care for bulk and weight, did indeed show symptoms of a figurative future.

We lingered for a while among the abstract paintings before passing on into the halls hung with Hélion's first major transgressions—his large figure groups of the forties. Meticulously painted in cool grays spiced by occasional hot tints, they showed people in urban settings engaged in such everyday pursuits as smoking and reading newspa-

pers; here and there a chap might be seen tipping his homburg or bowler. In these pictures Hélion had literally "continued to build," taking each figure as a sort of block or ion that might be structurally bonded with others. I could imagine him coolly asking himself how he could invent a stable composition with one standing and one sitting figure, or with two standing and one recumbent, or with one standing and one inverted, and so forth.

"I started this sort of work before the war, but the war had a lot to do with how it turned out," he told me. "I'd been living for some years in the United States, a country that fascinated me—the sheer power of it, the free way of life. I got interested in big pictures and decided to let my art float. When the war came, I went home to fight, not because I was a patriot but because it seemed inevitable. I was a Frenchman; I didn't want to be sheltered from what was happening to my country, just as I didn't want to be sheltered from nature by abstract art. During the war, I made a great many drawings; and then I was captured, near Orleans. After that, none. Absolutely none. It wasn't allowed. In the Army, I began to pay a lot of attention to the appearance of hats ordinary hats to protect the head against the cold, all sorts of strange hats to indicate rank. And then, of course, there was the endless saluting, the bringing of the fingers to the hat brim as a kind of wearisome parody or inversion of the civilian custom of tipping the hat. But only later did I begin to incorporate these hats into my paintings." As Hélion spoke, I recalled a passage from his war memoirs, They Shall Not Have Me, in which he and a group of freezing P.O.W.s break into a magazine of French uniforms and discover a preposterously silly gold-braided kepi, like the kepi of some village postmaster of the Belle Époque—an emblem of impotence. "One thing nobody did in the Army was to tip his hat," Hélion went on. "You certainly couldn't have done it as a prisoner of war-it would have landed you in very hot water. It was something I dreamed of as a symbol of peacetime, of freedom—just tipping my hat. Well, when I got out of Germany that was one of the first things I did, and that, too, is why I started painting my salueurs—my hat-tippers. They're simply saying hello to the world—you know, like this." He tipped his hat to the museumgoers about him. "Bonjour! To nobody in particular! To the whole world!"

Hélion's visual humor, a suppressed mirth that pokes out from the edges of things, has often been overlooked by critics, and I was surprised by its sly intensity. The big-city brassiness of his forties pictures was heightened by their design elements, which seemed to be living the life of Riley: color planes loitered in unsavory places while their outlines horsed around or just gallivanted off. The general effect was somewhat similar to riotously out-of-register color separation. Another aspect of the comedy was a distinct oddness of incident or detail. The elaboration in these paintings didn't serve to make things more real-looking, or to explain structure, as we've come to expect of such elaboration in figurative art. It was more like factual evidence—like those scraps of burlesque information on a newspaper's city page which confirm something you always half knew about people. Hélion's urban world was purely invented, but it also looked a lot like some slummy Paris suburb of the old days, with its punks in off-the-peg suits and its air of a carnival eternally breaking up. The poet Raymond Queneau had worked just the same turf in a novel of 1933 called Le Chiendent (Crabgrass); he was, among other things, an ardent boulevardier, and for a while wrote a column for the newspaper L'Intransigeant called "Do You Know Paris?" Queneau peopled Le Chiendent with a papery, shadowy crew that he might have collected in bistros and bars. These characters send up the novel form from time to time by saying things like "For me this bistro is splendid and tragic" or "Sometimes a vulgar thing suddenly seems beautiful." Queneau and Hélion were good friends by the late thirties, and though one wouldn't want to force a comparison between their respective endeavors, Hélion's interest in the expressive potential of the banal was undoubtedly strengthened by Queneau's slangy, expressly trite style.

Talking with Hélion, I realized that I couldn't resolve his affection for vulgarity back into irony or condescension—as one might be able to do with the much later phenomenon of Pop Art, for example. He seemed to sincerely prize vulgarity, as the medium in which most things actually happen, the oxygen of our moral lives; and it also provided him with the perfect foil for a pictorial perfectionism that might have seemed arid on its own. A certain coarseness or vernacularity of

gesture characterized his figures: here a louche type in a turned-down fedora emerged from an assignation, smoking a cigarette; there a pair of bland lovers nestled under an umbrella; in many images his *salueur*, a virtual signature item, doffed his hat at the sky. There was one personage, though—a one-legged fellow on crutches standing in a crumbling doorway—who did not share this saucy, funny-papers appearance; I wondered if he was simply the *mutilé de guerre* that he appeared to be. I'd read in Hélion's war memoirs about his escape from imprisonment—about his picking up German from talkative guards, his posing as a rabid Nazi on the westbound train to Brussels—and I sensed that the whole enterprise had become a sort of lived metaphor for him. Was it too easy an assignment of meaning to think that this crippled figure extended the parallel between Hélion's wartime escape and his quest for freedom as an artist?

"The figure does look like a disabled veteran, but he isn't one," Hélion replied. "I got the idea from a young man I knew who had to have his leg removed in an operation. He was a very beautiful young man—the homosexual lover of a friend of mine—and then suddenly he had only one leg. But there was something beautiful, too, in the way he propped himself up on his crutches, like a tower supported by flying buttresses. He was a Gothic figure—Cathedral Man—and that was how I painted him.

"You mustn't read any contemporary notions into such things as the bread and cigarettes in my paintings," he went on. "Perhaps one has to have gone through the hunger of the war years to see—as I saw when I first returned to Paris and watched people proudly parading their baguettes through the streets—that bread is everywhere only because it is rare, and that it has all the beauty of a rare object, the shimmering surface, the subtle colors. It was also in those years that I realized that the everyday act of smoking is actually a sacred service, the ritual bringing of fire to the mouth, whereas to pick up a dead butt is a serious act of self-humiliation. This figure here, coming out of the woman's door smoking a cigarette, only *seems* banal; really he is walking out into the world with fire in his mouth, which is something extraordinary."

As I scrutinized the paintings, Hélion enlarged on his notion that

certain daily events are as meaningful as the classical myths given form by the Old Masters. The men with newspapers who fill his pictures are like figures in a tragic chorus, he explained, only instead of intoning social norms they silently peruse "the lie of the day" while bumping into one another; the baguette, zigzagged with lips formed by the slashes of the baker's knife, is the emblem of sexuality and the "bearer of wounds"; the lovers' umbrella is a sanctuary dome. I'd often heard people say that subject matter was important to Hélion only as a function of style, of personality, but as I listened to him talk I felt that this view was too eager to disengage his art from the messiness of life. It was too genteel: it missed the voracity with which he'd devoured the pageant of the Paris streets. Yet there was no denying that his subject matter conduced to an artificial manner; the fondness for bizarre visual metaphors and the concern for abstract balance conspired efficiently together. Often Hélion's work seemed both saturnalian and engineered; it had, I thought, something of ancient Rome to it. Like the old Roman muralists, he chose to impound his mythical personnel within a framework of strict architectural rectangles, and his work of this period, as it hung in rows upon the walls, suggested the streets of an undestroyed Pompeii.

Continuing through the exhibition at a leisurely pace, we penetrated at length to the innermost core of the museum, which was developing a Piranesian complexity: at one point a gangway crawled along a wall while a show of Helmut Newton photographs incongruously intersected a row of Hélion's paintings. The artist by now seemed tired; several friends with whom he'd arrived were appearing in our vicinity with protective regularity. It would soon be rush hour, they hinted benevolently, and Hélion lived a good hour from Paris-at Bigeonnette, near Chartres. I began to feel vaguely oppressed, and not simply because an interesting conversation was drawing to an end. Despite his failing eyesight, Hélion had relived, even reseen, his paintings: he obviously possessed them in his mind's eye. Yet because he had once endowed them with the attributes of life, they had also escaped him, as creatures do escape their creators, and gone out to join the world. How far, I wondered, could I follow Hélion into his realm of symbolic correspondences? Of course, I could follow him all the way; yet also

not a step. What artist, after all, had ever really proved a reliable guide to the meanings generated by his work? And could anybody decipher the riddle of these hat-doffing, newspaper-reading, cigarette-smoking city slickers? Hélion seemed to be overinterpreting himself, reading his paintings as if they were a rebus; I'd never expected to hear an artist do this. At the same time, however, I had to remember that certain of his aesthetic reflections had matured under the threat of death; he had reached for the objects about him as if they were anchors and portents.

Sometimes, when I least expected it, Hélion would suddenly revert to an abstract way of talking about his work. In one of his paintings, the A Rebours, of 1947, he had juxtaposed the figures of a painter and an upside-down female model. The inversion fascinated me because it showed that his vocabulary had a place for the tumbled and the fallen. Yet when I asked him why he had inverted this nude he casually replied, "Because she becomes abstract that way, and balances the standing figure well; and because her body is so sensual when you see it upside down." I was momentarily taken aback, for the unsettling naked girl, with her rich tones and tresses of soft black hair, seemed to be telling me something else: that she was laid out as if for an offering, and that in her offering, as in every voluptuous act, there was some element of catastrophic sacrifice. This was a fleeting and perhaps overpersonal intuition, but it was something that the painting was definitely suggesting to me at that moment; I didn't feel inclined to let it go.

I walked with Hélion and his friends out onto the avenue du Président Wilson. As we shook hands, he invited me to come out in a day or two and have a look at his recent work, in the studio at Bigeonnette.

After Hélion's departure, I returned to the museum to study his paintings of the fifties, which we'd barely had time to glance at. Dispersed for many years, they were first shown in a body by the Paris dealer Karl Flinker in the summer of 1984. At that time, I chanced into Flinker's gallery, in the rue de Tournon, and was at once fascinated by what I saw.

These pictures are far more realistic than Hélion's other work, but it isn't their realism that makes them so good. It is, rather, I believe,

their revelation of an exceptional readiness of empirical response to the solemn ugliness of everyday surroundings. There's a still-life feel to most of them, even though they aren't all technically still lifes. Curiously, Hélion turned the genre to social ends. "My still lifes," he once wrote in his diary, "are like theatre intermissions during which my objects usurp, in their own way and always comically, the players' roles. The people have all gone off to drink, or to make love or war, and the objects invade their space. . . . It is really the people who are 'still." These pictures are worked in a dry, explicit manner, rather like commercial renderings, and the crowded surfaces threaten at any moment to take on a dull, actuarial density. At first, you think that Hélion is indulging in a lot of illustrators' tricks, but you soon realize that he's simply bringing a weird fondness for pedestrian execution into alignment with the crass visual evidence he feels compelled to set forth. In fact, these pictures are testimony of a highly personal order. Hélion looks into his big, bleak, windowless studio in the avenue de l'Observatoire and tries to make sense of depressing things like a tableful of junk half-devoured by gloom. Cigarette butts and holes in the wall vie as points of obsession; under the dirty skylight any model at once acquires owl eyes and a mustache of shadow.

Occasionally, the artist looks into a mirror and paints himself. He is well into middle age; he has had his first heart attack; no one in Paris will show his work. "Decidedly, all has been lost," says his diary for this period; yet he's surprised by how hungry for life he is. His paintings disclose an appetite for the humblest things he can see: he almost wants to gobble up the beautiful greasy light on the floor and make it part of himself. Odd things preoccupy him: he does a whole nude in one breezy day and then spends a month fiddling with her shadow. He feels silly, his hunger grows, and he begins a food still life that turns into an allegory of love. There are marguerites and a bottle of Rhône wine on the floor, and the tea things and sardines and peaches have been hurriedly abandoned in the midst of mounting desire. A lacy chemise has thrown itself upon a pair of pants. The emerging image is unambiguously personal but not confessional or anecdotal. Sexuality is not the content but the form of the tale. Gender declares itself as a slight but telling difference—something like the difference between

men's and women's buttons—and the half-eaten food gangs up to ape the topology of seduction: the concavities and the convexities of it, the ins and the outs. In the foreground, the pants open their big mouth and stick out a ragged white tongue of a pocket.

During his period of ostracism, only a few artists visited Hélion. Balthus came by loyally, as did Matta and Victor Brauner and Alberto Giacometti. One day, Giacometti introduced Hélion to the poet Francis Ponge. Ponge, who soon became one of his closest friends, had written a book of prose poems called Le Parti Pris des Choses (The Voice of Things), in which he spoke of the "passion" of cigarettes and the "madness" of water and the pleasure of holding a door in one's arms. Like Hélion, he delighted in shells and shell-like structures, and he often seemed overwhelmed by the world's provender of material incident. He was especially awed by vegetables, and meditated at length on the essence of vegetable time. Plants kept their whole lives palpably about them, he observed with envy: their inner stems and lower branches were also their past selves. Also, they expressed themselves thriftily, in blooms, instead of wasting evanescent gestures on the air, as people did. Engrossed in Ponge's poetry, Hélion began to paint flower and leaf arrangements cut out against various dark corners of his studio. In one poignant picture, five arum lilies reach up imploringly, as if to illustrate Ponge's notion that spring flowers "try to say everything"; in another, a bough of beautifully painted leaves droops to the floor. Through all these pictures, Hélion's feeling for the complementarity of blossoming and wilting, opening and closing, day and night, spring and autumn is enriched. From this point on, every one of his images reminds you of another, and the retrospection is invariably marked by the same melancholy that we feel when we hear beloved old songs rescored for new instruments.

Hélion's house in Bigeonnette was a tidy manor with a roof of red Burgundy tiles overgrown with lichen and moss. On one side, obliquely behind a big hornbeam in the front garden, stood a gatekeeper's lodge, where the bigger paintings were kept; off the lodge was a painter's studio—a nice, old-fashioned one, with rows of tall windows on three sides.

Hélion was in excellent spirits when I arrived. His wife, Jacque-line—whose warmth, charm, and reserve are not unlike his own—had made a tasty gigot with flageolets for lunch. And for dessert, though it was weeks after Christmas, the three of us had some of that Christmas cake called *galette des rois*, which Hélion was extremely fond of. He was full of teasing paradoxes about painting and people, and as we trooped toward the studio through a high-ceilinged gray sitting room, past an ogee-shaped marble fireplace, and along a row of deep-embrasured windows, I felt moved to ask him about the man with whom he had so much, and so little, in common.

"Balthus is a very strange case," he replied. "There was something in his nature that refused from the very beginning to accept the reality of what was going on in art. He simply didn't want to be a part of it. Look at his color—it's often good, yet he didn't care to come to terms with the modern problem of composing in pure hues. The course Balthus chose wasn't an easy one, and he has been very brave about persevering in it. He wanted"—Hélion searched for the right expression—"to get out of modern art. He wanted to get out, and he wanted to get in. And he succeeded."

As Jacqueline guided us through a darkish, twisty passage that led into the gatekeeper's lodge, I noticed a set of Queneau's collected works sitting on a chest. As if in reply to the question I'd begun to formulate in my mind, Hélion said, "Le Chiendent is for me Queneau's greatest book, his fullest and richest. Everything's in there, and it influenced me enormously. You know, people have said a lot about my figures—how they incorporate into themselves the difficulties of realization—but they forget that that's what people are actually like. Queneau's characters in Le Chiendent—Narcense, Potice, and the others—talk about themselves as characters in a drama, yet this is what people do nowadays, especially in America. And Queneau had the ear to pick it up."

In the lodge and the studio were fairly new paintings, some of which had been exhibited and some not. Other, similar ones, he told me, were gone—at the Paris show, or elsewhere. In order to arrive at a conception of Hélion's recent work, I had to reassemble all these pic-

tures—the present and the absent—in my mind, and that, in some respects, is what I spent the next hour doing. I was convinced soon enough that he'd been shrewd to shift out of literal realism into these big, brushy things. I supposed that he had needed a phase of contraction to dwell upon the finer points of nature before expanding into a looser manner; the change might have had something to do with the ending of his unhappy marriage to Pegeen and his eventual happy marriage to Jacqueline. It was also apparent that Hélion did everything in prolific quantity—a given motif might appear in as many as six or eight rather similar pieces. Often only one of these was a really good painting—what you might call the prime version in the series—and I suspected that not until these prime versions were winnowed from the superfluous versions would their true merits come to be appreciated.

Hélion's long experience seemed to have given him a remarkably elastic sense of what powers to employ: when to generalize, when to spell out, when to venture the stylish approximation. There was in some of the latest paintings a curious admixture of comic and half-mis-begotten forms—partly the result of vision problems—which unexpectedly added to their interest. Fine examples of what has sometimes been called "old man's play," these pictures escaped all limits and confounded all rules: they seemed to be trying, like Ponge's flowers, to say *everything*. What was most remarkable about them, I thought, was their freedom from any system of inner stylistic imitation or analogy: within the same painting, some lines were descriptive and others abstract; some objects threw normal-looking shadows and others impossible ones of hot, light pink; some colors were observed and some made up; some things seemed illuminated by the light of the mind and others by a tungsten bulb.

"Light is really only understanding," Hélion said. "Though I have hopes of getting a corneal transplant, my eyesight is very poor for the moment, and I must follow the inner light, the interior reverie. The dimmer my eyesight gets, the clearer grows the picture inside. It's almost too clear, really; I've ended up overconcentrating sometimes, and the picture hasn't been able to grow. For *Free Fall*, which you may remember from the show, I had to mix up pots of color in advance, very carefully, and then brush the color over a big rough drawing.

The painting's about a catastrophe—partly my own old age, partly the crazy things happening out in the world—but even if you paint a catastrophe you must do it with joy."

What he was saying abut catastrophes reminded me of the beautiful upside-down girl in *A Rebours*. I decided that before I left I ought to tell him about my reaction to the painting and to what he'd said about it in the museum. So I told him how mysteriously vulnerable that girl had seemed to me, and how coolly, to my sense, he had described a figure laden with overtones of ritual sacrifice.

"It was only after I finished that painting," Hélion replied, "that I saw the upside-down angel in the Romanesque sculpture group at Souillac—the *Sacrifice of Isaac*—which you probably had in mind while you were looking at my inverted nude. But I was hugely pleased when I saw it; I approved of the connection. You know, of course, that one puts things in a painting for reasons not decidedly clear. You turn left when you were counting on turning right; you use black when you were expecting to use white; you welcome unsuspected associations. And in the end," he added, as we stepped outside into the dusk, "you must come to terms with what Giacometti used to call 'the providential fatality': that it all would have been very much better precisely the other way around."

Stealing a March on the World

Henri Cartier-Bresson

Vous avez vu parce que vous avez cru, donc vous êtes un heureux homme. (You have seen because you have believed, and so you are a happy man.)

—Charles de Gaulle in a letter to Henri Cartier-Bresson

Thenever I think of Henri Cartier-Bresson, I see him sitting at the dinner table with a tube of North African red-pepper paste in one hand and a pocketknife in the other; these are two things that he loves. The tube of red pepper is stamped with a picture of a lighthouse and the legend "Phare de Cap Bon"; the pocketknife has a pearl handle and several wicked curves. He puts the red pepper on most of what he eats, while the knife is for spearing and cutting and spreading—and for flourishing. It's a tool, but it's also a weapon, and there is always a chance he'll use it that way. I've heard a lot of stories: for instance, about how a certain photographer once tried to take his picture on the sly, and he spotted the maneuver right off, and his knife flashed; or about how he went into a museum, and the coat-check girl asked him to check his camera, which is like asking anyone else to check his hand, and he said no, and she said yes, and that's when he whipped out his knife.

This sort of behavior might seem a trifle insincere in one who never actually harms anybody. And it has abated of late—Cartier-Bresson may feel that there is some lack of decorum in an eighty-three-year-old's brandishing a dagger. But he often draws an oratorical blade, his eyes flashing as his voice rises to some shocking pronouncement: a blanket condemnation of the advertising business, say, or the Ministry of Industry, or the people of Marseilles, or, worst of all, the belief in one God—not since Caligula has anyone railed so at the spectre of monotheism. He makes these remarks with a serious expression, but most of his friends let them pass. One is not obliged to answer an agent provocateur.

"In one way, I am like a cop or a whore," he says. "I do not want to be photographed." It is the professional aversion of the street photographer, the need to pass unremarked. Wishing to be always the person seeing, never the person seen, he has preserved his incognito so well that he is perhaps best described as the fellow holding the paper in front of his face (as he did when he received an honorary degree from Oxford), or the fellow skulking out of the dining hall (as he did at a gala dinner given by the International Center of Photography), or the fellow who recently appeared on French television as a pair of hands holding a camera. Ideally, he would be a man without physical qualities—"the color of a wall," as he puts it. Time, in fact, has conspired with his wishes, for his hair belongs mostly to the past, and his thick-lensed wire-rimmed spectacles shield his eyes from inquisitive stares. Yet distinguishing features remain: his cheeks are still "the color of shrimp" (as the Mexicans told him in 1934), and his eyes are still forget-me-not blue, and when he puts on his walking shoes and his knapsack and strides through the Tuileries he looks just like a Scandinavian socialist schoolmaster en route to a May Day parade. The halfloping gait, the vulnerable eyes, the boyish satchel—all contribute to the impression of a man in the last blush of youth.

Cartier-Bresson shares more with the East than a fondness for red pepper. Long sojourns in India, China, and Southeast Asia reinforced a vaguely Buddhist world view acquired in the nineteen-thirties. He doubts the existence of death, of life, of the past, and of the future—which makes it hard to persuade him to form any plans or to talk

STEALING A MARCH ON THE WORLD

about what he has done. At the outset of the war, he destroyed a large number of his early negatives, and if you ask him why, he will tell you it was like trimming his nails or going to the barbershop. He will tell you he hates accumulations: why are you badgering him about these figments of an antecedent world? Only in odd moments, as when his mind veers home to Charlotte Corday, does he reveal how aware he is of the past and of his own place in it. "What a wonderful figure, what an admirable character!"—his eyes brighten and his hands fly up as he recalls this revered ancestress. His connection to the illustrious knife wielder runs back through his Norman mother, and in at least one respect he himself suggests the stereotypical Norman the coyly equivocating rustic of popular mythology-and that is in his endless vacillations. It is always an experience to fix a rendezvous with him, to listen as he dithers on the phone: "Shall we meet? Why not. . . . What time? Whenever you prefer. . . . Where? Wherever you like. . . . At the wine bar down the street? Yes, we could do that, or we could meet somewhere else, somewhere nearer you, but the bar is all right—though actually I would prefer somewhere else. But really, it's O.K., I guess, unless perhaps you'd consider the public gardens." In the end, the appointment probably hangs fire, until the phone rings a week later and he informs you without bothering to announce himself that the wine bar will do beautifully, really, it's a perfectly acceptable idea. Fine—but you begin to wonder how this perpetual waffling fits in with the decisiveness you see in the photographs.

When I first met Cartier-Bresson, about five years ago, I was struck by his nervousness, his darting glances, his use of oral sound effects to illustrate his speech. When something excited him, he made a sound like "Vrrh," and he sniffed twice—nose up, nostrils flared—to illustrate his aroused curiosity. His expression was chilly, perhaps somewhat shy, but often he broke into a radiant smile, and when he was really amused his voice hit coloratura territory, as if he were trying to smother a giggle. He wore an elegant gray wool suit, and he spoke slowly and articulately, for the most part shunning slang, and conveying in many small ways his interest in his listener's opinions. If anything he said was unclear, he was only too happy to explain it—if necessary, several times.

His demeanor seemed the expression of natural manners, but there was something else as well. I came away with the feeling of having encountered a social thoroughbred, and this was surprising, because upper-class Parisian boys of the nineteen-twenties simply did not become photographers, much less photojournalists, "journalism" being a dirty word in the fashionable arrondissements. Nor did his photographs say anything about his social origins, though the absence of outlandish camera angles did suggest a dignified reluctance to engage in public contortions. Some days later, I mentioned my perplexity to a French friend, and he gave me the pitying look that people generally reserve for the last person to find something out. Didn't I know that Henri was one of the scions of the great Cartier-Bresson textile firm? Didn't I know that the Cartier-Bresson logo could once be found in every French sewing basket? Why, the very name spelled magic to countless older Europeans, who had grown up with memories of Mother at her sewing machine working wonders with the help of Cartier-Bresson thread. It was no secret that Henri had been reared in a cavernous apartment on the rue de Lisbonne, a street lined by very substantial palazzi built in the latter half of the nineteenth century.

But Cartier-Bresson is a deeply contradictory person, and he happens to be intensely averse to the bourgeois society whose child he is. He has never lost his attachment to the classics of Surrealist rebellion: among the books he will readily pull off his shelves for you are André Breton's Mad Love and René Crevel's The Harpsichord of Diderot. As a teen-ager, he used to go to the Café Cyrano, in the place Blanche, and sit at the "Surrealist table," where, back to back with off-duty clowns from the Cirque Médrano, Breton would hold forth to the faithful. The lion-maned Breton was the pope of the movement, a master of encyclicals and excommunications; the spectacularly handsome Crevel was (until his suicide, in 1935) Breton's trusted cardinal and intellectual goon. Cartier-Bresson still swears by Breton's and Crevel's social and artistic ideas, yet a note of circumspection creeps into his reminiscences of the Café Cyrano. "The trouble was, I never got close enough to the center of the table," he told me once, "so I missed a lot of what Breton was saying."

Cartier-Bresson never actually joined the Surrealist movement,

STEALING A MARCH ON THE WORLD

and, despite a certain prewar sympathy with the Communist Party (the Surrealists allied themselves with the Communists between 1930 and 1935), he never joined it, either. If you ask him what he has kept of his original "revolutionary" Surrealism, he will tell you that it is primarily a respect for human creativity and an attitude of revolt against the bourgeois social order. This suggests a rather one-sided reading of Surrealism, and it also implies some need to wrench himself away from his rich family. The implication is misleading, however, for he was fond of his family, and as a married adult he lived for some years in the apartment on the rue de Lisbonne. In a sense, his cultural attitudes are not personal to him but representative of the whole generation of French artists and writers who came of age around 1930.

The world has so few novel beings, so few genuine originators, that one is always startled to recall that Cartier-Bresson bears the same relation to itinerant small-format photography that Euclid bore to geometry: he is a founder and an ancient of his art. It is by now an old story: how, at age twenty-four, while recovering from a severe case of malaria contracted in the Ivory Coast, he bought and almost instantly mastered a remarkable little camera that had just come on the market. The camera was the first Leica, a hand-held machine with a viewfinder mounted on the body: it was light, quiet, easy to focus, and equipped with an excellent lens. It seemed to have been invented with him in mind, and if you ask him today how long it took him to grasp the technique of 35-mm photography he will crisply respond, "Three days." He will tell you that he studied the Leica manual, made a few trial exposures, and that was it: he would never alter his basic working method. Flash units, tripods, umbrellas, reflectors—none of these were for him. One lens-the "normal," or 50-mm-suited him perfectly (though he would occasionally resort to a 90-mm), and, despite a few brave tries, he never really took to color film.

His technique was simplicity itself, and so it has remained. When he spies a likely subject, he begins at once to position himself, and at just the instant when he feels that gestural expression, background, and lighting coincide to form a forceful composition, he snaps. He does not develop or print his pictures himself but leaves his rolls of

film with a trusted printer, on the invariable understanding that only whole negatives will be used—that no image will ever be cropped. If you examine his proofs, you discover that he rarely shoots a subject more than half a dozen times; indeed, he cautions against overshooting, if only because it weakens concentration. A sort of blank awareness of the target, as in Zen archery, is all the technique he really possesses. He is fond of saying that he cannot take a photograph, the photograph has to take him.

Cartier-Bresson's first mature pictures—the ones dating from his convalescence in 1932—were soon followed by a host of others, taken in the course of trips to Spain and Italy and during a yearlong stay in Mexico. In those days, Cartier-Bresson knew almost no photographers; most of his friends were writers or painters—people like André Pieyre de Mandiargues, Léonor Fini, and Christian Bérard—and his work reflected his passionate absorption in Parisian avant-garde culture. In 1934, he was invited to Mexico City as the photographer for a surveying expedition, which almost instantly collapsed. Stranded and broke in the poorest part of town, he fell in with a group of creative people (among them was Manuel Alvarez Bravo, who became his first photographer friend) and started selling snapshots to local newspapers; eventually, an exhibition was organized at the Palacio de Bellas Artes. This Mexican phase offered him a foretaste of what became, in the late nineteen-forties, his standard operating procedure: he roamed the city and mixed with its inhabitants, adopting their customs as freely as he could; all the while, he photographed them in a way that combined his Surrealism with a distinct sympathy for the downtrodden.

The Mexico City photographs confirm the power and consistency of the young man's vision. One of the most exemplary is a market scene in which the viewer looks down on three weary people resting in the shadow of a canvas umbrella. They appear to be sitting on crates by a stall—a workman in overalls studying a newspaper, and a woman with a grown girl sprawled in her lap. All traces of social context are caught with the utmost deftness—the man reads with a magnifying glass, the girl wears a dirty apron with a comb at the ready in its pocket—so one's attention never wanders from the gorgeous, Pietà-like pose of

STEALING A MARCH ON THE WORLD

the woman and the girl. The shadow of the umbrella adds a touchingly protective, and characteristically surreal, note to the picture.

By the end of 1934, Cartier-Bresson had shown his work publicly in New York and Madrid as well as in Mexico City, but the following year he largely abandoned photography in order to study moviemaking. Returning to Paris, he signed up with Jean Renoir as an assistant director; he would work on A Day in the Country and Rules of the Game, and he would also make a film of his own—a documentary about Loyalist military hospitals in Spain. At the outbreak of the Second World War, he was mobilized into the French Army, and in June of 1940 his unit was captured in the Vosges. After three years of forced labor in Germany, he escaped and returned to Paris, where he became involved in photojournalism—first for the Resistance, then for the picture press. In 1947, he helped found Magnum Photos, the first photoreporters' agency with real clout in the marketplace; the agency forthwith dispatched him to Asia, where over several years he created a body of work that is widely regarded as one of the glories of postwar photojournalism.

As a professional, Cartier-Bresson began to spend a lot of time with other camera reporters. In Magnum itself, there was Robert Capa, the daring war photographer, whose character and judgment he deeply admired, and also David Seymour—known as Chim—who became one of his dearest friends. Within Magnum, Cartier-Bresson figured as a sort of specialist in decolonization: the Western empires were rapidly losing their Asian possessions, and he felt called to bear witness to this rift. He was in India just after the close of the Raj, in China at the triumph of the Communist Party, and in Indonesia for the first months of independence from the Dutch. During the next three decades, he would often return to the East, and he would also photograph both the Soviet Union and the United States.

In 1952, his friend Tériade, the Greek-born publisher who had earlier created the art review *Verve*, brought out the first comprehensive book of Cartier-Bresson photographs. Called *Images à la Sauvette*—the idiom is suggestive of speed and furtiveness—it appeared in the United States as *The Decisive Moment*, and this title, which soon became a catchphrase, did much to confuse the American public about

Cartier-Bresson's intentions. It implied that as a photographer he had some preternatural grasp of the unfolding of events, that he was able to discern those objective instants when people's gestures supposedly betray the moral nature of their actions. The truth was otherwise, for Cartier-Bresson had little feel for storytelling and never excelled at composing photo essays or catching historic moments; in fact, one of his maxims is "The anecdote is the enemy of photography." Inge Morath, who worked as his assistant before becoming a photographer in her own right, once told me that Cartier-Bresson had counselled her to look for composition, for visual order, and to let drama take care of itself. He persuaded her to try a viewfinder that inverted and reversed the image, and she found that by working in this "abstract" way she actually enhanced the social content of her shots. The lesson was that "the decisive moment" did not inhere in the story but was an expression of the beholder's form-sense.

Cartier-Bresson's photographs of the late forties held less mystery, tension, and spatial compression than his youthful work of the thirties. He was more interested in crowds and chaos now—he had to be, it was part of his job—and a certain compassion rose more readily to the surface of his pictures. His range of concerns grew broader, too, as he warmed to his role as a witness. Testimony, he felt, could be a form of expression; indeed, it was doubtful whether anyone would heed it if it were *not* a form of expression.

In conversation, Cartier-Bresson calls his camera "a tool for quick drawing," and refers to his photographs as "a visual chronicle" or simply as "my journal." Year after year, this journal's finest leaves have exhibited a geometrical patterning so subtly irregular as to seem a kind of organic growth, a rehearsal of some principle of natural creation. Yet what surprises you in his pictures is not this quality by itself but, rather, its coöperation with another quality—the sense of a fleeting moment seized. In your amazement at a picture, you do not usually ask "How can this be so?" but "How can this be so while that is also so?" Time seems to contrive puns with space, as in the famous image of the puddle jumper, whose leap is echoed by a dancer in a billboard ad, or the portrait of Alberto Giacometti duplicating the silhouette of one of his statues. In this

game, Cartier-Bresson has shown a consistent eye for the subtlest of conjunctures, and has routinely captured the complex and revelatory interplay of large casts of characters. In India, for example, he once snapped a naked ascetic who unconsciously mimics the configuration of a nearby tree while several devotees peer out from between its branches; farther off, an indifferent goatherd surveys his flock. A picture like this has ambiguous meanings, and though it may not tell you much about Indians, it tells you a lot about people, and even more about the questioning nature of sight itself.

There is something hobgoblinish about Cartier-Bresson's visual alertness: his glance cuts through the Paris streets like an advance guard for his body. "Beautiful ironwork up there; good light on that old lady's face"—where the glance goes, he will usually follow, threading his way through the crowd to some apt post of observation. Despite his age, he still ranges rapidly through the city, and though he doesn't usually take his camera with him these days, he still often points with his index finger (a typical photographer's habit) at objects or actions that interest him. Even when he sees only what others see, the sight seems to tickle him more. Once, as I entered his living room, I saw him standing outside on the balcony, laughing softly; when I asked him what he was laughing at, he pointed to the southwest. A black, eelshaped cloud had balanced itself with protractorlike accuracy on the tip of the Eiffel Tower, and he watched it as raptly as a child. The cloud was certainly a buffoon among clouds, and anyone might well have noticed it, but probably no one else in the world would have been so delighted by its prank.

Cartier-Bresson's friends often liken him to a cat or a bird—the enmity of these two animals suggesting the tensions in his makeup—so a balcony seems a natural place for him. He lives, with his family, on the fifth floor of a porticoed and pedimented building overlooking the Tuileries (a favorite subject). For nineteen years, he has been married to Martine Franck, herself a brilliant photographer, and they have a nineteen-year-old daughter, named Mélanie. Martine is a tall, attractive woman of fifty-three, who moves with swanlike grace; she has that Iberian litheness and depth of color one finds sometimes among the Flemish. Born to an old Antwerp family (her paternal grandfather was

a friend of Ensor), she grew up in London, where her father was for many years the president of Samuel Montagu & Company, a merchant bank in the City; like her husband, she is a child of the high bourgeoisie. My earliest memories of Martine are of someone listening and listening to what other people are saying; she does not hold a silence so much as inhabit it, and in the end its sheer intensity dominates the conversation. Along with an impressive eye, she has extraordinary powers of sympathy, and in her work one strongly senses the photojournalist's chief moral dilemma: how to reconcile natural modesty with the professional habit of trespass.

When I try to imagine life with Cartier-Bresson, several images jump to mind. There is the H.C.-B. of the tear in the eye and the catch in the throat—the exponent (as a friend of his put it to me) of "oldfashioned tenderness." There is the H.C.-B. of the sidelong look, of the glance tracking over toward some momentary, peripheral action so visually exquisite that the mere remembrance of it brightens your day. And then there is the H.C.-B. of the unpredictable towering rage. Such outbursts rapidly blow themselves out, and few people take them amiss; you might say that they are merely his way of entrusting you with a parcel of his grumpiness. He himself confesses that he is "milk on the fire," but it is not, one suspects, his grousing or his adventurous opinions that tax his intimates so much as his pouncing impatience. This impatience—this compulsion to steal a march on the world surely contributes to the quality of his photographs, but it also sorely tries his family and friends. His wife is calm in the midst of it all, as if annealed by his heat, but even she sometimes sighs at his fretting, his waffling, his fits of temper.

Because he seems to be living in a different time frame from those around him, Cartier-Bresson can remind you of a wildly dissenting clock in a clock shop. His minutes are not other people's minutes. He burns to do five things in the time it would take to do one, and when he finds he cannot he wastes precious moments trying to choose among the five. Then, there is the matter of his memory, with its selective lapses: though he expressly forgets large tracts of his past, he often resumes very old conversations, or even conversations that never took place. This has nothing to do with his age; it's his nature. Once, he

greeted me at his front door by informing me, "She is here! Anna is here!"

Knowing no Anna, I stared and ransacked my memory.

"It is Anna today, not Kim!" he insisted. "And she came at two, not three!"

I accepted the implied correction, then inquired who these people might be.

"Oh, I'm sorry," he said, and explained that they were his models.

There is often a model expected at Cartier-Bresson's these days. For the last fifteen years, he has done a lot more drawing than photography, and in a way this practice is another of his resumed conversations, because for a time in the late twenties he was an art student in the school of André Lhote, an influential prewar painter and teacher. He still speaks almost reverently of Lhote's teaching; it was Lhote who sensitized him to the prime concerns of modern picture-making. One of the things Lhote talked about was "screens"—how space in a painting could be treated as a succession of planes cut out against other planes—and such screens, often in the form of grilles and perforated walls and doors, have always played a major role in Cartier-Bresson's images. Cartier-Bresson also came to share the serious modern artist's distrust of grand themes and stagy figure compositions. "What I am after," he told me, "is geometry. I once played a silly game with Alberto Giacometti in which each of us had to pick his three favorite painters. In common we chose van Eyck and Cézanne, and then one of us chose Paolo Uccello and the other chose Piero della Francesca. This is my taste—I have no feeling for the theatrical in art. I have no feeling for Caravaggio. Poussin and Cézanne hated Caravaggio. And I do not really care for Tintoretto. I was in Venice once with Léonor Fini, the painter and set designer, and I told her that I did not care for those vast Tintorettos in the Doge's Palace and that other palace. And she came at me with her long nails and tried to push me out of our gondola, all because I did not care for the Tintorettos."

Cartier-Bresson has a litany of objections to contemporary tastes and public policies. These objections came together for him one day when he was looking at the Sistine ceiling and saw it suddenly as "a prophecy, in comic-strip form," of the end of life on our planet. He

objects to the mutilation of the earth, to the vulgarity of consumer society, to the crushing of native cultures, to the swamping of regional customs. He hates all self-consciousness in dress, food, and furniture, and he believes that people think too much and perceive too little, and that nothing worth learning can be taught—at least, nothing about photography. Often he has a public letter out or in the works—another practice he picked up from the Surrealists—and he commands every trick of this grotesque literary subgenre, including the insulting joke and the willfully tasteless pun. He is appalled by the hordes of shutterbugs who barge through those places in the Third World where once he prowled with his little Leica and his stock of black-and-white film.

He also insists that he does not believe in morality, and is prepared, with all his moral nervature showing, to hotly defend this point. I remember one evening when he got involved in a curious dispute with a friend of his, a famous poet, who had come to see him. The poet, Yves Bonnefoy, seemed a difficult man to argue with: his hair was patriarchally white, his face impassive; he was distant, weathered, dour, and not prone to hasty judgments. But none of this daunted Cartier-Bresson, who initiated the discussion with a ringing assertion of the utter fatuousness of the idea of right and wrong. The whole notion of guilt, he announced, had been invented by the Hebrews and passed on to the Christians, and now we were all saddled with it. The Orient, he claimed, had no such preoccupation with guilt—the Orient was guilt-free.

During this harangue Bonnefoy studied his left shoe. At length he avowed that he was not convinced of the truth of what Cartier-Bresson was saying. Mustn't we all accept some responsibility for our actions, he suggested, whether we live in the East or the West? Look at the insurance companies; they were based on a concept of accountability, yet he had never noticed anything particularly Christian about them. Had Cartier-Bresson?

Cartier-Bresson pouted and blushed—he is a great blusher—and gamely discharged some conversational ballast. He was willing to admit that he did approve of some things in the Christian religion. He quite liked the saying of the Latin Mass, the dignity of the old melodies and chants.

"But of course," said Bonnefoy. "That goes without saying. You don't believe in God, Henri, and the less anyone believes in God the more he insists that the Mass be said in Latin."

I looked over at Cartier-Bresson and saw, to my surprise, that he was glowing: far from feeling trumped, he obviously relished this rejoinder. Why, then, had he started this discussion? To ventilate his mind? To spur Bonnefoy's wit? He began to argue his point again, and though his words yielded no hint of burlesque exaggeration, somewhere in his eyes the tiniest point of humor glimmered and dissolved.

One summer I paid a visit to Henri and his wife and daughter at their second home, which is near the town of Forcalquier, in the part of Haute-Provence called the Luberon. This region is an hour to the east of Alphonse Daudet country, and if you arrive with no more knowledge of Provence than what you gleaned as a schoolchild from Daudet's *Letters from My Windmill*, you will lose your bearings there. It is much steeper territory than Daudet's, much more eccentric and mysteriously compartmentalized, and is chiefly devoted—or was, until recently—to the herding of sheep. The houses are fortresses of thick, irregular stone masonry, surmounted by terra-cotta tiles, and often shaded by a full-crowned evergreen oak tree (the "ilex" of the poets). They are called *campagnes* or *bergeries* by the people of the Luberon, and usually contain a huge granary—now rarely used as such—in the midst of the living quarters.

The Cartier-Bressons' house rests on a broad shelf in the vast northern declivity of the Montagne du Luberon. Though they have planted a few trees and shrubs, generally they have done as little as possible to alter the appearance of the old *bergerie*. The adjacent fields are worked by a neighboring farmer, and the surrounding banks of lavender and rosemary, which in summer emit a heavy scent, are indistinguishable from those that flank the dwellings of the native countrymen. At the rear of the house sprawl a bed of petunias and another of impatiens, enclosed by a stone retaining wall; beyond this wall stretches an overgrown meadow dotted with a few fruit trees, and beyond that rises a very steep knoll, whose ancient terraces are choked by a tangle of aromatic bushes and vines.

The interior is a matter of deep embrasures and hand-hewn beams, of tawny or varicolored terra-cotta tiles, of "country" furniture, dowelled and pegged, and of rustic pottery and rush-bottomed chairs—all local things, or things that could pass for local. The only object that looks surprised to find itself there is a statue of the Buddha, which stands by the rear entrance to the largest room, a former granary with walls of undressed stone.

Some months before my arrival, Henri had undergone an operation to replace a knee prosthesis, and since he was still unsure of his right leg it fell to me to chauffeur him around. The roads were poor, the gradients steep, and I often felt as if I were zigzagging through an immense storeroom of stage flats and backdrops. Piled up pell-mell, in the oddest relations of plane to plane, were tilled fields, pastures, escarpments, defiles, canyons, copses, and alleys of stately trees; here and there rose clusters of those soft hillocks of farmland which the French call *mamelons*. Winding its way through this shifting terrain, the road would climb by degrees to higher ground, perhaps to the severe geometrical stonework of a hill town; more likely than not, we would soon be caught in a series of hairpin turns, with one shoulder of the road plunging giddily down into what appeared, from my place behind the wheel, to be sheer vacancy.

Often, Henri had errands to run in the morning, and we would nose warily off from the house in his Volkswagen Golf through an alley of parasol pines and down a steep, unpaved road through a forest of scrub oak and Aleppo pine. At regular intervals, the Golf would jounce over a culvert made of stone bars: difficulty of access clearly belonged to Henri's concept of a rural retreat. At the bottom of the hill, where we entered a network of byways, funny things started to happen. "Get way up on the right shoulder," he would command, as a gully opened up under the car. "Honk here—beep-beep!—there's a road merging from behind. Keep wide of that hummock there, now swing to the left. Stop! Anyone coming from your side?" At this point, a Citroën would very likely shoot by, eliciting an "Oh là! Salaud de Marseillais!" and a shake of the head from my passenger. "Watch out for these No. 13 license plates," he would say, and go on to list every fault in the Marseillais manner of driving. The one license plate he fra-

ternally saluted was the 04, which betokened the local man or woman. There was a certain presumption in this—after all, Henri is basically a summer person in Provence—but also a certain naturalness. His liking for the Provençal character is relatively new, for until 1970 or so he had a country house in Touraine, whose soft light he adored. But deeper than any particular affiliation lies his innate tendency to blend into the landscape, to find out about local traditions, to grant that the natives around him—whether Provençal or Indian or Chinese—know more about many things than he does. "Look at these houses, their perfect proportions," he would say as we drove along. "People simply cannot make these beautiful things today, and don't tell me it's a matter of expense. They've lost the sense of geometry."

Three mornings a week, Henri went to train his weakened leg under a physiotherapist's supervision at her office in a nearby village. She would first massage the leg, then attach weights to it for him to pump. He always chatted companionably with her, but once outside he would fall into a petulant mood, appalled at the chunks of time his knee problem was costing him. All this wearisome husbanding of energy was not the sort of life he was used to.

"I like to say that a photographer must be something of an acrobat, because he is always running, balancing, about to tip over," he told me once as we left the physiotherapist's office. "Do you know what it takes to be a photographer? It takes one finger, one eye, and *two legs*. I used to run or walk thirty to forty kilometres a day, and because of this I've kept fit my whole life, without ever engaging in sports. As a matter of fact, I hate sports. Sports always involve these *round* things—as in soccer, cricket, basketball. Why must they be round? It's so boring. The shape of the rugby ball is such a relief after all this *roundness*."

"But didn't you like sports as a child?" I asked.

"As an adolescent, I liked to paint," he said, "and on Sundays and Thursdays—our days off from school—I often did paint. My father liked art, and drew well himself, and on Sundays he might talk to me about painting, or take me to look at antique furniture and old bindings."

"So you come from a visual family?" I said.

"Well, my great-grandfather was an artist—I'll show you a fine

album of his drawings the next time we're in Paris together—and my uncle Louis Cartier-Bresson was a talented painter. He studied under Cormon at the Beaux-Arts—like Soutine—and he won the Prix de Rome in 1910. He was killed at the start of the First World War."

We settled into the car and headed out of the village. "As a child, I was not aware of how well-off we were," he went on. "We didn't take vacations—holidays meant visits to my grandparents. And the food was, well . . ." He gave a disparaging smile. "We were very frugal. Everyone was mending stockings, and one year my grandfather halved the expense of my Christmas present, because times, in his opinion, were so hard. My family, who were Catholics, but republican Catholics, were ashamed of their wealth—they never gave money to their young children—and later, when I was old enough to realize that we were not at all poor, I, too, began to feel ill at ease. I began to feel a certain guilt toward the working class."

As we drove home Henri told me more about his family. "My father's people were farmers, from about twenty miles north of Roissyen-France and also from the northern part of Burgundy, near Avallon," he said. "My mother's family had been living in northern Normandy since always. Both families were in the textile business, but their peasant background never seemed far away. Those were the early years of industrialization, when young adolescents worked in the textile mills, and the ethic of paternalism was still in force among the grand bourgeoisie. Work hard! No cheating! No talking about money! Build a church to justify the money you've made! But, at the same time, there weren't any taxes to be paid. Eventually, this ethic led into left-wing Catholicism and—in my own generation—to the guilt complex I have mentioned.

"My father was stern and quiet, and looked very much like an English gentleman. He was always in his study writing—he gave me a distaste for business, except when he had samples of threads of different colors. Then I'd enjoy helping him judge one blue swatch against another blue swatch—then we were chums! My mother was extraordinarily beautiful, right up to old age. She was highly sensitive, nervous, always wondering whether she was right or wrong, and she had a passion for psychology and philosophy, and for music. My brother

and my two sisters were all much younger than I was. One of my sisters died before the war, of an illness. I spent my childhood summers very largely in Normandy, and I still dearly love that province. As a boy, I explored all the quays of Rouen, where my maternal grandparents lived—I was nourished by wharves, by boats bound for Africa, by taverns where sailors drank. My Norman grandfather was a Dreyfusard, something rare in his Catholic milieu—but personally he was very strict. I remember that at the age of eighteen I was carrying a book around, and he saw it and asked me, 'What have you got there?' I showed it to him—it was Strait Is the Gate, by Gide—and he said, 'Step into my study, Henri.' He looked very serious. He said, 'Listen, Henri, don't you know that the woman this Gide fellow married is our own cousin Madeleine Rondeaux? He may be a fine writer, but he's a very wicked man.' My grandfather was terribly disappointed when I failed to earn my bachot. In those days, it was the custom to give a boy his first hunting rifle when he got his bachot, and I suppose he was looking forward to that moment. Later, when he heard that I was going about with a camera, he asked someone if I had become a photographer. 'He has? Then he's a failure,' he said."

Nearly every day, Henri and I would drive in to the village to pick up the mail or a newspaper, and usually we would stop for a cup of coffee at the principal village café. This place was run by a neighbor of Henri's, a farmer driven to café-tending by the increasing unprofitability of agriculture in the Luberon. We would drink our coffee, stories would be exchanged, and a verbal skirmish would erupt as we took our leave-Henri emphatically trying to pay, the café-keeper adamantly refusing payment. Then we would head out of the village and up into the hills. Away from the Marseillais and the monotheists on holiday, beside a quiet winding road, is where Henri likes to stop and draw; often he returns to some favorite lookout that commands a number of views. The Luberon, with its many brusque shifts of vista and mood, seems divided into a collection of miniature provinces, corresponding not to any actual holdings but to some system of supernatural domain; here and there, you feel that you are invading the personal arena of some storybook deity. What binds Henri to this landscape, and what gives it the look of externalized thought, is simply

the fact that it was made by man. You sense this in the shapes of the copses, which often resemble scraps from a tailor's cutting table, and you see it in those *mamelons*, which swell like puffed-up patchwork squares out of a network of artificial depressions, and which form a recurrent feature of his drawings.

"I could never draw the American West," Henri once told me as he began to sketch such a landscape, "because it was not made by man. Your Grand Canyon, for instance—I could never draw it. It reminds me of the entrails of animals." He was working with a lead pencil, and as his hand skittered over the paper it conjured up not only the motif in view but also some quality I remembered from his photographs. He had sometimes puzzled me by calling himself "a stingy Norman," but at that moment I sensed how his photographs and drawings embodied the ancient, secretive thrift of the French countryside—not the meanness of Balzac's provincials (that was a different, though perhaps related, matter) but simply the provident peasant's instinct for the deployment of resources. Like the plots of land unfolding before us, Henri's little rectangles of light and shade abhorred all waste and excess.

Sometimes on our way home from a drawing session, I would induce him to tell me a little more about his early life. He would talk about his days at the Lycée Condorcet, and how he had lost interest in earning his diploma; about his immersion in Schopenhauer and Proust; about his passion for Rimbaud; about a school friend who had taken him to meet Élie Faure, the famous art historian and anarchist; about another friend, Pierre Fosse, who became a banker and a sculptor of considerable if unrecognized talent, and whose three daughters modelled for Balthus; and about Max Jacob, the poet, who had pulled Henri's leg constantly but had also encouraged his artistic interests.

"I used to visit Max a lot, and at his place I met Pierre Colle, the art dealer. Pierre's mother knew how to tell fortunes with a tarot deck, and one day I asked her to tell mine. I told her I wanted to sail to the Far East. 'No,' she said, 'maybe later. Now you go to the other side of the world. There you'll be robbed, but you won't care. Somebody will die, and you'll be very sad. Later, you'll marry somebody from the East, though not from India and not from China, and not white. The

marriage will be difficult. You'll make a name for yourself in your profession. When you are old, you'll marry someone much younger than yourself, and you'll be very happy, and you'll have one or two children.' Then she gave a hint about the way I would die. And, so far, everything has come about as she foretold. I went, as you know, to Mexico, where I signed a blank check made out to the head of our expedition, and he cashed it. I didn't give a damn—I had only a little money, which my family had given to me in case of illness. Then an uncle died, in an accident—it was he who had given me my first copy of Proust. Later, in 1937, I married Ratna, my first wife, who was Javanese. At every turn, my life has been marked by coincidence, and I am often reminded of what André Breton used to call Objective Chance. Breton felt that coincidence was everywhere, like a hidden pattern, and one ought to look out for it. He liked to say that one had to put oneself in a state of grace with Chance."

Cartier-Bresson's first great adventure, his trip to West Africa in 1931, offered him a personal confirmation of the fact that fortune could be wooed. By going to Africa and getting extremely sick there, he fell in behind Rimbaud, who had done the same thing in the eighteen-seventies. Lots of remarkable Frenchmen were wandering around Africa in the twenties and thirties—Gide, Céline, Cendrars, and Michel Leiris among them. The experience was a sort of baptism into the world of left-wing and bohemian anticolonialism.

At that point in his life, Henri told me, he was deeply involved with a married woman ten years older than he was. Yet despite the joy of their attachment, and despite all his gratitude to her, he longed to get away from Europe. Since he had always had a yearning for adventure (what he likes to call "mon petit côté Viking"), he decided to ship out, and with the help of his grandfather he found a freighter in Rouen bound for Douala, in Cameroon. As soon as he arrived in Africa, he got work on a steamer that delivered goods and mail to the towns along the coast. He was entrusted with the ship's manifest, and at each port of call, with this document in hand, he would ride a landing craft piled with cargo to the shore. It was "great fun," he told me—the roiling surf, the bobbing boat—until the day the little craft capsized in

shark-infested shallows and he had to swim ashore. It was then that he observed that no measures had been taken to protect the black crew; their lives were hazarded with utter indifference, and they were paid mostly in bananas and cheap rum.

Sometime later, in the Ivory Coast, he fell in with a timber merchant. He had just made up his mind to work for him when the fellow took ill from sunstroke and began to show signs of derangement. Abandoning this plan, Henri plunged into the bush to work for a planter, who operated an antiquated palm-oil harvester. The planter lived about fifty miles from the coast, in a corrugated-tin hut, with his beautiful Sudanese common-law wife. In addition to helping him out with his work, Henri sold candles and various trinkets in a nearby bazaar. He also met an Austrian hunter, who taught him how to hunt the local game. As a boy, Henri had occasionally hunted with his father in Normandy or in the Île-de-France, and now he stalked boar and antelope and swamp deer with the Austrian; hunting only at night, wearing a cork helmet fitted with an acetylene lamp, he learned to direct a beam of light at his prey and identify it by the color of its eyes.

After a while, wishing to make more money, he moved south to the port of Tabou, on Cape Palmas, near the Liberian border. Five or six French civil servants lived there with their families, as did a similar number of French families engaged in trade; the two groups despised each other and avoided all contact with each other. As Henri described it, Tabou bore a striking resemblance to Louis-Ferdinand Céline's imaginary colony of Bambola-Bragamance in *Journey to the End of Night*. When he read Céline's novel, several years later, he was impressed by its brutal characterization of French West Africa, and especially of the moral self-destruction of the European settlers, who, "like scorpions" (in Céline's phrase), were slowly poisoning themselves with their hatred of their black underlings and of themselves.

Appalled by this manner of life, Henri decided to head into the wilderness again, away from the white settlers. With his treasured copies of Rimbaud's poems, Lautréamont's *Les Chants de Maldoror*, and Joyce's *Ulysses*, he walked up the Cavally River, accompanied by a few porters, until he came upon an abandoned coffee plantation with a native village beside it. There he made friends with a black

man named Doua, and together they crossed the river into Liberia to buy cartridges and white rum. He began to hunt again, and to sell the meat through runners heading downriver. After several months of this primitive existence, he contracted blackwater fever, a highly lethal, little-studied complication of malaria whose principal symptoms are blackish urine and bouts of violent trembling. There were rumors abroad in the village that Doua was a violent person who had once murdered an abusive white woman; nevertheless, he nursed Henri with tenderness and expertise. A runner was sent to Tabou for help, and eventually a pirogue arrived; the young Frenchman was carried aboard, but his terror and despair were so great that after several miles he begged to be returned to Doua's care. "I believe that Doua saved my life," Henri told me. "He seemed to know a great deal about medicinal herbs. Perhaps he had even studied sorcery." At one point, Henri felt that he was very near death and wrote a letter to his grandfather asking to be buried in Normandy, beside the forest of Eawy, to the strains of Debussy's String Quartet. "Your grandfather deems that too expensive," an uncle wrote back. "It would be preferable that you come home first."

He made it home, of course; and though he apparently didn't have much in his bag—his three books, a few mildewed snapshots he had taken with a box camera, and a pair of tribal statues, which he later learned were endowed with supernatural powers—his life had begun to acquire a metaphorical texture. It was no accident that he had resorted to hunting to support himself, or that he had been saved from death by a mysterious remedy from the nonwhite world.

One afternoon as we were chatting, Henri casually mentioned to me that as Jean Renoir's assistant during the shooting of *Rules of the Game* he had been put in charge of the rabbit-hunting scene. I realized that—as if to confirm the cliché about the predatory nature of photographers—he had often appeared in the guise of a hunter. Having observed his alertness on the Luberon roads, I suggested to him that his sense of beauty was perhaps the same as his sense of danger, but considered from an altered angle: he had hunted—and, later, been hunted, by the Germans during the war—and his fine nose for the chase had concentrated his mind.

"But of course the cliché is apt," he said. "I am a natural hunter. Even as a boy, I was a very good shot. De Gaulle once told me that a photographer was like a gunner—he had to aim well, fire fast, and cut out. But I must tell you that something about shooting those animals in the Ivory Coast rubbed me the wrong way, and after my return to France I never hunted again. What I like, you see, is the stalking; I have no use for the meat. After I became a photojournalist I used to send in negatives without showing much interest in the printed stories, and that exasperated people—they couldn't understand it. To them it was like a man shooting a pheasant and then not bothering to eat it—something profoundly taboo. But I am like that. To push the shutter release—ping!—that is a great joy. But looking at photos is something else. I don't particularly like to look at photos. Have you seen any photos on my walls?"

For Carder-Bresson, Provence is not only a source of motifs but also a vast social spectacle. I began to realize this one day at the tail end of a little lunch party the Cartier-Bressons were holding on the terrace. Helen Wright, Henri's elegant and very knowledgeable representative, was there, as were several friends who lived in the area.

The main course was over; we were all dabbing our lips and patting our stomachs and leaning contentedly back from the table. All, that is, but Henri himself, who sat ramrod-straight, with his pearl-handled pocketknife in one hand and his Phare de Cap Bon in the other, contemplating a half-finished platter of stuffed tomatoes.

"Who would like another tomato?" he asked. "Martine? Can I tempt you?"

"No, thanks," said Martine.

"Split it?" he suggested.

"No, thanks," said Martine.

He speared the tomato with his pocketknife and put it on his plate. I was sitting across from him, where I could look out at the hills on the far side of the valley, and I made some remark about the layered aspect of the landscape—how the fields and vineyards gave way, as they mounted, to straggling scrub forests, and the forests to those gorse-studded slopes the botanists call "garigues."

"I might add," said Henri, who is interested in landscape primarily as it reflects mankind, "that there are also three levels of society here. There are the locals—the people of Haute-Provence—who have thinned out considerably since the war. There are the summer people, mostly Parisians and Marseillais, with their ostentatious houses and cars. And then there is the Mob, which is composed largely of burglars and the antique dealers who fence for them. Yes indeed, some of the dealers are very thick with the burglars!"

One of the guests, a bearded Provençal, emphatically confirmed this opinion. "Stripping a summer house bare during the winter is a specialty of the burglars of the Midi," he said. "And many are in league with the dealers."

"Some of those burglars tried it right here," said Henri. "Of course, they didn't take much, because they couldn't get their truck up here fast enough, and since then we have removed the entire contents of the house at the end of each summer. But, all the same, it was an unnerving incident. The first thing the police asked me after the burglary was if I had received a visit from the parish priest of Saint-Michel l'Observatoire. It seems that a thief was making the rounds of the neighborhood disguised as a curate on a charitable mission, his real aim being to case people's houses and belongings. He had an accomplice, a Spaniard, who did the actual boosting for him, but he hadn't figured out what sort of person this Spaniard was, and he wound up being robbed and tortured and murdered by the man. This happened about four years ago."

Henri helped himself to a piece of guinea fowl and coated it with red pepper. "Maybe I should point out that I'm not sure I'm opposed to stealing," he continued. "After all, it puts property back into circulation. I am a convinced anarchist, and I think Rousseau had a point when he suggested that the first real thief was the man who put an enclosure around a field and called it his own. The problem is that these robbers have the habit of smashing things during their breakins, and that is dreadful, really dreadful. Thieving should be done with elegance! A good pickpocket is an artist!"

Almost imperceptibly, Henri had launched into one of his verbal crescendos, and his hortatory tone triggered his wife's skepticism.

"Oh, Henri," she said, "I don't think you'd have such a great regard for thievery if your pocket had just been picked."

"But, *chérie*, I myself have been a pickpocket," he replied, putting down his knife and his Phare de Cap Bon. "Of course, it was only for a minute. It was at the opening of the show of Tériade's paintings at the Grand Palais. Tériade had come in, and when we embraced I felt his wallet pressing up against me, and then it just sort of—well, slipped into my hand, and I paraded it around the gallery for a full five minutes, calling, 'Fine Greek wallet, any takers?' Was he furious! He was a dear fellow, but I must say that he was very close with his money."

Smiling helplessly, Martine stood up. "There's still cheese, fruit, yogurt, and pastry," she said.

"Excellent, we'll have all those things," said Henri, triumphantly.

The day after this speech, I got a chance to watch Henri spying on the local population. He and Martine and Helen Wright and I had driven to L'Isle-sur-la-Sorgue, a pretty town east of Avignon, to look over the shops and the markets there. For a while, we wandered about the tree-lined boulevards by the River Sorgue and picked our way through stalls laden with earthenware, faïence, and écru lace; then, when our hunger had ripened, we strolled over to a café-restaurant, where Henri had made reservations. The restaurant was near a quay, and seemed to partake of the dancing light of the river. We entered through a suite of salons, whose mirrors caught scraps of blue-andwhite sky, and then emerged into a courtyard furnished with tables and chairs; in the midst of the tables was a hexagonal stone fountain studded with frowning masks. As we sat down, a busboy threw a flowered cloth over our table. All around us, elderly ladies in sprigged frocks were sitting over other flowered tablecloths, while off to one side some people had started a game of pétanque, the Midi form of outdoor bowling.

Three huge plane trees formed a vault over the court, and as Henri surveyed the sun-dappled crowd he stretched discreetly and waggled his head, like a sparrow taking a dust bath. A mysterious transformation had come over him: he radiated a strangely mischievous serenity, and all the weight of his gnarled impatience seemed to roll off his

back. He asked if Martine cared to pass him her camera. With a faint clandestine smile, she handed it to him in the shadow of the table.

He leaned over toward me. "The local bourgeoisie is very conservative," he said, in an undertone. "These people all have the same sort of face. Look at that pair of ladies by the fountain, the light on their heads—it's perfect."

I glanced over at the two ladies: they wore quiet floral dresses and leaned together like a pair of pleached fruit trees.

"Don't stare so," he said. But he kept right on talking about them, divining the roles they played in the social life of the province, and though he seemed aware of their every gesture, he wasn't actually looking at them; there might have been a prism in his head. His gaze wandered, resting on one or another festive group—this flashing wine bucket, those raised glasses—till at length it lit on the enclosing backdrop of ivy-covered walls and plane-tree boughs. "That background is the problem," he said, and I saw what he meant. It was too busy: sun-spotted leaves rustled behind the heads of the luncheon crowd, creating a figured-chintz effect.

"Now look at those people coming in," he said. "That one, he's a doctor—no, excuse me, a psychiatrist." The man was tall and fat, and wore wire-rimmed glasses and expensive lightweight-wool trousers. "And those people over there, they are completely different. They are difficult, very difficult, I don't know. . . . Aha, now look at those! *They* are antique dealers, maybe fences—just the sort I was talking about at lunch yesterday." Three squat people—a woman, a man, and a lumpy adolescent, who appeared to be their son—were just walking into the courtyard. They looked like anyone else to me.

As Henri gave up the idea of taking pictures, his pickpocket air vanished, and he peered about more frankly. A lot of people had come in by now, and there were bits of action everywhere. At the other side of the dining area, several small tables had been drawn together to make a big one, and between the two rows of smiling faces a little drama was taking place: with exaggerated care, a waiter set down a huge package, of the sort that florists concoct. It had an electric-blue wrapper. "That blue is *not* good," said Henri, with a kind of stage manager's dismay. "That blue is not good at all." Just then the headwaiter

veered by our party, and Henri caught his elbow. "If you please," he whispered, nodding toward the giant blue package, "why the flowers?"

Of course, this was a piece of out-and-out nosiness, and the head-waiter shrugged in feigned ignorance. It wasn't a very convincing gesture, but Henri paid it no heed; he was too engrossed now in the amazing package, and I noticed that he had once again lifted Martine's camera off his lap, up level with the tabletop. Over at the other table, the huge package was being eagerly opened; several hands were snatching off the electric-blue wrapper, and what they revealed, when the paper was cleared away, was not flowers at all but a cone made of monstrously garish fabric.

"Look, it's a lampshade," whispered Henri. "Some lucky fellow has actually been presented with that extraordinary lampshade." In a trice, the camera flew to his eye, and then sank down again. "Bad background," he muttered.

There had been no click.

Later, when we had finished our meal and were standing outside by the river, I thought over the scene that I had just witnessed. At lunch, Henri had taken his time in sizing up a potential subject, and I had been able to observe him for perhaps two minutes. Now I rehearsed his behavior, trying to see how it differed from the approach of other, less celebrated photographers I knew. But there was no real difference, and as I tried to assess what I had learned I soon saw that I had learned nothing. I saw that though some artists may pass through a mental terrain, leaving characteristic tracks, H.C.-B. does not. With him, everything that is genuinely original happens in the twinkling of an eye. That twinkling is for him a burst of light, but for anyone else it is darkness.

Presently, Martine and Helen left us to go look at an antiquarian's stall farther along the river, and since Henri's bad knee was paining him a bit we sat down on the embankment beside a little stone bridge. It occurred to me to ask him what plays he had seen that year; he seemed the ideal playgoer, and he had, after all, worked for some years in the Paris film world. But it turned out that he had no interest whatever in the stage. He confessed that he had never gone to the Comédie-Française and had no desire to do so; instead, he went fairly often to

cafés—for him the café was theatre. "Except," he added brusquely, "for Saint-Germain-des-Prés. I do not like Saint-Germain-des-Prés. I can never figure out who is what there. Anyone could be anything!"

For a moment, he absently massaged his right thigh.

"You must understand that I have no imagination," he said suddenly.

"No imagination?"

"I mean imagination for plays, for stories—theatrical or narrative ability. And Jean knew it."

Apparently, he meant Jean Renoir.

"May I ask how you got to know him?" I said.

"Oh, I just went to see him," he replied. "I had wanted to make films for a long time. I had even applied to work with Pabst and Buñuel, both of whom I admired, but they didn't need anyone, so I made up a collection of my photos and showed it to Jean. He liked it, and made me his second assistant. As a film director's assistant in France at that time, one did everything except the shooting and the editing. I never looked at a single frame. But I chose the château for Rules of the Game, and I worked on the scripts—on dialogue—and this I enjoyed very much. I also met some interesting people. Luchino Visconti came to visit when we were shooting A Day in the Country; and then there was Jacques Becker, that charming and intelligent man. Jacques was Iean's first assistant, and he liked to tell stories that rambled on and on, and I thought, How will he ever make a film of his own? When I started to see his movies after the war, I was stunned. What movies-vrrrh, vrrrh! Jacques had a Model T, and I remember that the evening before we were mobilized for the war we made the rounds of all the best places in Paris—the Ritz, the Plaza-Athénée, the Meurice, the Continental. Usually we would only have made the rounds of the brothels. Anyway, it was a tremendous privilege to work for Jean. He was like a great river of warmth and simplicity, though sometimes he became discouraged too easily—he wasn't enough of a fighter, perhaps. When his energy was flowing, what generosity, what humanity! But Jean knew very well that I would never make a feature film. He saw that I had no imagination."

For a while, Henri reminisced about the late thirties, and about

the war. We were still sitting at the edge of the Sorgue, watching the cloud-shadows chase along the river, when he started to tell me about his three years as a prisoner in Nazi Germany.

"We soldiers were deeply disappointed by the cowardly behavior of the Daladier government," he said. "A comrade of mine inscribed on his belt the words 'Betrayed-Sold-Delivered.' When we arrived in Germany, they put me on various labor details, and I did thirtyfive different types of manual labor in my three years of captivity gathering hay, shovelling manure, working in quarries, railroads, farms, factories. We always knew very well which of the Germans were Nazis. For example, a civilian worker might pass us half a loaf of bread and say something like 'Krieg nicht gut.' That sounded fine, but then he would go on: 'Hitler didn't want war. It's the fault of the Judeo-Marxists and the filthy British. Why don't you join us—you are Frenchmen, civilized, intelligent, not like these Italians we're allied with.' He would say this right in front of the Italian labor conscripts. I sensed that some of the Germans weren't like this—they weren't Nazis—but I must say that I never detected the slightest evidence of a German anti-Nazi underground. Secretly, we tried to seek one out, but we soon saw that we were alone, and we learned not to shout protests in the typical French way, because that would only have invited German brutality. We learned to use humor or irony. I remember particularly one sentence in German: 'Mit Vergnügen, sobald sich die Gelegenheit dazu bietet'—'With pleasure, as soon as the occasion presents itself.' I would say this, with a click of the heels, whenever they asked me to clean the latrines or something of that sort.

"I escaped three times. The first time was in May. A comrade and I walked toward the Swiss border at night and slept in the bushes during the day, but it started to snow, so we couldn't make much headway, and we were picked up after a few days. We were given twenty-one days of solitary confinement and two months of hard labor before being returned to ordinary compulsory labor. The second time, I escaped from a factory in Karlsruhe that was making crates for bombs, but I was captured within twenty-four hours. Just before the bridge on the Rhine, at two o'clock in the morning, I was stopped by one of the *Schützpolizei*, who began to question me. I said to him, 'I

look more German than you do,' and he answered, 'Maybe so, but, you know, you forgot to do "Heil Hitler!" The third time, I actually made it, but it doesn't matter how. There was no great risk in trying to escape. If they caught you, it was just three weeks of solitary again and two more months of hard labor."

I did not yet know, when I heard this story, that Henri had got out of Germany on a train, together with an aspiring clothes designer named Claude Lefranc—they had disguised themselves as foreign laborers. At first, I thought he disdained to recount the exploit; I thought he was showing the characteristic modesty of the former stalag escapee or Maquisard, who has seen others display far greater bravery than his own. But gradually I realized that the experience no longer interested him. It had lapsed into dead antecedence, like the old negatives he had offhandedly destroyed. What held his attention now was the little bridge by our side, the shallow curve of its arch spanning the water; the boy biking lazily across it; the sliding clouds overhead; a certain shadow bisecting the wall behind us, which he turned occasionally to scrutinize. All were present to his mind at once—filling it, doubtless, with notions of pictures—and it came almost as a surprise to me when he resumed his story.

"To live in captivity is so terrible that we tried all sorts of things to divert our minds from the sheer anguish of it," he said. "I didn't make any pictures—I read Plutarch and some poetry—but I recall one fellow who did use to make pictures, though of a different sort than the kind I would have made. He was by trade a pastry chef, and as a prisoner he spent a lot of his spare time designing cakes and tarts on small pieces of paper. Whenever he wanted to show what some part of a confection would be made of, he would run a line from that part out to the margin and write a note there. So his drawings looked something like the drawings of the old landscape painters—the ones with lines leading out to scribbled color notations—only *his* notations read 'meringue,' or 'hazelnut cream,' or 'glazed peach slices.'

"I suppose the Pétain regime could have arranged to help us. We might perhaps have been replaced by other French workers and sent home, but we didn't want to be replaced. We were proud of the

responsibility of being soldiers. We even thought of starting a strike, but instead we engaged in sabotage and work slowdowns. The tendency of French prisoners to yell at the Germans about their living conditions was dangerous. The *grève perlée*, the slowdown strike, was much better, because then everybody was committed to action and they couldn't hide behind the leaders. That way, too, the Germans had no identifiable leaders to execute."

As the summer eased into the dog days of August, I was overcome by an agreeable torpor. I began to look forward to the drawing sessions, to our calls on the physiotherapist, to the regular arrival of amusing house guests. There was also the enjoyment of Martine's cooking, and of watching her husband wolf it down; and after lunch I liked to sit on the terrace in front of the house and imagine that the vast carrousel of pastoral and sylvan forms about us was actually a sort of vegetal battlefield, a diorama of tree regiments in rout and hot pursuit.

The old farmhouse would have seemed an impregnable retreat but for one unhappy breach in its defenses—the telephone. When it rang, and it rang often, Henri's face assumed a piteous, shattered-vase look. He would lift the receiver with trepidation.

"You what? You are doing a survey on what? . . . Do I like champagne? Ah, no, listen, that is a very personal question and one that I am not at liberty to answer. . . . A less intimate question, yes. You should have asked me when I last made love, for example. You should have asked me when I last made love and enjoyed it."

All extravagances were so sternly barred from the *bergerie's* interior that Henri's fulminations appeared a stylistic anomaly. It sometimes caught me off guard when he hung up the receiver while still venting his spleen: what I had thought was a private chat became, in one second, a harangue. "I detest all commemorations," he announced to me once as he strode away from the phone. "Some people want to organize a commemoration of the first forty years of Magnum, but what is that to me? Why should I wish to dwell on the last forty years, when it is only today that I care about? I suspect that they are after me on account of my *petite notoriété*," he added darkly. "But I am just a photographer like any other—only better!"

Despite his sudden rages, which often seemed projected at the ceiling, Henri displayed an old-style courtliness, and to Martine he was unfailingly gallant. As time went on, I saw that beneath his conversational pyromania there resided a nearly unimpeachable sense of good form: his very refusal to hang his own pictures on his walls suggested the gentleman's reluctance to parade an advantage. He always begged pardon before contradicting me, yet when he agreed with me there was often something imperious in his manner of concurrence. I noted, too, that he had the English gentleman's horror of elaborate food, and love of comfortable old clothes; in fact, he had that easy familiarity with Anglo-Saxon customs which so often marks the upper-class Frenchman. It was not so much despite his patrician background as because of it, I began to feel, that he had acquired the common touch, and he had often sympathized with "the people," that was surely because his secure social position permitted a deep, disinterested savoring of the ways of simple folk.

In line with his upper-crusty egalitarianism, he insisted that everyone address him as tu, though doing so sometimes had the unintended effect of making him seem more remote. It pointed up his gruff, almost glacial reserve, which was really an expression of shyness; in time, I came to suspect that this shyness was bred in the bone. Just as his quick temper had nothing to do with anger at the world but was merely the product of a tightly coiled nervous system, so his emotional reticence was the product of his social milieu. Some months after I left Provence, I discovered, from an old friend of his, that at the rue de Lisbonne Henri and his siblings had, even as adults, waited to be addressed by their parents before venturing to speak up. At table, they had called their parents vous.

Henri's knee had been rapidly improving, and one evening he took a friend of his and me out for a spin and did all the things he had told me not to do. He tooled about single-lane roads and veered hard around death-trap turns, and at one point he nosed the Golf off the road altogether and down a steep stubble field, until the whole Luberon Valley tilted up at us and his friend made a remark about tank warfare in the Vosges. We got safely back to the house, but there Henri discovered that, try as he might, he couldn't fit his car where it

belonged. Some visitors' cars were parked in the driveway; this in itself would not have been troublesome, except for an ill-positioned tree.

"It's ridiculous, that tree!" Henri exclaimed. He was red in the face with frustration. "All the trees I planted here I put in the wrong place! I'm utterly incapable of visualizing what things will look like in ten years' time."

Early one afternoon, as I was returning alone from the village, driving the Golf up the access road to the house, I saw a white-haired man resting under an evergreen oak by the side of the road. He wore jeans and espadrilles and a blue cotton shirt, and he lay with his head propped up on one arm and chewed on a blade of grass. I supposed him to be a newcomer, and when I reached the house I asked Henri who he was.

"His name is Claude Roy," Henri replied, "and he has come down from Paris to spend a few days in Provence."

The name rang a bell—I had read a few books by Claude Roy—but I couldn't say that I knew much about the body of his work. Henri was glad to fill me in, for it seemed that he had known Claude forever. He had followed him through most of his many shifts of social and artistic orientation, and he believed that Claude had arrived at old age with a great reserve of serenity. He told me that Claude had recently survived a dangerous operation for an even more dangerous illness and was filled now with the convalescent's zest for life.

A little later that afternoon, after the siesta hour, I found Claude sitting on the front terrace chatting with Henri. He looked as frail as a reed, yet his downturned, beaglelike eyes radiated subdued merriment. A Ping-Pong game was going on inside the house—Mélanie had been challenged by one of her friends—and at each sound of volleying Claude's blue eyes lit up, intensifying the color in his florid face. "I love the sound of Ping-Pong," he said during one volley. "It's so light. It's the Mozart of sports."

There were tea things on the table, and also a plate of biscuits and one of apples. Henri sipped his tea steadily while he sampled the biscuits. The air was heavy and still, and haze clogged the Luberon basin so densely that nothing but dim shapes could be seen beyond

the line of poplars marking the highroad. A change in the weather was due.

From the conversation, I gathered that Claude had met Henri during the Occupation, when both worked in the National Movement for Prisoners of War; in fact, Claude had written the text for a documentary movie, called The Return, that Henri made at the end of the war. As I listened to Claude, I got an inkling of what the French mean by the expression "beau parleur." He listened keenly to what his friend had to say; he drew irony out of his friend's turns of speech; he refrained from wounding his friend with that irony but made it seem like his friend's invention; and, thus improvising his own tune with Henri's notes, he would double back on certain ritornellolike motifs until they suggested a theme for the whole conversation. This time, the theme was old friendships, and as Claude spoke of various people— Paul Éluard and Louis Aragon came up—Henri would smile and nod, or perhaps interject a word of disagreement. Claude seemed to exert a palliative effect on Henri's innate restlessness, and he had a knack for prodding Henri's memory, which again seemed quite capacious, hardly resembling the blank tablet he had often claimed it to be.

"Do you remember when you and I were both living under the Queensboro Bridge?" Claude asked at one point.

"That must have been shortly after the war," said Henri.

"You had invited me to stay at an apartment that wasn't even yours, and I only found out when I rang at the door. It was a *very* crowded apartment, as I recall."

"I had been invited to stay there by a man named Jimmy Dugan," said Henri, "but it wasn't Jimmy's apartment, either. I had met Jimmy at Éluard's, in Paris—he was still a G.I. then, working for *Stars and Stripes*, I think—and we went together to cover the La Rochelle front, which was one of the last major battlefields inside France. Through Jimmy, I later contacted some friends who had arranged an exhibition for me at the Museum of Modern Art—Lincoln Kirstein and Beaumont Newhall—and they invited me to come to America. It was initially planned as a posthumous show, since they thought I had been killed in the war, and I must say it was kind of them not to have your obedient servant assassinated when they found out he was still alive.

By this time, Jimmy had moved into an apartment under the Queensboro Bridge, and he asked me to come there and stay with him. He had a great imagination and believed that this apartment was his. So Ratna and I took an empty Victory ship to Philadelphia—I remember we were tossed by a very rough sea-and when we got to New York we rang the bell at Jimmy's address, and a lady I had never seen before opened the door. 'Is this the home of Jimmy Dugan?' I asked. 'Well, he's staying here as my guest,' she said, 'but actually it's my home. Why don't you come in?' It was a railroad flat, and Jimmy walked down the long hall in his underwear to greet us, not at all embarrassed, and told us there would be no problem with our living there, so Ratna and I went to Bloomingdale's and bought bunk beds and moved in. Jimmy stayed in his underwear all day long, pounding at his typewriter and drinking, and lots of people turned up, for a short or a long stay. My sister, Nicole, showed up en route to California—she had just won the Prix Valéry for poetry, and Darius Milhaud had invited her to Mills College, where he was teaching. Then you came, Claude, and then the whole Indonesian delegation to Lake Success, including Agu Salimat least six people—and we were all packed into that little railroad flat. I met Truman Capote at that time, and Ratna gave a recital of Javanese dance at Hunter, and I recall that Carson McCullers was there—I adored Carson-and it was all quite marvellous. New York after the war was marvellous."

"But you have to admit that you gave us a turn or two with your carryings on," said Claude. "I remember that we went once to a black Baptist revival meeting in Harlem, and there was all this splendid singing, and then a huge lady stood up to witness, in a state of absolute exaltation. All of a sudden, I saw you coming right up under her nose with your blasted camera, and I thought, This is it, we've had it, they're going to kill us. I was totally terrified. But nothing happened—nobody was at all offended—because nobody except me had even noticed you." Claude shook his head and turned to me. "He can make himself invisible, this Henri of ours—it's magic."

"It's not magic, it's the métier," said Henri. "Quick—vrrrh!—you take it, and nobody's seen you. They forget you, because you've forgotten yourself. When I first read Zen in the Art of Archery, I felt like that

monsieur in Molière who'd been speaking prose all his life without knowing it. I realized that the intuitive photography I'd been practicing had always had a Buddhist quality to it. Life changes every minute, the world is born and dies every minute—that is what Buddhism teaches."

"Which Buddhist sect are you referring to?" said Claude, knitting his brow.

"Well, I'm not a student of religion," Henri said, "but I suppose I feel closest to Zen Buddhism. I don't know—Martine says that I belong to the sect of the Agitated Buddhists. Anyway, I am attracted by the idea of anatta, the Non-Self, though what I suppose is not so terribly Buddhist in my character is my attitude of revolt, which comes from Surrealism. I asked some Buddhist friends about this—Tibetan lamas—and they told me that revolt was actually quite compatible with Buddhism, on one condition: that it remain constructive and compassionate. It must never become bitter—bitterness only falls back on your head."

"Maybe I'm just being contrary," said Claude, "but I don't think you're any more of a Buddhist than I am, Henri. There are quite a few Westerners who are much better Buddhists than either of us."

"That may be so," said Henri, "but I do think that I have a sort of Buddhist direction in life."

"Fine, if you want to believe it," said Claude. "But think about the statues of Buddha, Henri. Their eyes are almost always closed, while yours are almost always open."

This seemed a grand slam, but Henri had a ready reply. "One eye is wide open, looking through the viewfinder," he conceded, "but it cannot be separated from the other, which is closed and looking inwards. It may be that I'm not a Buddhist, by your lights. But I *am* an anarchist—you can't deprive me of that."

"But what is anarchism, anyway?" Claude pressed on, unrelenting. "It had one extraordinary moment, during the initial phase of the Spanish War, and even then there was this weird business of people saying 'Be free!' while pointing a gun at your head. In a way, it wasn't so different from the Cultural Revolution, when Mao was saying, 'Obey me: disobey!"

"Let us say, then, that I am a libertarian. The word has a more elegant ring."

"Ah, a libertarian. Now, that is grand," said Claude.

Henri was looking with dawning interest at the plate of apples, and Roy pushed it toward him. "For me, your photography is a sort of journal, Henri—a diary that is at once intimate and public," he said. "I mean that one reads your feelings there, and at the same time it's an image of history."

"Actually, most people's photography is a sort of journal," said Henri. "Photography is a thermometer of mood—in that way, it's like painting. But for me it is primarily structure, geometry, the golden section. It's having everything in the right place, a matter of millimetres."

"But, my dear Henri, for you to go about telling everyone that geometry is the spinal column of your photography is completely misleading. If anything, that spinal column is time itself—your wonderful feeling for the moment. Take that photo of Giacometti in the rain, when you ran ahead and turned to snap him with his coat over his head like a tent."

"Actually, I didn't have to run ahead for that one," said Henri. "I had already crossed to the other side of the street. But I did have to run to get that shot of Claudel."

"Ah, Claudel." Claude pulled a face. He looked unhappy with the memory of Claudel.

"I'm sure you know my story about Gandhi and that Claudel photo," said Henri. Claude nodded, but I told them I hadn't heard it. "Well, I photographed Gandhi in 1948, and when I went to see him I showed him the catalogue of my 1947 show at the Museum of Modern Art. He looked at it slowly, page by page, saying nothing, but when he came to the photo of Claudel gazing at the hearse he asked, 'What is the meaning of this picture?' 'That's Paul Claudel,' I said, 'a Catholic poet very much concerned with the spiritual issues of life and death.' Gandhi thought for a moment, and then he said, very distinctly, 'Death—death—death.' I said goodbye to him at four-forty-five that afternoon, and fifteen minutes later I heard the cry in the streets, 'Gandhi's dead! Gandhi's been killed!"

A longish silence followed. Then Claude observed that the Ping-Pong volleys had ceased. "I suppose they've stopped playing," he said wistfully.

"Or they're digging out the ball," said Henri. "It often gets into the woodpile. That woodpile is a *farci* of Ping-Pong balls."

"Well, anyway," said Claude, "there is for me a great difference between your photo of Claudel and your photo of Giacometti."

"Ah, yes—and in my feelings about the two of them," said Henri. "Alberto was my friend, whereas Claudel was remote—though actually Valéry was even more remote than Claudel. When I came to photograph Valéry, he held his head in a series of standard positions—full face, three-quarter face, profile, and so on. He thought he was helping me out." Henri's voice hit one of his odd, almost giggly top notes.

"Tell me about your portrait of Matisse at Le Cannet," Claude said. "How did he take to being photographed?"

"He was quite kind, actually, and I decided to ask him about something that had been bothering me ever since I visited the church at Vence, a few days before. 'Monsieur Matisse,' I said to him, 'you have never shown any serious interest in religion, and you are all the time painting these odalisques, these beautiful girls. Why didn't you decorate, instead of this Christian church, a Temple of Voluptuous Delight? Wouldn't that have suited your temperament better?' He listened to me carefully, and his face grew very serious, and he said, 'You are right, of course. But the only institution that would ever commission a Temple of Voluptuous Delight is the French Republic, and no French government has ever made me the offer."

As I looked out over the valley, I saw that the weather had changed, as foretold. The declining sun raked the forests and the stubble fields, and a dry breeze had sprung up, wafting the aroma of lavender and rosemary. It was only a local breeze, nameless but friendly, and it blew all the haze from the air. Soon the file of poplars marking the highroad stood out like teeth before the vast jigsaw puzzle of copses clambering up the knolls behind them.

Claude said, "Just think, Henri, here we sit talking about Matisse, Claudel, Surrealism, anarchism—it's prehistory. We must sound like a pair of dinosaurs."

"A pair of diplodoci," said Henri, without conviction.

"But we are nice diplodoci," said Claude.

There was a snapping sound, and I realized that Henri was crunching on an apple.

Between 1937 and 1970 Henri lived in a flat near the place Vendôme, and he still often goes there to draw. It has a tiny bedroom, a rudimentary kitchen, and a longish, many-windowed work space, whose shelves are stocked with books on drawing and painting. Quiet and bright, the little flat makes a charming atelier, and it also serves as a sort of guest room for Henri's out-of-town friends: there is a café downstairs and a caterer's establishment across the street, so the visitor has all that he needs and more. But when I stayed there recently I kept trying to picture the place in earlier, rougher days, when there was no shower and no modern toilet, and Henri had bathed by pouring casseroles of water over his head. Henri and Jean Renoir and Robert Capa and Chim had given tremendous parties there, and Roberto Rossellini had hidden out there from the press for a time. I knew that the little pantry had been a darkroom then, and had often been littered with prints by Capa and Chim; with this fancied scene in mind, I began to rummage through piles of Henri's old papersscrapbooks of clippings and photographs and proofs, and faded copies of illustrated magazines—trying to round out my mental picture of photojournalism in its shining moment, before television newscasting stole much of its function and almost all its thunder.

Most of the Cartier-Bresson photographs I came across were from the forties and early fifties. A lot were fairly routine, but sometimes a strong forgotten picture caught my eye. One was of a Nazi functionary, tall, gaunt, and vulturine, being held at gunpoint by two stubby, delighted-looking French partisans; there were also good shots of General Leclerc's troops distributing food to Alsatians; a touching story on the roundup of some women who had consorted with German troops by soldiers of the French Resistance; and interesting snapshots of Paul Valéry and Paul Éluard. There were some delicate Italian views.

These photographs represented a great variety of subjects, but

one event they all documented was how Cartier-Bresson had gradually backed into the profession of photojournalism. Originally, he had studied painting; though he liked taking photographs and knew he was superb at it, he hadn't wanted to be a full-time photographer of any sort, and even up to the late forties he had harbored serious doubts about becoming one. He also felt—with some reason—that the editorial needs of the bourgeois picture press would collide with his Surrealist aesthetic. During his three years as a prisoner of war, however, he had been forced to engage in over thirty kinds of hard manual labor, and this had changed his attitude to work itself. He was no longer the bourgeois *fils de famille* that he had once been, and he felt differently now about the whole business of making a living. Yet it took Robert Capa to convince him that professional photojournalism might actually suit his temperament.

As early as 1936, during the first phase of the Spanish Civil War, Capa had talked to friends about creating a "brotherhood" of camera reporters which would enable them to retain their copyrights and the legal ownership of their negatives. For years, he intermittently championed this project, and finally, in the spring of 1947, he succeeded in bringing it about. The new association was to be called Magnum Photos and to have seven shareholders, five of whomhimself, George Rodger, William Vandivert, David Seymour, and Cartier-Bresson-would be photographers. The other two would be administrators: Vandivert's wife, Rita, would run the outfit's main office, in New York, and Maria Eisner, a veteran photo-agency director, would head the Paris branch. To induce the recalcitrant Cartier-Bresson to help found the agency, Capa used two shrewd arguments. He appealed to Cartier-Bresson's anticolonialist sentiments and love of adventure by proposing India and the Orient as his future turf, and he also pointed out that nothing in the craft of picture reportage could corrupt Cartier-Bresson's Surrealist soul if he refused to let it do so. "Watch out for labels," Capa told him. "They're reassuring, but somebody's going to stick one on you that you'll never get rid of: 'the little Surrealist photographer.' You'll be lost, you'll get precious and mannered. Take instead the label of 'photojournalist,' and keep the other thing for yourself, in your heart of hearts." What Capa perhaps

failed to see was that Surrealism and photo-reportage, far from being inherently opposed, actually had an affinity for each other.

By the summer of 1947, when Cartier-Bresson sailed for Bombay, he was operating under a specific set of assumptions. Among them were that Magnum would be his exclusive broker; that he would control the rights to his work; that every effort would be made to ensure that his pictures were not cropped in magazine layouts; that his exclusively pictorial and noncommercial approach would be respected; and that he would supply at the least the rough draft, if not the actual words, of the captions for his photographs. One long-term consequence of this arrangement was that all his contact sheets and their accompanying commentaries have remained on file in the agency's Paris archive. As I thumbed through the scrapbooks in his atelier-apartment, I began to feel that even if there were few or no great pictures buried in the Magnum archive—this was what I had heard from the man himself—it might still prove illuminating to look through some important groups of contact sheets and their corresponding captions.

Today, Magnum Photos is situated on the rue des Grands-Augustins, not far from the house where Frenhofer meets Poussin in Balzac's novella *The Unknown Masterpiece*. I never had time to discover whether an unknown masterpiece of Cartier-Bresson's was hidden there (his files were too vast for me to comb through), but I soon realized that the pictures and captions from 1947 to 1949—roughly, from the partition of India to the Communist victory in China—constituted an extraordinary document, a gripping picture-diary of the Orient at a turning point in its history. Each set of captions was invariably preceded by a long typewritten commentary, or correspondent's "letter," composed in a vivid, rather ungrammatical English that often lapsed, by design or ignorance, into French.

At the time of his departure for India, Cartier-Bresson was not yet regularly supplying *Life* or any other magazine with pictures. *Life* had Margaret Bourke-White in India, and only a little later, when it grew clear that more than one photographer would be required, did the magazine solicit his help. So he departed as a free-lancer, pure and simple. He assumed that he would be years in the East, and he took his wife along with him. Cartier-Bresson was then married to a Javanese woman,

pretty and round-faced, who went by the stage name of Ratna Mohini, though all her friends called her Eli. Trained as a child in the ritual Javanese dances based on the *Ramayana* and the *Mahabharata*, she had later studied Indian dance under Uday Shankar, and had given recitals at the Musée Guimet and the Archives de la Danse, in Paris, with her partner, Rai Gopal. "She was at once a Muslim and a follower of the Vedas," Henri told me. "Whenever I set off somewhere she would slip a copy of the *Bhaghavad-Gita* in my valise. If I came to understand the Orient better than many Westerners, the credit is all hers." Ratna was well connected in Delhi, so Cartier-Bresson hoped that he would rapidly gain an intimate sense of Indian society.

Indian independence was declared in mid-August of 1947, but Cartier-Bresson and his wife did not arrive in the new state until a month later. Their ship, a German vessel that the British had captured during the war, was beset with problems that outwitted its crew, and it lingered for some weeks at Port Sudan before steaming on toward Bombay. The ship also put in at Aden for a few days, and as I looked over Cartier-Bresson's shots of that city I couldn't help remembering that Paul Nizan had passed this way, too, in 1926. Nizan is more or less unknown in the United States, but he has long been almost a cult figure for the French left. A novelist and publicist, he became in the late thirties a correspondent for the Communist newspaper Ce Soir, for which Cartier-Bresson, though not himself a Communist, also worked. (When they covered the coronation of King George VI together, Cartier-Bresson characteristically shot the crowd instead of the pageant.) Nizan was temperamentally unlike Cartier-Bresson, but some of his feelings about what it meant to travel to the East might also have been expressed by the photographer, with his Buddhist sympathies—or, for that matter, by any number of French Communist or Surrealist intellectuals who matured in the interwar period.

"Once it was established that the collapse and decay of Europe was a simple, inescapable fact, the renaissance and flowering of the Orient became a fact equally obvious," Nizan wrote in "Aden, Arabie," his dyspeptic tract of 1931. "For Europeans, the Orient held salvation and a new life. It had medicine for our ills, and love to spare. We made free use of false analogies with antiquity and drew on the official history

of religions. We endowed Asia with all the human virtues that had been gradually disappearing from the West over the last three hundred years. . . . The spirit of civilization hovered over India, China seemed more marvellous to us than it had to Marco Polo," Nizan rang the obvious changes on the already shopworn idea that a colony (like a prison or a brothel) gave a true, unvarnished image of Western capitalism, but he hadn't much use for the "lazy, dirty, unknowable" natives. Cartier-Bresson leaned the opposite way—he found the natives knowable, and worth knowing—but his trajectory along a path already described by Nizan affords yet another example of his tendency to reprise, as a photographer, a number of celebrated literary voyages to the nonwhite world. In Africa, there had been Rimbaud, Conrad, and Gide; in Aden, there was Nizan; and later, in the Far East, he would arrive in the wake of André Malraux. By the war's end, Cartier-Bresson had been largely disabused of his earlier idealism, but it is nonetheless significant that most of his Asian theatres of vision already belonged to French literature's roster of paysages moralisés.

Teeming with men and gods, India summoned up all of Cartier-Bresson's luxuriant powers of observation. Equally interested in folk-lore, religion, and politics, in the portraiture of types and individuals, he took pictures that encompassed the widest moral context; he also saw that he could capture public events, record little-known ways of life, take note of arresting performances, and still discover, in all these situations, an element of the surreal. In Cartier-Bresson's contacts, there are snapshots of textile workers, forts and mosques, migrating peasants, refugee camps, flashy durbars, religious feasts, historic leaders, markets and ashrams, classical dancers, warriors, and saints; there are whole unpublished reportages on the Pathans and the Harijans. One frame may seem chiefly ethnographic in nature, the next a pure registration of form. Yet, though the kind of scrutiny varies, the point of view—that of the passionate diarist—remains unchanged.

When he arrived in Bombay in September of 1947, Cartier-Bresson discovered a land recently partitioned into two states. India, despite its Hindu majority, proclaimed itself secular; Pakistan wavered, contemplating the adoption of an Islamic constitution. Communal violence had claimed over half a million lives, and riots still raged fitfully in the

streets, prompting Gandhi to begin a total fast in protest against the persecution of Muslims. As it happened, Cartier-Bresson's wife was a close friend of one of Jawaharlal Nehru's sisters, Krishna Hutheesingh, and through the latter he eventually obtained an introduction to the Mahatma himself.

Cartier-Bresson's coverage of the last days of Gandhi seems at once fortuitous and predestined. The day before his interview was to take place, he went to have a look at the scene outside Birla House, in Delhi, where Gandhi had taken up residence. It was January 29, 1948; word was out that Gandhi had just received assurances from the principal Hindu leaders that Muslims would be treated fairly. The contact sheets at Magnum show that Cartier-Bresson first glimpsed Gandhi through an open door, propped against two pillows on a mean camp bed, his head swathed in white; a worship service had evidently just ended, and a crowd of well-wishers had surged into the Birla House compound. In subsequent frames we see the Maharani of Baroda, the ex-Minister of Gwalior State, and Princess Kolapur paying their respects, and Gandhi receiving a delegation of survivors of a massacre that had occurred on a train from Gujarat.

The next day, Cartier-Bresson rode his bicycle to Birla House, a scene of increasing political tension, for his scheduled four-o'clock interview. He photographed Gandhi and showed him his MOMA catalogue, which the Indian leader carefully perused; then he rode off, and fifteen minutes later he heard the cries that Gandhi had been killed. He sped back to Birla House. The first frame of the relevant contact sheet is captioned "Place where Gandhi fell half an hour before." From our retrospective perch, the absence of any material directly relating to the murder constitutes a huge lacuna in the journalistic story; but for Cartier-Bresson this story did not actually exist until it was created, instantaneously, by the assassin. "It must be understood," he has said in this connection, "that when you are in the midst of extraordinary events you often can't see anything but minor and apparently unrelated incidents—it's a little like what Stendhal said about the Battle of Waterloo. My camera enables me to catch details that are very important at the moment when I want to compose a synthesis of all that I have seen." Cartier-Bresson apparently felt that there were more inter-

esting tasks than staying on top of a developing political crisis, and this suggests how far the sense of a potential "story" and the search for the pictorial are from being the same thing. He was out to ambush scenes that would stand on their own merits rather than furnish illustrations to the text of history. If the two activities happened to overlap, so much the better; if not, the pictorial impulse was bound to win out.

One cannot forget that Henri is a prodigy of nature. His nervous and ocular organization so far exceeds that of the ordinary photo-reporter that he learned within a few months of acquiring his first Leica to take snapshots of incomparable eloquence. He has never had to struggle for greatness in this field, and his work has never improved or declined. Nobody has ever been able to figure out how he takes his incredible pictures, and many people make the mistake of thinking he knows. In fact, he doesn't-or if he does, he cannot articulate that knowledge. If he had a precise idea of what he was doing while he was doing it, he would probably be too slow to do it well. But people still want to know how he got this or that shot. Usually, he tries to be helpful and offers some affable reply—but, really, you can hear that he has nothing to say. At first, he regrets having to sound so disobliging, but after a while he begins to resent the burden of regret. "What can I say?" he sputters. "I like that shot, too. But I don't know how I got it, I don't even know what I was thinking at the time-probably nothing. I guess I'm just an impostor. O.K., the scene is remarkable, but I didn't create it, you know—I just happened to be there." And finally he loses his temper. "I tell you, I just happened to be there! I'm not responsible!"

Cartier-Bresson's photo essay on the death of Gandhi, which first appeared in *Life* and formed a part of his 1988 India show at the International Center of Photography, in New York, is really a portrait of popular distress; through it runs a marked preference for exemplary tableaux at the expense of current-events reportage. The key pictures are studies of crowd rhythms. Down the years, his work has shown an exceptional feel for the rapids and whirlpools of bodies in motion; no one else has ever seen so clearly how a single mysterious force seems to ripple through many heads of hair at the same time, making one brilliant scrawl of tresses, or how certain knots of figures, striking queerly consonant attitudes, seem to rise like symbolic sculpture groups out of

the human tide. Aside from this visual quality, the sequence on Gandhi's funeral has a moral dimension, in the broadest sense of the word. With his finely tuned sense of the right distance to be from the crowd, Cartier-Bresson caught masses of distinguishable persons: his sense of where to position himself, implicit in each picture, conveys his empathy for those he is recording. He does not wish to render suffering picturesque but to enable his audience to feel the anguish of an orphaned people.

And yet, for all their vividness, these reportorial shots do not really equal the other Indian images: the crowd of veiled Muslim women outside a shrine at Srinagar; the women praying at daybreak on a hillside in Kashmir; the *dhobis*, or clothes-driers, of Ahmadabad; the men dancing in the Kurukshetra refugee camp—which rise above the topical into the realm of the magical. Transcending the Indian context, these pictures confirm the persistence of Cartier-Bresson's Surrealist bent; they also remind us, in their eloquence of structure and pose, of the author's deep visual culture. Especially in the famous Kurukshetra picture (whose personnel perform a Punjabi dance called the *bhangra*), a certain friezelike, almost Poussinesque clarity of gesture and balance is unmistakable.

Cartier-Bresson was in Rangoon when, in December of 1948, *Life* requested him to cover the civil war in China. He and Ratna flew first to Shanghai, where he checked in at the bureau office; then he flew on alone to Peiping.

At that time, the Communist forces, known as the People's Liberation Army, had consolidated their grip on Manchuria and had advanced almost as far south as Shanghai, but their power was concentrated in the countryside, leaving a number of important towns, including Tsingtao and Tientsin, in the hands of Chiang Kai-shek's Kuomintang. Peiping itself was surrounded, its fall a foregone conclusion. Neither side had any wish to see the city destroyed, however, and the garrison commander, General Fu Tso-yi, was haggling with the People's Liberation Army over the terms of surrender when Cartier-Bresson arrived. A tough old soldier, Fu held out for good conditions for himself and his troops; after the surrender, he went over to the Communist side.

It was perhaps in China that Cartier-Bresson experienced the most profound disconnection from his European past. To cross the Chinese frontier was to enter a kingdom self-proclaimedly "central"; it was to discover one's own provinciality, if not downright barbarousness, in the eyes of a fifth of the world. A sort of transaction also took place, in which Cartier-Bresson's intense desire for invisibility—a trait he shares with other photojournalists—was forfeited in exchange for access to a splendidly pictorial situation. The trade-off entailed much in the way of discomfiture: his white skin began to feel like a morbid abnormality, and he often rued the Norman blueness of his eyes. He realized that it would be terribly hard for him this time to remain the unseen observer: there were so very many people in the streets, and they were, in the Chinese way, so unappeasably curious. The curiosity was a contagion: if one pair of eyes caught sight of his own, all eyes were instantly upon him. His mobility was reduced, as he informed the people at Magnum, "by fifty kids stuck to my legs." The citizenry was so alert that it made China "the most difficult country to photograph I have been to," he reported. "A photographer should, to work well, have the same space as a referee has around . . . boxers." Moreover, the Chinese considered all impromptu photography a breach of etiquette. Cartier-Bresson once told me that to take a picture in a Chinese home "showed about as much tact as patting the fanny of the daughter of the house" in an English one. He noticed, too, that in a land struggling to awaken from the nightmare of treaty ports and foreign gunboats he often figured as a malevolent intruder. He was the subject, as he still tells people, of hatred and envy but "never of respect."

The dismaying complication was that he himself felt a deep, deferential regard for the Chinese. In Peiping one morning, he chanced upon a group of men doing gymnastic exercises in the T'ai Miao Gardens, by the Imperial Palace, and when they broke up and walked off to work a few were still "sketching some movements unconsciously, as one going out of the opera hums an air." "Charming town," he added, "when one can act as an individual without being called an eccentric or a character. I did not take this pix of dancing away in the street as I have too much respect for them and it might have seemed that I was making fun of them."

Ten miles outside Peiping, a battle was shaping up, but the Kuomintang, which had recently lost about two hundred thousand deserters to the enemy, seemed doomed to defeat. Everywhere in the streets and shops, an air of dispassionate expectancy reigned:

We went to a teahouse, a large room here where around nine a.m. gentlemen come and have a cup of tea, bringing with them their bird and crickets. They hang the cage at the ceiling or put it next to their cup on the table. With the faint rays of the winter sun floats into the room the fumes of gone centuries. An old man rubs in his fist two nuts against each other, they got dark red and shiny, he is the fourth generation who is rubbing these same two nuts, while his neighbor holds a stick with a string, at the end of it flies a bird as kite or a toy—it is a companion not a captive; another one reads the paper—is it about the government troops progressing southwards or just the local ads? The old waiter passes ritually from table to table, pouring hot water on the tea; a man stood up and took out of his sleeve a little piece of wood with a horsehair at the end, introduced it through the holes in a little box where he keeps his cricket, and this makes the cricket sing; behind him some refugee students are sitting in leather battle jackets; an old man comes in with his cage with a cover around so the bird does not catch cold or get frightened in the street: all is very quiet, everyone thinks more than he talks, the birds sing and the crickets too when their master tickles them with the little hair. On the walls some posters: "Track down unstable elements" (Communists). . . . The room is full of lip noises of sipping the tea, birds, crickets, and kind smiles.

A splendid photograph of this teahouse, or one very much like it, appeared a few years later as a double-page spread in *The Decisive Moment*.

The Chinese, on the whole, were helpful, though they rarely confided in him. He fell in with a pedicab driver, known for some reason as Buddha 34, who ran him about town and did a little rudimentary

interpreting for him. This fellow had a sardonic smile that reminded Cartier-Bresson of the poet Max Jacob, and he seemed to enjoy the role of dragoman. Once, Cartier-Bresson caught sight of an old lady with a fox fur around her neck walking in a crowd of Army recruits. He took a picture of her and conveyed his surprise to Buddha 34, who at once ran up to her, looked her over, and returned with the gleeful information that "she has no hole in her ear, so she is a eunuch." This was a stroke of luck, for the eunuchs of the former Imperial Palace were precisely the sort of outcast group that excited Cartier-Bresson's curiosity. A day or so later, to the sounds of a nearby bombardment, he made his way with Buddha 34 to the Temple of Kang T'ieh, which stood some seven miles away, in a no man's land near the front; this temple sheltered a community of forty eunuchs, who formed the only remnant of the three thousand castrated servitors of the late Emperor Kuanghsü's seraglio. Their head, by this time a Taoist abbot, had once waited upon one of the Emperor's concubines; as custom dictated, he would wrap her naked in a length of red silk and carry her to the foot of the Emperor's bed, so that she could crawl into it. The eunuchs were now working a patch of land; since all were holdovers from the pre-1912 regime, many were rather elderly. Cartier-Bresson proposed photographing them; he liked their beardless chins, as wizened as dried-up apples. "They said that times were hard for them," he reported, "so if I could be so kind as to give them a little money, they would be glad to pose. I did not wait for that, nor for the sun to come out and put the apple quality of their skin in full value, and I shot them while clever and faithful Buddha 34 did them a striptease act, with some dollars to make the pleasure last." One of these eunuchs was immortalized in a portrait. We see him standing below the ornamental coping of what might be the temple's retaining wall, obsequious, epicene, his pointed ears just touching his skullcap. Apparently about to move out of the frame, he pauses, as if in a vision. Yet, surrounded though he is by a Surrealist scenography of sharply receding walls and the shadows of unseen objects, he is more than a theatrical "type," a scrawled chorus figure in a costume sketch: he is an individual, though as such absolutely unknowable.

So while the battle for China raged, the photo-reporter shot news-

worthless people of such tenuous reality that they seem mere figments of the imagination—people who were surely of their place but not, or not only, of their time, for they belonged to eternity. Prowling slowly about the streets in search of "deep rich stuff," he encountered officers, courtesans, students, venders. Once, coming out of a temple, he began to follow a passing wedding procession. Drummers in green beat golden drums, musicians blew pipes, children carried ornamental staffs, and then, grandly, came the berobed men of the family, followed by a silk-draped palanquin holding the bride. Trooping under a polychrome arch, the procession turned into a narrow lane, which led, after some time, to an open expanse beyond the city walls. It was wending its way forward,

absorbed in the glorification of this marriage and its accomplishment, when at the horizon of our way appeared, moving up clouds of dust in the winter sun, an army marching. The retreating soldiers were not in order, they seemed to have been marching from the infinity of the Chinese plains to some gigantic adventure. Their origin seemed as untraceable as the origin of these streams of ants one comes across in the jungle. Our procession and the army finally met, passed each other, neither paying any notice to each other, as separate worlds never meet in a cosmic universe. Our procession had reached the house of the parents of the groom and the carriers were pushing the palanquin with its precious load through the narrow gate, while the army was still passing by, on their way to meet their fate somewhere.

The photos of this wedding never became well-known, but the commentary is revealing in itself. Innocent of the battlefield, half avoiding the events of the day, Cartier-Bresson is attracted by the spectacle of a parade, and, like a small boy, falls pliantly in with it; yet where does this parade lead, after a sudden swerve, but straight to an army in disorder, whose very retreat looks to the beholder like a "gigantic adventure." His point of view, in which even defeat figures as high romance, is eminently pictorial; he knows, like Delacroix, that

there is a savage beauty in disaster. But, typically, his glance is also moral. In looking away from the frenzies of conquest toward the small or middle-sized stirrings in the landscape, he focusses on those things that abide. His thirst for the pictorial allies him with the people, whose tiny endurances fit perfectly into the frame of his tiny viewfinder.

In mid-December, Cartier-Bresson returned to Shanghai, and he and Ratna took an apartment in the Broadway Mansions, where much of the press was quartered. Their room was somewhere near the top of this seventeen-story building, overlooking the Suchow Canal and the Garden Bridge; during his first days there, he would often stand by the window and contemplate the view. Beneath the bridge drifted the houseboats—the famous sampans—which reminded him of ice floes in their ever-changing configurations, while along the Bund the "buffalo-men" struggled under their loads, dropping from time to time some article, at which swarms of street dwellers would desperately lunge. Longshoremen unloaded bales of cotton under the eyes of the homeless, who would swoop in and carry off handfuls under their clothes, scuttling swiftly away from the truncheons of the police. Once, Cartier-Bresson observed a crowd of refugees boarding a ship, some peering through binoculars to get a sense of where they would be heading; a week earlier, a similar boat had sunk, taking with it three thousand souls.

One morning, he made his way through the dense traffic on the Bund to the building where *Life* had its offices. Not far from the entrance, a large crowd had gathered, with the aim of withdrawing gold from the four government banks nearby. This crowd always appeared during business hours, but today it was swelling by the minute, and Cartier-Bresson soon realized that he was witnessing a massive run on the Shanghai gold vaults: the Kuomintang currency—the so-called gold yuan—was collapsing. He dashed upstairs to make a phone call, and when he returned the lobby was filled by a "soursmelling" overflow crowd from the Bund. Retreating back upstairs, he stationed himself at a window and began shooting the scene. By then, a detachment of mounted police was trying to hold back the throngs, but they surged relentlessly forward under the cover of passing trucks and trams. In the aisles between the traffic lanes, the policemen sallied

forth, occasionally bending to beat people with the steel ramrods they normally used for cleaning their rifles. After observing the struggle for a while, Cartier-Bresson remembered that one of the besieged banks was situated on an alley bordering the building he was in and clearly visible from one of its windows. From this vantage point, he discovered a long file of patrons compressed between the desperate crush behind them and the tellers' windows in the bank up ahead. No one wanted to be forced out of line, so the bodies were being squeezed more and more tightly together, and the taller men seemed caught up to the neck by some writhing, slithery being—like Laocoön being strangled by the snakes. The police, he noticed with some surprise, were behaving not unkindly, merely splashing the people with the water in the gutter, or thwacking them with ramrods and stray umbrellas; most of them wore quilted Chinese clothing, which absorbed the force of these blows, and nobody's head was bleeding. Both sides seemed to observe implicit ground rules.

Cartier-Bresson felt that "looking from a window a few feet above the crowd was not right, and a little sadistic." He tried to work his way out through the lobby but got locked in the mass of straining bodies. For over an hour, people rifled through his pockets and eyed his camera, some even asking its price. Eventually, he made his way outdoors, but by this time order had been largely restored. Two women were scavenging for lost shoes and umbrella ribs; across the Bund, the stevedores were still hauling their loads, humming plaintively while the cotton thieves darted about them.

From the "Shanghai Gold Rush" Cartier-Bresson derived one of four or five great photographs of his first sojourn in China: it shows a rhythmic centipede of tightly packed people. Though there is, perhaps, a certain surreality to this picture—Cartier-Bresson later described the queue as "a human accordion, squeezed in and out by invisible hands"—it remains primarily a news shot. Cartier-Bresson is not simply raiding Shanghai here—milking it of bizarre imagery, like Max Ernst cutting up Victorian catalogues for collage material—but neither is he conforming to the usual practices of photojournalism. In framing this picture, he fails to include any clue to the narrative meaning of the scene: we see no sign of a bank, no bars of gold, no

mounted constabulary—nothing but the unexplained human accordion. Here "the decisive moment" is really that of the photographer's own intuitive realization, as he peers across the alley at the crowd, that the perfect visual metaphor for civil strife has been delivered into his hands. What no image of wounded soldiers or bombed-out buildings could possibly convey is rendered, in all its anguish, by this snapshot of a bunch of people caught between a force behind and a force ahead.

When Shanghai fell to the Communists, Cartier-Bresson's job became much more dangerous. All foreigners were under grave suspicion, and since the port was blockaded he had no access to cameras or parts (he had only two Leica bodies and three lenses). One of Cartier-Bresson's friends in China at this time was Anne Ford Doyle, a former reporter for the Chicago Tribune, whose husband, Bob Doyle, had become Time's bureau chief in Shanghai in mid-1947. I visited Mrs. Doyle one day in Georgetown, where she now lives. She told me how Cartier-Bresson would float along behind her on the street and suddenly pop up over her shoulder with his camera. "That way he had of taking a picture and then innocently walking on as if he hadn't—it continually saved him from arrest or worse," she said. "For such a neryous person, he could be incredibly cool when the occasion required it. He always had two cameras with him, and one day when we were riding in a crowded streetcar together he discovered that one of his cameras was missing. He showed me where its strap had been cut with a razor. The streetcar was approaching a stop, and without a moment's hesitation he signalled to me, and we jumped to the ground. Then Henri frisked each passenger who got off—he did it nonchalantly, as if it were the most natural thing in the world—and he began to look increasingly crestfallen as he realized that no Leica was turning up. One final passenger got off, and he didn't have the camera, either, but as we climbed back onto the car we saw it lying on one of the steps, off to the side. That frisking was really audacious, because the vehicle was full, there were people clinging to the outside, and anyone of them could easily have spotted him. But nobody noticed him at all, and the trolley moved on."

After side trips to Hong Kong, Hangchow, and Tsingtao, Cartier-Bresson arrived in Nanking in early April of 1949. Though Nanking

was still the Kuomintang capital, Chiang Kai-shek had virtually abandoned it, in the face of a million-strong Communist Army encamped on the far shore of the Yangtze River. Cartier-Bresson sniffed around the town's commercial center, which seemed overcome with lassitude: soldiers and townsfolk got about on ponies and in wheezing vehicles, and cabs often bore dense clusters of people. The variety of costumes—cut-rate foreign uniforms, pom-pom-bedecked ceremonial hats worn for want of anything better—suggested comic opera or an early Chaplin movie. Some soldiers were taking advantage of the lull in the fighting to get a shave or a leeching in the street, and toward nightfall, by the Drum Tower, small throngs gathered around the professional tellers of tales.

Cartier-Bresson departed from his usual concentration on the sideshows of war when he saw the opportunity for a portrait of a significant player: in Nanking, he snapped General Ma Hung-k'uei, the Nationalist governor of Ningsia Province. This portrait is so compelling a depiction of a physiognomic type that you think "warlord" even before reading the caption. Powerful as a panda, encased in muscle and fat, the General slouches before three vertical panels of calligraphy expressing political bombast. The photographer noted in his commentary that Ma was notorious "for his Muslim soldiers and his taste for ice cream served by his young wife," and that he "has the body of certain sculptures of the Buddha but none of the features of the face." This sly comparison of bully and Buddha can be felt in the formality of the portrait, which may owe something to Cartier-Bresson's earlier visit to the shrine of the Laughing Buddha Maitreya, in Hangchow; now, before the personality type he most loathes, he plays the decorum of the composition off against the strongman's smug, menacing aura. What we see is brute domination masquerading as moral authority.

As Cartier-Bresson's China sojourn drew to a close, a valedictory note stole into his dispatches. He was about to take leave of the gymnasts in the public gardens, the ambulant ear-cleaners and tale-tellers and barbers, the merchants of painters' brushes, the old antique dealer who spoke of a "Chinese" deftness in the drawings of Nicolas Poussin. Hoping that the Chinese Communists, with their evident love of homeland, would see fit to preserve the finer elements of this world,

he booked passage for himself and his wife aboard the *General Gordon*, a British steamer. All of European Shanghai was struggling to escape, and the pier was crowded with stateless wanderers—White Russians, German Jews, and Portuguese half-castes from Macao. There were the Afghan, the Argentine, the Brazilian, the Siamese ambassadors; elegant ladies with their lapdogs; a band of Eurasian children. At last, the ship sailed—"a bubble out of Shanghai"—and a whiskey party was held to the music of a fiddler and an accordionist from the Silk Cat nightclub.

So it was that Cartier-Bresson helped to create one of the most provocative social roles of the twentieth century—that of the professional picture-taking witness. This role, like that of the professional mourner, involves a privilege: the photojournalist is an interloper and does not share the destiny of those whose plight he records. On this score Cartier-Bresson has not lacked for critics. John Malcolm Brinnin, who travelled across America with him in 1946, later described him as "a humanitarian indifferent to people," a man whose leftist "rigidity of mind obviated argument and enjoined silence." And Susan Sontag, clearly with him and his colleagues in mind, has characterized the photojournalist as a "supertourist" engaged in "middle-class social adventurism" and the "sublimated looting" of non-European cultures. Cartier-Bresson himself resorts to Norman equivocation when this subject arises. Sometimes he claims the high moral ground: he speaks of "living with the people" and "respect for the subject," as if such pieties had anything to do with the ruthless invasiveness of all honest observation, be it photography, writing, or portrait-painting. At other times, though, he grimly concedes the point. Obviously, he was troubled by his inadvertently "sadistic" overhead viewing of a crush of impoverished Chinese, and by the "bubble" that so gaily bore him away from the miseries of Shanghai. He ruefully admits that "one does nothing with impunity." Yet, by and large, his testimony has been warm and unbiased, and if his rebellious Surrealism seems to us today a mere contortion of the bourgeois liberal mentality it must also be granted that—whatever his aim—he represents that mentality at its most humane.

Cartier-Bresson's venturesomeness belies a certain prudence, a fru-

gal expenditure of energy and feeling; he is confidently at home within the Latin tradition of visual economy. In his pursuit of experience, he has shown that an age-old gestural syntax, a lyrical architecture of bodies in motion, exists not only in Classic art but also in the wide world. Coming as a final, empirical confirmation of French painting, his work has also imparted to his often humble or exotic subjects a formal dignity based on pictorial structure rather than on sentimentality or "false pastoral." This exchange, this mutuality of world and picture, is the real heart of his testimony.

Recent criticism has tended to split Cartier-Bresson's photographs into two fairly discrete blocks: the early, Surrealist work, executed primarily from 1932 through 1934, and the later, journalistic work, executed primarily between 1947 and 1966. There is a kernel of hard fact to this view, for the early photos were taken by an unpaid amateur indifferent to documentation, whereas the later ones were mostly intended for magazines; and it is doubtless no accident that the early pictures were first displayed in museums and an art gallery, while the later ones initially appeared as published illustrations of news stories. Nonetheless, the dichotomy is not wholly convincing.

Actually, most of the American audience for photography may have been unaware until recently that Cartier-Bresson ever was a Surrealist. In the autumn of 1987, however, Peter Galassi, the curator of photography at the Museum of Modern Art, mounted an exhibition titled "Henri Cartier-Bresson: The Early Work," and the pictures he selected, together with his fine catalogue essay, conclusively demonstrated the importance of Surrealism to Cartier-Bresson's early development. In particular, two Surrealist techniques—the dreamlike juxtaposition of objects that do not rationally belong together, and the "exile" of an object from its everyday context—were amply illustrated by the photographs on view. Even a cursory glance at their subjects—women who seem to pop out of walls, a man smoking under the gaze of three nosetwitching epicures in a billboard ad-confirmed the truth of Galassi's proposition. Yet at the same time he mildly overstated his case, thereby obscuring the bond between Cartier-Bresson's Surrealist and photojournalistic impulses. "His early photographs," Galassi wrote,

"have virtually nothing to do with photojournalism; indeed they insistently and quite inventively subvert the narrative expectations upon which photojournalism depends." This assertion reflects an understandable concern to protect the early work from inaccurate labelling, but it is somewhat inaccurate itself. Galassi's catalogue contains many examples of photojournalism: about a quarter of the plates in the book reveal Cartier-Bresson's deep interest in social conditions—especially those he found in the slums of Mexico City and Juchitán. Though they do not tell a cohesive story to a specific audience, they are still a kind of reportage, for all serious journalism begins as a report to one's own heart. Any reasonably broad definition of journalism—one that had room for imaginative figures like Daumier and Orwell—would easily encompass these pictures. Cartier-Bresson's Surrealism is probably not dissociable from his photojournalism; there is much to suggest that the two have always functioned in tandem.

Since Surrealism insists on the primacy of dreaming, and since anyone who strolls about a metropolis with a camera can easily find some very dreamlike material to shoot, it has often been claimed that photograph is "natively Surrealist." And this is true, but only partly true. Because the camera is confined to the realm of wakefulness, it cannot penetrate the dream world. The dreamer's eyes are closed, the photographer's are open—indeed, if he is a good photographer, they are very open. Unlike the poet, the musician, or the painter, the photographer can never let his mind wander; he certainly cannot let it enter the current of a reverie or a trance. Freud, who had a great influence on the Surrealists, would surely have said that the photographer responds not to unconscious but to preconscious stimuli, to concerns that lie just below the surface of awareness. The camera, so apt at registering the outside world, cannot except circuitously and superficially apprehend the inner one. It plumbs not the dreaming state but, rather, the phantasmagoric aspects of reality—what the Surrealists called the Marvellous.

As you look over the lineup of Cartier-Bresson's Surrealist photographs, you may well begin to feel that the whole endeavor shows small but telltale signs of strain. Genuine images of the Marvellous occur only intermittently, and often there seems a conscious longing

for serendipitous coincidence. But Cartier-Bresson was too good a photographer to be an orthodox Surrealist, and he appears to have surmised that his Surrealist impulse would gain in suppleness if he could hitch it to some more easygoing activity—some activity for which the camera has a truly natural vocation. This was supplied by the element of reportage.

Those critics who have approached Cartier-Bresson's work under the spell of a sort of aesthetic bimetallism, identifying in his pictures two separable standards of value, have overlooked the essentially dependent nature of surreality itself. Breton and his colleagues assumed that the surreal world cannot, by nature, exist save within the real world: it requires some medium or atmosphere in which to be suspended. And, very early, the Surrealists felt a distinct attraction to the small dramas that tend to catch the interest of the city reporter. They realized that embedded in the surface of everyday news stories lay a trove of suggestive or equivocal details—"equivocal" was a word the Surrealists liked—which, upon close inspection, turned into a doorway to the exotic and the bizarre. Though the Surrealists never created any substantial body of journalistic prose, the writings of some of them—and especially those of Louis Aragon—contain a fair amount of what might be termed hallucinatory reportage. In his autobiography Aragon characterized his viewpoint as a sort of "Surrealist realism"; this phrase aptly describes Cartier-Bresson's sensibility as well.

Though the Dream is not really accessible to the camera, the Marvellous, which occurs where reality resembles a dream, became the stuff of Surrealist photography. One of the qualities of the Marvellous, as the Surrealists almost at once discovered, was that it tended to turn up in any place you didn't know or understand: you could enter the domain of surreality not only by exiling objects from their logical surroundings but also by exiling yourself from your own habitat. This insight gave rise to a Surrealist technique called "the cretinizing voyage," in which you boarded a suburban train and rode aimlessly about the outskirts of Paris until you lost your bearings and almost your reason—until you became, in the going parlance, a cretin. Only in the cretinous state could you begin to perceive the irrational, dreamlike relations of things. Once, the poet Paul Éluard went on a

really audacious cretinizing voyage and by dint of transferring hap-hazardly from trolley to train to ferry to steamer ended up in the New Hebrides. In a way, this excursion of Éluard's—half vagrancy and half pilgrimage—was the prototype of Cartier-Bresson's first long sojourn in the East. When the photographer went to India in 1947, he was "cretinously" ignorant of the subcontinent's customs and languages, and that very ignorance worked to his advantage: it allowed his vision to register coincidences and conjunctions that a trained eye would have slid over too knowingly. Ironically, it was a bourgeois profession that brought him to this land of the Marvellous; and perhaps the most marvellous thing about the whole episode was that *Life* wound up footing most of the bill.

By becoming a photojournalist, Cartier-Bresson forfeited a lot of control over the fate of his photographs: in the offices of the picture press, they became "artwork," to be switched about and scaled up or down by professional layout people. Fortunately, the graphic design at the magazines where his work was published—most often Life, Harper's Bazaar, Holiday, and Paris-Match—tended to be strong and effective. Though he tried to see to it that his images were never cropped, he had few qualms about letting art directors compose layouts with his work; often he didn't even get a chance to see his photo essays until months after they appeared in print. Many of his finest pictures were eventually collected in book form, and in this ongoing process he gladly yielded responsibility for sequencing and design to his publishers. The first of these was the great art impresario Tériade; then came Robert Delpire, an enterprising young publisher who was also a layout ace and an expert on photography. Another person who has had a large influence on the appearance of Cartier-Bresson's published pictures is Pierre Gassmann, the founder and former director of Pictorial Service, a Paris photo lab colloquially known as Picto. Gassmann began printing Cartier-Bresson's negatives in 1947. Today, he is semiretired, and lives with his family on a quiet street off the rue de Rennes. Though his actual age is seventy-six, he looks more like sixty, and he has young children.

One day I fell to talking with Gassmann at his home. He is a watchful man with a tough, wised-up expression; a great gossip, he puts a

highly personal slant on his accounts of the lives of his photographer friends. He told me that he had been brought up in Breslau (now Wroclaw), where his mother was a radiologist. As a child, he grew so accustomed to looking at X-rays that the reading of negatives became second nature to him. He began taking photographs at thirteen, and submitted his pictures to the sympathetic scrutiny of Paul Klee and László Moholy-Nagy, both of whom were acquaintances of his mother. After finishing his studies at a local gymnasium, he went to Berlin to study law, but he also enrolled in several serious photography courses offered by the Agfa company. He joined the Young Communist League as well, and when the Nazis came to power, in 1933, he sought refuge in Paris. The city cast such a spell on him that he spent a lot of his time just wandering around with his camera; he also discovered that Brassaï, the great Hungarian photographer, lived in his building. Before long, either through Brassaï or on his own, he had met many of the best photographers then working in Paris-André Kertész, Robert Capa, David Seymour, Erwin Blumenfeld, Philippe Halsman, and others. A number of them were, like himself, refugees from Central European Fascism. At the Dôme, in Montparnasse, where the art crowd palavered into the night, he would often encounter Cartier-Bresson. ("Henri was a fixture at the painters' table," Gassmann told me, "and when I got to know him better I realized that he always had three or four girls trailing after him.") During the war, Gassmann served first in the French Army, then in the Toulouse Maguis; after the Liberation, he worked for a while as a photojournalist, but on the whole he preferred his friends' photographs to his own. He was fascinated by darkroom technique, which bored most of them, so in 1950, at Capa's suggestion, he founded Picto. It instantly became Magnum's semi-official lab, and today has five branches in Paris, with a combined staff of more than two hundred people, and a sixth branch in Toulouse. Gassmann personally printed Henri's photographs for only a few years, but his team continued to give them the look he had established.

"For fifty years, Henri and I have been screaming at each other," he told me. "For example, we do an exhibition together, and Henri says, 'This one we throw out,' and I say, 'No, we keep it,' and he says, 'We throw it out,' and I say, 'Good, then throw out the whole damn

show!' That is the way it is with us. Listen: one day, he decided to cut his favorite negs out of a batch of film, and do you know what he did with them? He tucked them behind plastic strips in a stamp album—'because I don't want those negs manipulated,' he told me. And then he gave me this whole book's worth of little cut negatives—what a nightmare! Believe me, I had to stop him from throwing away hundreds of others—wonderful shots of the liberation of Europe. You have to have nerves of steel to work with that man. Yet, in spite of it all, there's a sort of complicity between us. Sometimes he wouldn't get to see my prints until several months after I made them, and when he did he'd just say, 'How?' It was simple—I felt them, like a musician reading a score."

When Magnum was founded, Henri's little studio near the place Vendôme became a hub of feverish activity. "We all shared our insights, our ideas," Gassmann told me. "No one ever knew which idea was whose, and it didn't matter. Our relations were strictly unserious, just good fun. In those days, Chim"—David Seymour—"was Henri's closest friend. Capa was unselfish, very expansive, always short of money, yet always able to find it for his down-at-the-heel pals. He took the risky jobs—the lucrative jobs—in order to pay his debts. In the end, it's not surprising that he was killed, in Indo-China. But, then, Chim, who was extremely careful, was also killed, in Egypt." Gassmann fell silent for a few moments, and closed his heavy-lidded eyes.

"Speaking of Capa, how about a sip of the Capa drink?" he said, looking up briskly. He left the room and returned a moment later with a bottle and two glasses; he popped the bottle open and poured us a round.

"So—you like the Capa drink? Champagne! Nothing but good champagne! He'd buy it in magnums, which gave us the name for our agency—we hadn't been able to think up a suitable one. I want to make it clear that Capa was antiheroic. All these stories about his being a war hero are ridiculous. I asked him, 'Isn't it dramatic when you parachute out of a plane?,' and he just smiled at me. 'It's not particularly scary to jump,' he said, 'nor particularly hard to go down. But when you hit the ground in a hail of bullets and discover that your pants are full, and you have to take them off—that's dramatic' You know what sardonic eyes Capa had—you see them in that famous Willy Ronis

picture. Well, believe me, Robert Capa was laughing mostly at himself." Gassmann's brow had turned into a net of lines. He took a sip of champagne and brightened again.

In the early days of Magnum, he told me, Henri would shoot at least one roll of film every day that he spent in Paris. Even if he was working in the studio all day, he would still be obliged to run around the corner for some bread or wine, and on the way he would be sure to see something, and then something else, and then more things. Gassmann again insisted that there were hundreds of fine shots among Henri's old negatives. He also told me that Henri never used a light meter, or even looked at his f-stops, knowing all this by memory and touch, and that he shot the golden section instinctively, not through calculation. He had no special nose for a good scoop—rather the contrary—but, wherever he happened to be, he saw more than anyone else, and he saw faster. Often other photographers couldn't keep up with him and so couldn't work alongside him. Gassmann recalled that during the general strike of May 1968, Henri hitchhiked from Brussels to Paris to cover the street battles. Every morning, Picto received rolls of film from people shooting all day and all night, but from Henri, surprisingly, only bad work. "I knew what he was up to, and I said to him, 'You were put on earth to observe, Henri. Please stop joining in the demonstrations and take some pictures.' The next day, as I was looking through all the proofs that had come in, I saw one that was fantastic, and when I turned it over, I found that it was labelled 'H.C.-B.' And this is the whole thing about Henri: in order to be really present, he must be absent—he must forget himself."

Gassmann refilled our glasses. "I have to ask you a question," he said in a conspiratorial tone.

I told him I would answer as best I could.

"Are you staying with Martine and Henri?"

"I'm staying in the studio," I said.

"But you go to the apartment pretty often? I bet they invite you over for dinner—and, after all, Martine is such an excellent cook."

"Yes," I said. "I go over there pretty often for dinner." I was beginning to feel like a police informer, but I wanted to know what he was so curious about.

"I wonder if you could tell me," Gassmann said, "if you have observed Henri when he's watching TV."

Yes, I told him, I had. I'd seen Henri watch the news on TV. I'd even found out that Christine Ockrent, France's most adulated anchorperson, had once been his associate on a documentary-film project. I was about to give Gassmann my impression of Henri as a TV-news watcher—the peevish outbursts, full of anarchistic vituperation—when I suddenly saw that I had fallen headlong into a trap. Gassmann was smiling exultantly.

"I knew it," he said. "Henri tells me he *never* watches—oh, he *never*, *never* watches."

"It's just the news," I said. "Nothing else."

"I don't even watch the news," said Gassmann proudly. "All those images are so badly framed it really pains me. I was very sick in the hospital last year, but I had to leave anyway, because the TV was on all the time. The other patients wanted it on, and the staff wouldn't turn it off. Actually, it was Martine who helped get me out of that place. I don't particularly mind the noise, but I just cannot stand those badly framed images. They're a terrible strain on the nervous system of any visual person. And I doubt whether Henri can stand them for long, either, with his sensitivity. But to say he *never* watches!"

We talked on for a while, until we had emptied the champagne bottle. "You know," Gassmann said as I stood up to leave, "Henri has tried to play the social rebel, and he has tried to play the self-made man, but really he is neither of those things. I know, because we know each other's illusions, Henri and I—he likes to say we've been married far too long to get a divorce now. And I tell you—Henri, like his father and his grandfather before him, is simply a man who can make something everyone wants. There's nothing wrong with that, but it makes me laugh. I tease him about it. I tell him, 'Henri, you are a Cartier-Bresson. You have something to sell."

The French have an expression, "to roll someone in flour." It means to make a sport of a person's vanity, or his pride, or his failure to see who he is. You can roll him maliciously or you can roll him fondly, and if you do it fondly you're really implying—backhandedly, of course—that the dear fellow's foibles only add to his charm. Quite a few of

Henri's friends told me that they liked to roll him in flour, and the reason for their affectionate chaffing seemed always to be the same: the gap between his self-image and his image in the minds of others. And, indeed, one comes away with the impression that Cartier-Bresson the social being is a sort of permanent double exposure, for next to the anarcho-Buddhist pepper-eating knife-puller stands a less colorful but equally extraordinary figure—an old-fashioned, wellbred gentleman who has absolutely mastered the art of watching other people. The problem, as some of his friends see it, is that he fails to recognize that his patrician origins are written all over him. This most clear-sighted of men seems blind to the truth that for him as well as for his subjects it is the little things that betray background, and that these things are not only indelible but instantly readable. Pronunciation, manners, fine discriminations play together in this unconscious self-presentation, and even when, as in the present case, every major high-bourgeois prejudice has been sternly banished, the minor ones remain to tell their unmistakable tale. A contempt for the ersatz, a love of the timeworn and the perishable, a horror of consumer society and the spread of parvenu taste, a heartfelt leaning toward the peasant and his works—all are classic signs of a patrician sensibility. Even the modest style of life, the exquisite simplicity of this man who has sometimes affected to be living in straitened circumstances, betray not "the stingy Norman" (as Henri, whose generosity is legend, likes to characterize himself) but the wealthy Parisian burgher mortified by displays of luxury. In this respect, the picture that Henri offers of his rich grandparents darning socks and lamenting their ruin could easily be retouched to include him.

Since getting to know him, I have also heard a lot about his remarkable impatience, his inability to plan, his fastidious irresolution at the minor crossroads of life. His capricious temper inspires amazement, hilarity, long garlands of tales, but I have never heard it more curiously characterized than it was one afternoon at the home of Romeo Martínez, the distinguished Parisian editor, who died in 1990. Henri had described Martínez to me as "the photographer's father-confessor, the man who knows more about us than we do ourselves." A Mexican, the son of a prominent Veracruz family, he served as a political commis-

sar for the Partido Obrero de Unificación Marxista (POUM) during the Spanish War, and later took charge of *Camera* magazine. Martínez had Zapata-like cheekbones and eyebrows like bits of fur trim and lived in a high-ceilinged apartment off the rue de Seine which had once been part of the palace of Margaret of Navarre and sat in the drifting silver light of his sitting room and talked of Cartier-Bresson's collection of knives, and of how Henri was always doing something other than what he appeared to be doing, and of how hard it was to induce him to speak openly of himself. "Henri is an unstable person," Martínez concluded. "But, you must understand, he makes a point of it. He is *scrupulously* unstable."

I had been keeping a mental list of the mixed metaphors and skewed paradoxes that Henri's friends so often used when they wanted to sum him up. He was a cat that was also a bird; a vulnerable predator; an absent presence. He adored his friends yet had the curious habit of pulling knives on them, and though his past was visibly on file at Magnum, his memory was a sieve, as if to suggest that the pictures in the contact sheets were recollection enough and he didn't need the redundancy of pictures in his head. One could never decide whether he was a naïf, a faux-naïf, or some weird hybrid of the two. My pile of metaphors had grown muddled, and here, to perplex me still further, was this Mexican father-confessor disclosing that Henri was "scrupulously unstable." The phrase had a cerebral, Jesuitical ring, but it also said something genuine about Henri's habits of feeling. There really was a scrupulosity in his way of courting chance, of looking carefully about him, of giving every new minute and every adjusted angle its due.

Hadn't that very scrupulosity often forced him to relinquish emotional moorings, to forfeit convenient or hard-won positions? At the age of twenty, he had given up his position behind the easel in favor of a sort of permanent truancy with the camera; then, one day in his mid-sixties, he decided he wanted that old position back. There seemed to be several reasons for this ultimate display of "instability" (or what I should prefer to call unpredictability). For one thing, he had never been much interested in the bulk of his photographs, preferring those rare images in which the arrested tableau held some haunting ambiguity, some drama whose next moment lay beyond divination. "It

takes a lot of milk to make a little cream," he likes to say, and the cream was all he really cared about. He left Magnum in 1966, and he freely confesses that by then he was getting tired of the labors of photojournalism (though not of landscape shots or of spontaneous portraiture). Several of his friends, principally Tériade and the painter Richard Lindner, perceived this, too, and encouraged his rekindled interest in drawing. He even began to wonder if photography had not played the role of "calisthenics, decoy, alibi"—as another friend, Saul Steinberg, later suggested to him—in relation to a deeper vocation for drawing.

There was perhaps another, more emotional reason for the reversion to an earlier fascination. In 1967, after a long period of domestic disharmony, Henri and Ratna Mohini were divorced. In 1970, he married Martine, and two years later he became, for the first time, a father; his new and happier existence must surely have played a role in his abandonment of professional photography. One gets the impression that he deliberately reduced the speed of his perceptual life, that he began to take a renewed interest in the idea of picture-making as a form of meditation rather than of interception.

In returning to the art of drawing from observation, Henri bravely cut his line of communication with the public; he descended from nearly unequalled eminence in the photography world to mere membership in the little lagoon of Parisian representational art. There was a certain logic to his decision, however. Of all the great photographers of our century, Cartier-Bresson is the closest to serious modern art by early training, ongoing self-education, and social preference, for he has always cultivated the friendship of artists. The composition of his photographs is so evidently an extension of painting ideas that even if he had never executed a single drawn or painted image, a chapter on his camera work would not be out of place in a history of modern French painting; his life has evolved alongside, and in rapport with, the lives of Christian Bérard and Alberto Giacometti, Avigdor Arikha and Georg Eisler, to name but a few of his artist friends. His move into drawing was a clear-eyed attempt to distill the purely structural elements of his pictorial vision, leaving the Surrealist and social elements behind in the retort of experience.

Henri was so serious and humble about improving his drawing that he decided he needed a critical eye. He took to discussing his work with Sam Szafran, a well-known Paris artist who had grown up in a building with an unusual staircase, had become obsessed with staircases, and painted them all the time. Before discovering art, Szafran spent his early youth as a ruffian on the streets of Paris. His speech is colorful and barbaric; he is the only person I know who insults people to their face and praises them behind their back. He mischievously told Henri that he would help him with his drawing in exchange for a fee to be paid in photographs, and in this way he acquired a strong collection of prints. He also insisted that Henri photograph a friend of his, the Paris-based American sculptor Joe Erhardy, and Henri, who naturally winced at this pressure but wanted Szafran's help, gave in. They went together to Erhardy's studio and spent several hours there, but Szafran waited in vain for Henri to start shooting. When at last they came out onto the street, Szafran was furious, but his anger vanished when Henri held up a pair of fingers and calmly said "Two."

"I didn't see a thing—I never even saw him lift his camera," Szafran told me over lunch one day near his studio, in the Malakoff section of Paris. "Everything about him amazed me. And he was so utterly courageous and industrious when he set about drawing. Ethically, he is very scrupulous"—I noted the reappearance of this word—"and it shows up in his work. I discovered that I couldn't be objective about Henri. I loved him, I hated him, I was wildly jealous of him. I still am. His photos and his drawings compose a total unity, because they are sincere—an expression of the man. But if photography is like respiration for him, drawing is like perspiration. It's hard for him, he takes endless pains. You know, it was after he married Martine that he took up drawing as a profession, and one reason he has so much energy is that he's in love."

Cartier-Bresson began to draw almost every day, a practice he has continued up to the present. Comprehensive shows of these drawings have been held at the Museum of Modern Art in Oxford and the gallery of the École des Beaux-Arts. From the outset, his approach has been that of a dedicated artist. Circumspect about his work and eager for tough criticism, he has none of the amateur's easy self-satisfaction,

and he nurses no illusions that his drawings will command the same reverence in the world of art that his photographs do in the world of photography. He draws cityscapes, landscapes, portraits, the model; he has also done many studies of the skeletons of prehistoric animals. Most often he uses pencil, sometimes ink. He hasn't much manual facility and isn't at all interested in gracefully running his mark around the edges of things, so his drawings lack topographical specificity; his hand weaves and shuttles. You see right away that the drawings are really "painters' drawings"—conceptions of possible arrangements but they are painters' drawings for paintings that will never exist, and to appreciate them you have to know how to read a painter's drawing as a poetic thing in itself. Generally, they are most successful when he mentally encompasses some perceived structure—a city block, a mountain, a prospect of tilled fields—in what seems a single contemplation, a long, unblinking glance. Then the most cursory placement on the page bears witness to his power as a composer. Yet his vision as he draws is not a sort of stretched-out photographic seeing or elongated "sniff." An artist friend of his aptly remarked to me that his move from snapping to sketching was "like trading the crest of the wave for the trough," and clearly the whole point of life in the trough is that you can be much more aware of what you are doing while you are doing it. Cartier-Bresson's mental processes at the moment he frames an image in the viewfinder are—for us, at least—a point of mysterious darkness, but his thoughts before the drawing board transpire as in a light-filled chamber. Drawing is a struggle that takes place in the open, and one suspects that Cartier-Bresson, who had always photographed with too much ease, longed for this exertion. He longed to put his wide-ranging visual intelligence to the test, and also to try for the depth of meaning that comes only from surmounting obstacles. Once, I quoted to him a famous line by Valéry about the artist's need for difficulty—"Ce qui se fait trop facilement se fait sans nous"—and his face lit up in assent.

The works of a first-rate visual imagination have this unique feature: that after you have seen a certain number of them each additional one recommends itself not only on its own behalf but also as a peek into a fascinating mind. Much of the appeal of Cartier-Bresson's drawings lies in their way of showing us how he can manually piece

together just the kind of delicate pictorial maze that he used to pull out of the air. The sketches that he did some eight years ago near the Swiss village of Épesses, for example, bear witness to an unfailing resourcefulness in the wedging together of landscape elements—vine-yards, hedgerows, terraces, lopsided walls. And, of course, this is really the same angular vocabulary that he explored in some of his photographs—his shots of cafés, for instance, with their wilderness of receding tabletops. Seen en bloc, Cartier-Bresson's drawings vary from the humdrum to the inspired, but all disdain irony and self-consciousness and over-crafting, and all have sincerity and naïveté and truth to perceptual experience.

As a social being, Henri advertises an intense delight in his own indiscretion. As if to spite his natural courtliness, he regularly flies off the handle; as if to mock his urbanity, he rails at the bourgeoisie. Small wonder, then, that his attempts at public invisibility should sometimes yield unexpected results.

One evening not long ago, he and Martine took me along to a chamber-music concert that was to be given in a private apartment. The largest room had been almost entirely cleared of its furniture, in whose place stood a grand piano, a music stand for a violinist, and several rows of auditorium chairs ranged in a semicircle. Most of the chairs were already taken when we arrived, so the three of us found places close together at one end of the audience. As we sat down, I saw that Henri was peering intently at something through his wirerimmed glasses, and I followed his gaze. At the other side of the room, two youngish couples sat next to each other, and as the violinist and the pianist took their places and played the opening chords of their first selection—it was a Schumann sonata—the two couples, shifting slightly, assumed a remarkably rhythmic group pose. It was as if they had found an archetypal attitude for the physical act of listening—for listening as a distinctly chic yet still serious activity. Then one of the women inclined her head, and Henri whispered "Now." He tapped his index finger in the air. Then he took a little sketch pad out of his jacket pocket and started to draw, but there wasn't much light on his page, so he gave up drawing and followed the music. The evening's program

was relentlessly Romantic—Schumann followed by Debussy, Debussy followed by César Franck. At the end came Franck's bittersweet Allegretto, so beloved of French radio programmers. Then the lights came up again.

Henri turned to me. "César Franck wrote the sort of music that reduced my mother to tears," he said. "She would sniff and fumble for her handkerchief. But I cannot say that I care for it. It is too—*unbuttoned*. But Debussy I love. He is a pagan. He reassures me that the monotheists are wrong—that none of us has a separate, eternal soul." He flashed a look of cheerful gratitude at the piano. "Debussy reassures me that we are all part of the compost heap of nature, the beautiful cycle of growth and decay."

We passed into another room, where a buffet had been laid; the books had been removed from the bookshelves and replaced by a multitude of cakes and tarts. For a while, the guests ate and drank, and chatted about the music and the news of the day and the nocturnal views of the city which brimmed outside the windows. Then they prepared to leave.

As Martine and Henri and I stood in the vestibule waiting for the elevator, a stranger addressed Henri. He was of middle age and wore horn-rimmed glasses and an expensive-looking dark wool suit; he might have been a financial analyst. It appeared that he had overheard Henri voicing his opinion that Debussy expressed a strain of reawakened paganism, and he began to affirm his own belief that the spirit-power of the universe ran through everything that existed on earth. Henri was all attention, but a cloud soon passed over his face. "That is pantheism," he said when the man had finished, "and I am not a pantheist. Whatever Debussy's convictions may have been, I do not believe in any sort of soul at all."

But the middle-aged man insisted that he and Henri shared some common ground. Didn't the very fact that they were standing there discussing such matters imply as much? And it was true that Henri was relishing the back-and-forth of the argument; as the two talked on, there were nods of affirmation, head-waggings of dissent, hands sketching thoughts in the air. Though neither metaphysician was prepared to yield to the other, both were keenly enjoying themselves—

so keenly, indeed, that they forgot the pressure of the crowd behind them. Deeply embroiled in their attempt to solve the riddle of existence, they failed to notice that the elevator had now come, and that one of them, the elderly chap in the wire-rimmed glasses, had already found room inside it, while the other, the middle-aged chap in the horn-rimmed glasses, had not. Yet still their debate went passionately forward, while in the hallway, which grew ever more congested with music-lovers wishing to go home, word went rapidly around that the source of the holdup was none other than Henri Cartier-Bresson. He couldn't see himself, but they could.

Postscript

Je suis un timide"—"I am a timid man," Henri Cartier-Bresson said to me once as we were strolling together down a slope not far from Forcalquier, in Provence. The confession astonished me, but he would repeat it often, a little wistfully. In 1988, I'd been sent by the New Yorker to write a profile of him, a commission that ended by claiming almost a year of my life; it precedes this postscript. During that time this fairish, lanky, rather elegant Norman gentleman told me a great deal about his background and his achievement, and since I had admired his work since childhood I couldn't see how timidity could have played the slightest part in his life behind the camera. Today, perhaps, I do.

Cartier-Bresson's memory was honored at the Museum of Modern Art in the spring of 2010 with a comprehensive exhibition dedicated to his role as a consummate professional. In the midst of this pleasurable and sensible tribute, however, one might almost have forgotten that there is another way of considering Cartier-Bresson's achievement, somewhat apart from the confines of his photojournalistic profession. For he was deeply immersed in the fine arts as well. He spent his first creative decade drawing and painting, studying with André

Lhote and Jacques-Émile Blanche, and in his sixties he returned to drawing as his primary activity, attending to it almost every day for the remaining years of his life (he died in 2004 at the age of 95). Many of his closest friends were artists—the Giacometti brothers, Alberto and Diego; the sculptor Pierre Josse; the Parisian painters Sam Szafran and Avigdor Arikha; the Viennese Georg Eisler; the English sculptor Raymond Mason. Cartier-Bresson distinguished himself only in photography, but his camera work, and indeed his entire aesthetic, is almost as closely related to the development of painting as it is to that of the photographic image.

Cartier-Bresson did not study art history systematically, but he had a way of mentally and almost instantaneously registering the compositional structure of any pictorial work he liked. That meant especially van Eyck, Uccello, Piero della Francesca, Poussin, Cézanne, and Alberto Giacometti. I have mentioned that once Cartier-Bresson told me that Léonor Fini, the Surrealist painter and set designer, physically attacked him in Venice. I do not know exactly when this attentat occurred. I do remember, however, that Fini, whom I had met at several gallery openings and who died in 1996, was an excitable Triestina with a great head of corkscrewy hair on permanent holiday. Fini had tried to push Henri into the Grand Canal because he hated Caravaggio. At the time I thought nothing of this anecdote, which I put down as mere old folks' shenanigans. Today, however, it seems to have a certain significance.

Cartier-Bresson's dislike of Caravaggio extended to most subsequent Baroque painting: just as he usually found himself underwhelmed by staged photographic imagery—the kind where everything is posed and lighted in advance—Baroque theatricality put him off. He once admitted to me, for instance, that he had never been able to cotton to Robert Doisneau's pictures, precisely on account of their choreographed quality, despite Doisneau's undeniable gifts and his own deep *sympathie pour l'homme*. Anything that smacked of the studio setup was too contrived for Cartier-Bresson, as though it slowed down the world's natural pace.

What's curious about all this is that during the age of Caravaggio, painters were trying to imbue their pictures with a semblance

of motion. During the early 17th century, scientists, geographers, architects, and painters were preoccupied with the problem of coordinates—that is, with placing things on the grid of space and time. What, from the pictorial point of view, was the right moment at which to arrest a story? What economical touches might convey a sense of location? And what elements might dispel ambiguity about meaning, or for that matter preserve it? Cartier-Bresson would confront many of these issues in his own work with his Leica, and though he didn't resolve them as a Baroque painter might have done—he preferred Quattrocento painting anyway—to study his photos in the light of such decisions reveals a lot about his aesthetic.

Sifting through Cartier-Bresson's contact sheets, I came across plenty of parallels with Quattrocento pictures and also with modern French paintings. I had to be careful, for some of these match-ups were merely coincidental—many strong compositions in all pictorial media share certain traits. But if you look closely at certain groups of Cartier-Bresson pictures, such as the Surrealist photos of the '30s, a portion of the Indian material of the '40s, and a fair number of the portraits, you can begin to detect these influences. Two characteristics stand out. The first, often mentioned, is his tendency to place important elements in accordance with the geometrical ratio known as the Golden Section (approximately 1:1.618). The second, rarely noticed, is his predilection for a certain dissociative type of figure arrangement, typical of Uccello and Piero della Francesca and other painters of the 15th century, in which very pure geometrical relationships are established in the absence of any discernible psychological communication between the people represented. In other words, the design of the figure groups conveys a sense of inevitability, yet the figures themselves do not share an activity whose meaning we can fully intuit. All the shapes are wonderfully right, and also charged with strange poignancy: but what are these characters doing?

Among the great French painters whom Cartier-Bresson admired was Pierre Bonnard—the man as well as the artist—and when, stirred by this admiration, I asked him what Bonnard was like, he said, "Humide." What did that mean? Well, he told me that he had once received a nocturnal call from the security desk at the Palais de Tokyo,

where an exhibition of modern French painting was being held. It seemed that the guards had arrested an elderly, demented clochard who was wandering among the Bonnard pictures with a tiny palette, muttering to himself, and trying to touch up the canvases. The poor fellow suffered from the delusion of being Bonnard, they said, and he claimed that Cartier-Bresson could identify him. When Henri arrived, he found Bonnard in tears.

Cartier-Bresson's favorite postwar American artist was Fairfield Porter (though curiously he never mentioned Fairfield's photographer brother, Eliot); dismissing the misapprehension, common among Americans, that Porter was a "white-bread," or nativist, painter, he readily perceived Porter's debt to Bonnard and especially to the early Édouard Vuillard.

It is doubtful whether Cartier-Bresson had any gift for, or any real interest in, telling a story straight, as one might do with an eyewitness photo-essay, a left-wing agitprop spread, or a fashion shoot (in fact, he failed dismally as a fashion photographer). That surely is one reason why he so detested the Baroque, with its mission to promote the ideology of the Counter-Reformation. When in the late '30s he tried to move into the film world, getting jobs as an assistant to Jean Renoir and Jacques Becker, he eventually realized, as I have mentioned earlier, that he "had no imagination," as he put it, by which he meant no feeling for continuous narrative. I do not believe, however, that he truly longed to possess this faculty of invention, which the art of painting often requires and which his sort of photography, being purely optical and mimetic, lacked. Storytelling in fact would have proved his undoing: his genius was for nabbing chance groups of figures whose destiny we cannot divine. Once, when I was driving him around his neck of the Lubéron, he turned to me suddenly and said, "Someone who invents, unlike someone who discovers, adds nothing to objects, brings nothing to creatures but masks." He was quoting the great poet René Char.

When it comes to Cartier-Bresson's forbears among French photographers, Eugène Atget might seem to be the one who might have influenced him the most. There is a dreaminess in Atget's pictures of shop windows and of the *petits métiers* of the Paris streets that argu-

ably foreshadows the Surrealism of Cartier-Bresson's photographs of the early 1930s. Yet Cartier-Bresson would regretfully declare that he found Atget "boring." It was not that he questioned the value or strength of the man's work. It was rather, I suspect, that he saw Atget as a recorder of France's threatened architectural and horticultural heritage, as a meritorious but unexciting preservationist. And indeed, a good case could be made that Atget's original, modestly documentary, intentions were effaced by the manner in which Berenice Abbott and later enthusiasts presented him to the American public.

For Cartier-Bresson, Atget's elevation to the status of great artist was a vexing complication that scarcely improved matters. Cartier-Bresson often stressed that he did not care to think of photography as an art at all, just as he always denied that he had had a career. "I hate careers," he would say, whenever people tried to quiz him about his own. He meant it quite literally, and his refusal to consider himself an artist was one of the secrets behind the degree of artistry he actually achieved.

There are several interrelated reasons why Cartier-Bresson did not regard photography as an art—or rather, why he was not interested in the sort of photography that sees itself as art. He had been trained as a painter and was steeped in respect for great painting and perhaps even more so for great draftsmanship. He drew well himself, at least in the sense of being able to compose interestingly on the page. "Photography is not a form of meditation, like painting," he said to me once, with the unspoken understanding that long meditation, and long training, go into a true artist's formation. He insisted that he had mastered the camera immediately-it was a knack, not an achievement, entirely unlike the years of training that went into the making of a Picasso or a Matisse, and no amount of study could help a student learn it. "There's nothing to learn, absolutely nothing," he would say. He claimed that no photo held his interest for much longer than half a minute, and he seemed particularly averse to giant enlargements and to almost all color photos ("bien vilaines"—"pretty ugly," he would say of the colors, not exactly because he found them garish but because they failed to achieve the fine-tuned emotional resonance that hand-mixed colors do in a successful painting). Most of all, though, Cartier-Bresson had

positive reasons for guarding himself against any assumption of the artist identity. In part this wariness probably betrayed a mental residue of the standard Surrealist anti-art posturing of the prewar period, as indulged in by André Breton; but it is also true that by the late forties he'd begun to regard his reportage as a kind of journal-keeping, the contact sheets corresponding to leaves of a diary. And just as it would be pretentious of a diarist to see every one of his entries as a work of art—you wouldn't say that even of the Goncourt *Journal*—so Cartier-Bresson was not prepared to claim that all, or even most, of his grab-shots were especially "artistic," either.

When, in time, Cartier-Bresson lent me the key to his former apartment in the rue Danielle Casanova in Paris, and I moved in for awhile and started to pore over his contact sheets, I noticed that despite the high level of professionalism and the shrewd, ghost-like hovering in search of perfection that one sensed from frame to frame, the illuminating moments were understandably rare. And as I remembered him talking about his "journal-keeping," two names that he had often mentioned came back to me. One was Stendhal. The other was the Duc de Saint-Simon. Early in Stendhal's Charterhouse of Parma. the protagonist, Fabrizio, finds himself caught up in the Battle of Waterloo and even catches sight of Napoleon without any grasp of the train of events. In these pages vivid images are framed and portraits drawn without regard to a strategic or geographical framework. Saint-Simon's memoirs of the court of Louis XIV at Versailles exemplify almost the opposite case, in that the duke's jaundiced observations are driven largely by moral indignation. It might be that the photo-diarist in Cartier-Bresson always felt beguilingly suspended between these two roles—that of the ignorant interloper, to whom clear-sightedness alone yields a kind of truth, and that of the outraged witness.

Cartier-Bresson's long-time printer, Pierre Gassman, who ran the Picto lab chain in Paris and Toulouse and occasionally drove him to distraction with his needling, once described him to me as *un hippy avant la lettre*. He meant that decades before the advent of the hippies Cartier-Bresson had roamed through the Orient, America, and Russia with the same armor of privilege, the same callous mysticism, the same overflowing baggage of stereotypes and misinformation.

His left-wing indignation, a product of his rich kid's guilt toward the downtrodden, was corroded by self-regard, a keenness to make you aware of his stance on the side of the angels. In a way, just as leftism legitimated a lot of Cartier-Bresson's petty peeves and anxieties, so the invention of the Leica provided the warrant for his habit of staring at people. The former produced nothing but comical rants, the latter a huge archive of major photography.

As Cartier-Bresson grew older, what he hated most, I felt, was "the consumer society," with its leveling effect on everything in the way of rooted traditions, ethnic gestures, and vernacular design that he loved to explore. He was certain that mass consumerism was destroying photojournalism along with the salt of life itself. That the same consumerism was putting bread on the table for a lot of eminently pictorial subjects who'd previously been starving to death—the good old peasants and workers—wasn't something he seriously considered. He spent most of his time drawing—the alliance of photography with commercialism and celebrity excited his growing contempt—though he did concede that advertising was one of the few ways that his fellow photographers could garner a decent living.

Je suis un timide . . . Often beneath Henri's erect carriage, his slightly glacial manner, his dogmatic speech, one felt a gnawing shyness, also tremendous warmth and generosity struggling to break out. Sometimes he would suddenly fall silent, and you would see tears standing in his eyes, and he would fling an arm around your shoulders; and in such moments you would wonder whether photography wasn't something he desperately needed in order to achieve a sense of intimacy with the world.

A Painting Dervish

Avigdor Arikha

And that," said Avigdor Arikha, concluding a short account of his early years, "is how I wound up gazing into my own freshly dug grave. I really can't say how much all this has affected my work. In the end, I suppose, very little—perhaps not at all. I do what I must do, what I would have done in any case. Though perhaps my experiences have helped me to see this"—he nodded toward the basket of bread on our table—"a little better." The basket, which he'd been scrutinizing for some time, seemed to recompose itself into a still life much like the ones he paints.

Arikha was sitting across from me at a table in the Closerie des Lilas, in Montparnasse. He had ordered oysters, which he was consuming with a bottle of English beer and the juice of a lemon. He was decidedly not, however, the sort of person who might be deduced from the sumptuous décor of this fabled old brasserie. With his pointy face and frizzy paprika-and-salt hair, he looked sometimes—just for a second—like a fox. The resemblance, such as it was, was deceptive: there was little or nothing of Reynard in Arikha; but I wouldn't have been surprised if he'd pounced on any of my ideas or preconceptions. Arikha was very close to Henri Cartier-Bresson, yet I knew that they

argued about everything, especially politics and Surrealism. They were probably the two most nervous men in all Paris.

"I was left in the morgue of a Jerusalem hospital with a ticket hanging from my wrist," Arikha continued, and for the first time I noticed the scar across his right eyelid. "I'd already been operated on twice, and in 1948 there were simply too many casualties to attend to, so the hopeless cases were left to die. Fortunately, a nurse saw that I was breathing, and called my sister, who was also a nurse. If my sister hadn't found a doctor who was willing to operate on me again, I'd have been gone within a few hours, and buried in the grave they'd dug for me." Arikha gazed at his glass for a moment and announced, on a brighter note, that he approved of the beer. "I love beer. I even like to drink it fresh, right at the brewery. But listen—I don't want to talk about my personal history. I can't see what my life in deportation, or later, in Israel, really has to do with my art." He paused, took another sip. "I think that a man's style is inscribed in his genetic code. It's like the timbre of his voice when he's speaking truthfully and with feeling: something that sounds right to his own inner ear and to everyone else's. Of course, what he goes through may temper his style. It may distort it, or even block it. But the general social experience really has no connection with artistic experience."

Be that as it may, Arikha himself, I had come to realize, was a most curious repository of experience both social and artistic. One of the few well-known contemporary painters to work exclusively from observation, he had grown up far from the centers of European art, in Czernowitz, in the province of Bukovina, Rumania. In 1941, at the age of twelve, he was deported to a Nazi death camp in the Ukraine; rescued with scores of other children by the International Red Cross, he was permitted entry into Palestine in 1944, and he retained his Israeli passport even though he had lived in Paris for over thirty years. In the early seventies, he had thrown himself with zealous professionalism into an ancillary career as an art historian, and had organized six exhibitions of classic and modern French art, for which he also wrote the catalogues. I'd wanted to meet Arikha partly because I was interested in his draftsmanship and partly because I was interested in his ideas, but there was also something else. For most genuine artists, art is a

means of survival, and in Arikha's case this was literally, hair-raisingly true—he had made drawings in order to keep his sanity in an extermination camp.

The Jewish community of Czernowitz, to which Arikha's family belonged, was largely destroyed by the Nazis and their allies in the nineteen-forties. Yet the dispersed children of this one town have distinguished themselves in many fields the world over. It is said of them that they do not know the meaning of small talk, and though I suppose that this must be taken with a grain of salt, it was certainly true of Arikha. Arikha, for that matter, had very little use even for medium talk: his practice was to launch into an erudite harangue on whatever was the topic of the moment. Luckily for his listener, he was also a gifted entertainer, like many of those Central European intellectuals who filled the great cities of the West in the forties and fifties. And there was a peculiar, rather amusing feature to his speechifying. Whenever he hit a crescendo his face would wring itself into a crumpled, quizzical squint, as if to say, "Does all this make any sense to you, or even to me?"

One thing that Arikha apparently didn't question, though, was that oysters made the perfect mid-October lunch. "I've been in Spain for a few days," he told me, "and I'm only just back. I was in Madrid—dreadful food!—so it's quite a relief to eat decently again. In Madrid, I of course saw Las Meninas. The lighting of the pictures in the Prado is ghastly, of course—artificial. But what a painting! The way that distant patch of light brings everything up to the surface! You see, Velázquez already understood the problem of the surface—it is not exclusively modern. And this great question 'But is it art?'—people have always asked it. It is not new. I have now studied Velázquez's technique—I have asked to see the X-ray—and I learned that almost all of Las Meninas was executed without repainting. The head of the painter himself was repainted, and so was that of María Agustina Sarmiento, but little else. Those hands! And that dog—so génial! To Velázquez's contemporaries it must have seemed that he was painting with a housepainter's brush, the equivalent of a broom for us today. Was this art? How could King Philip have stood for this broom bravura? And from his court painter, too!" The question wasn't rhetorical—Arikha's face wrung

itself into one of his expressions of incredulity. "You know what I think? I think Velázquez was lucky. He was lucky because Philip himself had taken drawing and painting lessons and was a great collector—he was smitten with the art of painting—and he must have had a good eye. Philip lodged Velázquez right in his palace, and there, too, Velázquez was lucky, because he got to paint those wonderful dwarfs, and this revealed his humanity. It always amazes me how much depends on the tiny coincidences, the little strokes of fate."

Arikha was launched; he held forth concerning the right hand of the Infanta and the left leg of the *guardadamas* and many other matters until only oyster shells and empty glasses were left on our table. "Spontaneity!" he exclaimed. "Spontaneity is what's missing in so much of modern art. I feel at times so dejected—I feel we're at a low point in the history of painting. Modernism started as a series of jolts or bursts of inspiration, and it has declined into a succession of strategies, like checkers being moved about a board. Really, I am very dejected."

I suggested to him that his notion of inspiration's coming in fits and starts seemed to describe his own personality especially well—that it seemed, indeed, to describe him better than it did anyone else.

"Ah, but always one sees in others what one is oneself," he replied. "Que faire?"

"You like it? ... Yes?... *Why* do you like it? ... You can't explain? ... You think all this makes sense? I *don't*. It's finished. The large public has the movies now, it cares nothing for painting."

Arikha and I were standing in the cool north light of his studio, off the boulevard de Port-Royal, looking at an oil sketch of Jerusalem—something rare in Arikha's work, for he seldom paints landscapes. I asked him if it was new.

"No, not new, old," he replied in his percussive accent. "I love Jerusalem, but it's a difficult place to paint, because of the intensity and rapidity of the light. This was done in one, one and a half hours. Walking around Jerusalem, you can find many fine views; it's like Toledo in that way. But one morning I am doing this, walking outside the walls of the Old City, when gradually I begin to feel that something is missing. What can it be? Then I realize: art! There is no art associated with

Jerusalem—archeological marvels, yes, but no masterpieces of painting, no Uffizi, no Louvre. The city is magical, in part because the local limestone is so handsome, but nobody could say that these buildings have architectural distinction. The Dome of the Rock imparts a certain focus to the place, but it has no real beauty. For one thing, it was better black, before the Jordanians gilded it. And then all that overelaborate tilework—it's so fussy. You like that sort of thing? Of course not—it's impossible! Though one can of course appreciate it.

"The Jerusalem landscape *speaks* to me," Arikha continued, "because if you know the Hebrew Bible you can look at the stones—this isn't schmalz!—and hear the prophets talking. I should paint in the wilderness. I should have a tent to paint in! Do you know Barbara Novak's thesis about American landscape painting? Well, she thinks that the American landscape became at one point an ideal thing to paint, because it was without history. No, no, it's more complicated than that—you must look it up. But my point is that Jerusalem does have history in its landscape. For that reason, it is still waiting to be painted. Edward Lear did it, and quite charmingly, too, but his water-colors are only illustrations, always stressing the literary associations, the picturesque. David Bomberg had some interesting things. But Cézanne in Jerusalem! *That* would have been something! But it wasn't necessary for him to go anywhere, so he never did."

I knew that most of Arikha's own work was made right in his studio. It was a modest room, about twenty-five feet square, with one tall, tripartite round-arched window. The room was two stories high. On one side, a staircase climbed to a loggia that held a rack for pictures. Beneath the staircase, double doors opened onto a small room lined with books; on a table in this library lay a horned Persian helmet. That the studio should lead into a library seemed a fitting expression of Arikha's mandarin cast of mind. Here and there hung framed drawings: a girl in sanguine chalk by Pietro da Cortona, an Ingres, a Delacroix, a Giacometti. A sketch by Arikha showing Samuel Beckett playing chess with one of Arikha's daughters. Out of this little place, with its gray walls and its easels and tables and chairs and its etching press and tools, Arikha had managed to squeeze most of the pre-

vious twelve years' worth of subjects for painting. Of course, he had an obliging collection of friends to portray, and his wife, Anne—the author of two books of poetry—and their two daughters. (The family lived in the adjoining apartment.) Still, it was amazing for anyone who has seen his pictures to realize that he had made so many images out of so few motifs.

Arikha paints with fierce speed and intensity, often for more than ten hours running. He favors spare compositions achieved with a limited but very fresh palette. Any single mark of a brush upon canvas—in its color, its crisp or drifting edges, its degree of "fatness"—is an intimate token of a painter's whole personality, and Arikha's touch, whether he is painting people or eggplants, has a highly personal feel to it. His brushstrokes, soft and atmospheric, float upon the canvas like pats of butter melting into a richly colored soup. The design of these paintings may owe something to the sparer sort of American Abstract Expressionism: Arikha often extends one hue over a large part of his picture.

No matter how big his canvases (some are more than five feet high), Arikha won't paint on them for more than one sitting—one day. Nor will he ever go back and "correct" anything. "I wouldn't necessarily recommend this practice to anyone else," he says, "but for me it is the only authentic way to paint. I simply can't return to a painting that I've left overnight. It would feel like wearing a foreign skin: how could I ever find the same touch again, or the same light?" Since each picture corresponds to one day, there is a diarylike quality to Arikha's work (just as there is, for example, a novellalike quality to the paintings of Balthus). Arikha paints studio and apartment interiors (some remarkably bare), family and friends, still lifes (mostly of painting tools, or food with kitchen things), nudes (sometimes mildly allegorical), and the odd landscape. If portraits are important to him, that is at least partly because the verisimilitude of a painted head—its representational accuracy—depends upon the easy recognizability of the subject rather than upon masses of detail. Arikha often depicts objects at life size, but, unlike many realist painters at work today, he doesn't attempt to achieve the photographic effect of continuous tone. In the portrayal of a thing, as in that of a face, he seeks economical ways for the brush

to mimic the substance in question and so provoke our recognition of its nature. Like all the chief historical exponents of painterly painting, he tries not for exact resemblance but for intimate analogy, not for the truth of detail but for the truth of vision and breadth.

One senses that the French "tradition of sincerity," which has no real counterpart in our culture, has been important to Arikha. This tradition is represented in literature by figures as diverse as Mme de La Fayette, Rousseau, and Benjamin Constant. The idea, as Baudelaire expressed it, is to "lay the heart bare"—to catch feelings or impressions on the wing while forgoing any attempt to remodel them into something more edifying or coherent. Form, it is hoped, will come of itself, much as the shape of a beehive or a wasps' nest gradually emerges into being. What especially marks Arikha's work is the faith accorded to alla prima, or one-shot, execution. In the context of contemporary painting, this is somewhat unusual: we are more accustomed, in our visual culture, to sincerity as the sum of many corrections—to the much-repainted picture of the sort that Giacometti offered. By contrast, Arikha's work can sometimes seem a trifle slight, intentionally underdeveloped; but his implicit plea is for continuity of response, for the will to act at once upon one's enthusiasms, and not for high finish or completion. Clearly, the long project, the masterpiece of a thousand sittings, is not for him; it would merely get in the way. "I painted the Queen Mother in less than two hours," he told me, "but overnight, while the portrait was drying in Clarence House, I felt horribly embarrassed. I pictured it in my head as a failure, and I was walking around in a cold sweat trying to figure out how to get it back! When I actually saw it again, though, I was satisfied. I'm not a professional portraitist, and it's no grand or elaborate thing. But it is an honest record of my sensation when I did it; I suspect that a half hour more would have ruined it. It's in the National Portrait Gallery of Scotland now, and they tell me the likeness is good. I really did get her—that sweet lady!"

What people tend to like about Arikha's painting is its casual elegance, its unforced way of seeming all of a piece. Yet his way of scumbling or stretching "short" paint over broad areas can get on some viewers' nerves. I suspect that these broad areas remind them of something they never liked about color-field painting—the overdesigned

or too graphic look. To a degree, this is a matter of taste. What is true is that Arikha cannot, in his bursts of energy, encompass any terribly intricate compositions. In the end, his way of working, like any other, has the drawbacks of its advantages. All style is born of forfeiture.

Nobody has had a greater influence on Arikha's conception of the act of painting than Samuel Beckett, a close friend of long standing. Yet Arikha shies away from talking about Beckett, as if there were something indecent in the disclosure of blue-chip sympathy. This seems needlessly prudent: Beckett himself is hardly beyond controversy, and though it is clear that he has in some sense given Arikha his blessing, only a simpleton would conclude that he has therefore endorsed all that the younger man had done.

"What I owe to Beckett," Arikha told me, after some prodding, "is a strict sense of the ethics of art—that every brushstroke in a painting must be justified. This notion of justification comes from Joyce. Beckett was never Joyce's secretary—that's just a myth—but he worked for Joyce, translating the 'Anna Livia Plurabelle' chapter from 'Work in Progress' into French. Joyce, of course, was phenomenally well organized: everybody worked for him. Well, one day, according to Beckett—this was in the thirties—René Crevel came to see Joyce. You must have heard about Crevel from my friend Henri-he was very beau garçon and the virtual bodyguard of André Breton. Crevel presented Joyce with a copy of Breton's Second Surrealist Manifesto. Breton was something of a terrorist, of course, but a very grand and beautiful one, with a lion's face and lion's hair, and he expected everyone to sign. Well! Joyce squinted at Crevel, and he put on his first pair of spectacles, and he put on his second pair of spectacles, and he lifted up his magnifying glass, and he began to read the Second Surrealist Manifesto. After a while, he looked up at Crevel and said, 'Monsieur! Can you justify every word in this text? Because I can justify every word and every syllable in everything that I write!' You see—the love of form! Joyce wasn't about to fall for this Surrealist . . . magma! After this, Breton's Surrealists made war on Joyce. Breton was like that: he couldn't bear to be disagreed with. The first evening he and I spent together, we argued the whole time. Anyway, Beckett took this notion of justification so seriously that sometimes he worked out the scansion

of his syllables in formulas on the verso side of his notebook. In 1954, I read *Waiting for Godot*, and it kindled a fever in me—especially that speech of Vladimir's: 'Was I sleeping, while the others suffered? Am I sleeping now? Tomorrow, when I wake, or think I do, what shall I say of today? That with Estragon my friend, at this place, until the fall of night, I waited for Godot?' My whole troubled frame of mind after the war—this expressed it perfectly! But I hadn't met Beckett yet, and I couldn't believe that he really existed, and people told me that no, he didn't exist, that Beckett was just a pseudonym for someone else, or for several people or a whole bunch of people. All sorts of myths were in the air. But I knew Roger Blin, who'd directed *Godot* at the Théâtre de Babylone and played the part of Pozzo, so I knew from Blin that there *must* be a Beckett. And eventually I did meet him, of course.

"Do you know," Arikha went on, "we called each other *vous* for six years. Beckett had—and has—a great love of painting and used to be a serious museumgoer. He owned catalogues of most of the great European museums, of most of the great collections of Old Masters, and they were all covered with his notes. I would show him my paintings—I was an abstract painter then—and he would look at them for a while and then say, *'C'est encore le tunnel.'* I stayed in this 'tunnel,' as he called it—this spiritual darkness—for some years. Then, one day, I showed him a painting—it was still an abstract one—and he looked at it for an extra-long while, and finally he said, *'C'est ça.'* And that meant only that I was out of the tunnel, nothing more.

"Beckett knew many painters, and in a way he was looking for something as denuded as an empty canvas—powerful but bare, like his own writing. So I was afraid he would discard me when, later on, I started to draw from nature. But actually his interest in my work increased. When I showed him my first drawings from life, he looked at them for over half an hour; in the end, he just nodded. For him, art has to be moving—that's the important thing. And I agree. Do you know what Delacroix said about the design of the Madeleine? "Though it satisfies the mind, it chills the imagination." Chills the imagination! For me, this is the problem with so much of modern art. It's beautifully done, it looks great, but that is all. And that is not enough.

"Not many people know that Beckett used to write about art. He

stopped back in the forties. I asked him why, and he said, 'I don't want to pull all the covers over to my side of the bed," Arikha broke into a smile. "I feel that by talking about Sam I'm doing the same thing now—pulling all the covers over to my side. But I'm so indebted to him! This thing of the *ethics* of art—I'm not at all sure I'd have hit on it by myself." Arikha's face screwed itself into a knot. "Maybe, but I doubt it. Look, it's getting dark. We stop now. Let me just put these paintings away, and I'll make us some coffee. Turkish coffee, you like it? Good! I bring it to boil seven times, which is the correct number."

We were drinking coffee again, this time at a café, and Arikha is peeking over at the porridge of Central European names on my notepad. "Dan, Dan, forget about biography," he says. "I wasn't born anywhere. For a Jew to be born in Czernowitz in 1929 was like being born on a train. Yes, it was part of Rumania, but Rumanians were distinctly in the minority. The province of Bukovina still retained its old character, from the days when it was the easternmost province of the Austro-Hungarian Empire. The people were Germans—Saxons or Swabians—or German-speaking Jews. Some Ruthenes, I recall. My parents sent me to a secular Hebrew school, which I think belonged to the Sephardic community, and I already spoke beautiful Hebrew as a child. I never regarded myself as anything but a Jew, though in a historical sense only, not a religious sense. Whenever people make me into a Rumanian, I feel hurt. Years later, I spent a day walking about Paris and arguing with Paul Celan because he wanted me to reminisce with him about the beauty of Bukovina. Paul Celan, the Bukovina patriot! I told him I didn't give a damn about Bukovina! You see, Celan went to Paris in 1948. When I met him, he had no regret at not having gone to Israel to fight its war. He later, much later, changed his mind. But I understand him now fairly well as a poet inhabited by the German language. What a singular destiny! That one of the greatest German poets should be a Jew from Bukovina—'a country that doesn't exist anymore,' as he used to say.

"My parents were both Austrian subjects up to 1918. What they became then I don't know. My mother's people had been wealthy Bukovinians. My father was an intellectual who finally did accounting. He was good at math. He used to make medicinal oils—all sorts

of chemicals. I don't know. Most of the time he was a fonctionnaire. He spoke Latin almost as fluently as he did German. I have no one to tell me about him. But I do remember that long after his death my mother told me in a pained voice that he was very intelligent and very sensitive, and, well—a skirt-chaser. He loved music and maybe art, too-I don't know-but he encouraged me, pushed me in the right direction: when I was eight, he had me read Confucius. He died with us in deportation, when I was twelve. This was in the midwinter of 1942, in the vicinity of Luchinets, in the Ukraine—a lot of the Ukraine had just been seized by the Axis. Rumanian troops were marching us, hundreds of Jews, to one of these so-called transit camps. My father had sustained a brutal beating. It was bitterly cold, and the idea was simply to march us to death—we were all of us contracting typhus. Suddenly—this was on a road, or something like a road, snow and ice covered it all—I felt somebody deftly pushing me from the rear with his foot, and then I rolled down a steep embankment in the snow with my sister and my parents. It was my father who'd forced us downhill. He was trying to get us to escape, you understand—though in the end we had nowhere to go. First, a Ukrainian peasant tried to kill us with a knife. Then another one, a wonderful old man with a long beard, took us to his cottage and made us soup, and gave us glasses of vodka. There you could see human nature stripped to its essentials. This one tries to kill you, this one tries to save you—cruelty or compassion, tenderness or hate. In the old man's cottage, early one morning when the snow was softly falling, my father died. His last words to me were: sei frei."

Arriving in Palestine in 1944, Arikha joined Kibbutz Maaleh Hahamisha, near Jerusalem, where he was to work for five years. A few months later, he was sworn into the Jewish underground army, the Haganah; in 1946, he joined the Jewish constabulary, a lightly armed force permitted under the statutes of the British mandate. "Maaleh Hahamisha was five years old when I arrived there," he told me. "It was bleak, with only a few houses and laughably tiny baby trees. The site consisted of barren rock, with all the earth lying down in the valleys, eroded; we carried the earth back up to make terraces. So I had the good luck to learn to enjoy not only hard work—what one can build with it, and the

pleasure of meeting challenging obstacles—but also everything about the land. At the same time, I finished high school and underwent military training. After two and a half years, I started going to the Bezalel School of Arts and Crafts, in Jerusalem, but I continued to work at the kibbutz. Every other fortnight was reserved for secret military training. The school was only ten miles from the kibbutz, so you might say I experienced Athens and Sparta in Jerusalem: my life was split between art and work—just as it is split today between art and art-historical writing."

It was as a soldier escorting a convoy that Arikha was caught in an Arab ambush in January, 1948, on the hilltop of Castel, outside Jerusalem; in the ensuing battle, a 9-mm bullet struck his spine, and one or two bullets passed through a lung. "I was lying there on the rock," he said, "and I could feel that I was dying, and I thought, Now I'll never get to Paris." After his recovery, he returned to the front and fought in the Arab-Israeli war of 1948.

Arikha studied art for several months more at the Bezalel School. In 1949, he went to Paris on a scholarship, and for the next two years attended the École des Beaux-Arts. He then returned to Jerusalem, where he met a man who was to be a major influence on his life. This was the elderly scholar and publisher Moshe Spitzer. "Everyone called him simply Dr. Spitzer," Arikha said, "because he had three German doctorates—in philosophy, Sanskrit, and Tibetan. He'd lived in Berlin almost until the start of the war. He was the director of the Schocken Verlag, the great publishing firm, and he knew Brecht and Buber and Rabindranath Tagore. He'd known and published Kafka. He was wise and calm and elevated, and remained a baby his whole life-innocent, enthusiastic, always flat broke. Once, his basement apartment in Jerusalem was flooded—the water was up to his ankles—and I said, 'Please, Dr. Spitzer, sell your Klee. Buy a house.' 'And why would I need a house, without a Klee?' he said. He was also a great liberal. He had many solid contacts among the Arabs and the various Christian churches and orders in Jerusalem. He was skeptical of novelty, and imparted that skepticism to me."

Arikha became enmeshed in the artistic life of Paris in 1954, during a long visit; half by accident, the visit turned into a permanent

residence. His first mature work, executed in the late fifties and early sixties, was abstract. These paintings were full of slivers and splinters, black and red and white, with hard or feathery edges, and many subtle transitions. "They always had this apocalyptic feel," Arikha told me. "Things up in the sky, prophets talking. This was my inner vision. Black was dominant in those years; maybe that's why I'm now so keen on white."

He abandoned abstraction in March of 1965; coincidentally, he saw the great Caravaggio exhibition that opened at the Louvre that month. He was especially excited by The Raising of Lazarus, with its fusion of realism and spirituality. "The abstract painters I knew were furious with me," he said, "and, myself, I thought I would never paint again." In fact, he found no way to use color for the next eight years. What did feel right, though, was to draw. Drawing is usually a spontaneous activity, and Arikha saw that he could pursue it without getting pinned down by aesthetic anxieties. Within a time span short enough to be perceived as a unit of experience—rarely more than an hour he would give himself over to the thing to be drawn, and register as truthfully as he could its immediate effect upon him. The drawing was never to be thought of as preparatory to anything—to a painting, for example, or a print—and was never to reflect any borrowed notion of form: no echoes of photography, popular imagery, or the hallowed drawings in museums. Hoping to rid himself of acquired stylistic habits, he accepted all his strokes as final, and forbade himself ever to return to his drawings. Of course, his program was idealistic; its aims could never be thoroughly realized. What it might allow him, though, was to discover how his hand would respond to what his eyes were seeing rather than to what his mind had learned. He soon observed that the subject had first to strike or move him; he likes to describe this summons as being "like a telephone call—when it rings, I run." Nonetheless, he had no concrete notion of how he wanted his drawings to turn out, except, of course, that they should please him. His approach to drawing was rooted not in a specific conception of form, but, rather, in the striving for a state of mind, a receptive emptiness.

Arikha's new drawings nearly at once won many admirers; some influential critics wrote that he was the best draftsman alive. From

1965 to 1973, he drew mostly with brush and sumi ink on paper. This sort of drawing is a strong but demanding technique; good darks may be produced right away, but the brush is hard to manipulate, and nothing can be erased. The first thing one notices about Arikha's ink drawings is not their accuracy but their personality. One senses a kind of execution that flows directly out of the body, affirming his belief that style is a matter of biology. Style, as he puts it, "immunizes one against what isn't oneself, against what doesn't feel true." Arikha scornfully dismisses most of the art movements of the last quarter century as "flu epidemics"—"everyone coming down with photo-realism or neo-expressionism, and then it passes."

Arikha's unusual "touch" is evident even in his handwriting. Right now I'm looking at a postcard he recently sent me. The writing is barbed and close-set, full of quaint hookings and angularities; it looks like free-flowing cuneiform, the kind of cursive one might imagine an ancient Babylonian artist or designer tossing off. Even more unusual than the handwriting itself, though, is the body of the text. It has an irregular, shard- or tablet-like shape, and this shape has been fitted into the oblong of the postcard in an eccentric yet pleasing way. Everywhere in Arikha's work one finds this visual event: some oddment being fitted into a space where it wouldn't seem to belong and yet does.

There is also in Arikha's ink drawings a vividness, an accuracy, that is somewhat reminiscent of certain seventeenth-century French draftsmen. Many classical French pen-and-wash drawings were influenced, it seems, by their creators' experience of freely copying Roman bas-reliefs under a single source of illumination. The idea (somewhat simplified) was to divide the lights from the darks by playing crisp shadows or halftones against areas of white paper; if this was done cleverly enough, the viewer could read the image as a satisfactory rendition of form. Arikha, too, works around "reserved" areas of white paper to achieve an image expressive of economy. All the same, there is a certain nonclassical eccentricity to his handling. He's fond of plaitings and snags, and his hand tends to weave or circle. It crawls with labyrinthine patience through topiary-looking landscape structures, or zigzags through the halftones on a sitter's face. Not infrequently, it

goes a little astray. These drawings—both the early ones, in ink, and the more recent ones, in pencil or charcoal—seem remarkably candid to many observers. They somehow manage to conjoin sophistication and an unspoiled naïveté.

A scene in the Louvre: A smallish, reddish man, electric with enthusiasm, whirls from painting to painting, fusilli hair standing on end; behind him, exhausted, a larger fellow with a spiral notepad. The reddish man has come here to make a point about the Egyptian Book of the Dead. Only a quarter of an hour ago, he was chatting in Montparnasse with his companion when the spirit seized him. The spirit is the love of pictures mixed with an affection for art-historical puzzles and solutions. But now it is late, it is nearly closing time. The reddish man keeps valiantly trying to make headway, but the Book of the Dead is many halls away, and the paintings keep pulling him sideways with magnetic force. He stops short before Raphael's portrait of Baldassare Castiglione. "Génial," he says reverently, then cocks his head and holds his quizzical squint for a long moment. "No, but every time I see this painting . . . Really, it is absolutely génial." The squint vanishes, and he gazes at the painting for what seems an eternity, sometimes raising his palm, softly, to sketch the famous courtier's outline in the air. Then he is off again, tacking slowly up the Grande Galerie.

"And to think," he says, frowning, "that Raphael wrote to this same Castiglione that because there was a *carestia di belle donne*—a shortage of beautiful women—he would paint his own idea of female beauty. When he had *that* power of observation! But, really, he died too young, Raphael. He never had time to shake off this peculiar notion of improving on nature, which descends, of course, from Plato, who never really understood art anyway. It is partly because of Plato that Michelangelo painted his 'divine heads,' which unfortunately are atrocious. It is why Bellori condemned Caravaggio. And now I will direct your attention to a remarkable fact. Artists today are still trying to decide in advance exactly what to put on a particular canvas, even a whole series of canvases. Trying to deduce their feelings from their formal intentions. And this is to take the act of painting from the

wrong end; it is to paint backward, like building a house from the top down. Well, I reject it! Our intentions are rooted in what we already know, in what's already closed or accomplished. If what I paint doesn't surprise me, it certainly won't come as a revelation to anyone else."

In the past few years, as Arikha has been building his secondary reputation as an art historian, he has come to be quite at home in the Louvre. One senses, as one follows him about, that like many natural polemicists he is reeling off a screed, a settled view of the pictures that interest him most. At the same time, however, he steadily revolves that view in his mind, adjusting it a bit as he points out some freshly meaningful detail, or draws a comparison that dawned on him only seconds ago. This running exposition is interlarded with social commentary—a sort of gossip column, really—offered almost in an undertone, and with an impish smile.

"Jacques-Louis David," he says, "painted Mme Récamier because she was beautiful, but also, I think, because she was an example of virtue." We have halted before the celebrated portrait of the reclining Juliette Récamier. "This white frock... This simple blue ribbon... She is sad, perhaps; perhaps only perplexed. Here is how David really liked to paint, how he also painted for himself." Arikha points out the free quality of the background and certain other passages. "This unfinished look upset Mme Récamier," he says, "and she complained to David. He wrote back, 'Madame, ladies have their whims, so do painters. . . . I shall leave your portrait as it is.' And—can you believe it?—it was still in his studio when he died."

Arikha gazes for a moment at the unhappy-looking girl in her white shift, then falls into a discussion of David's looser manner, his hand leading slowly down to Mme Récamier's feet. He seems to be feeling the feet from the inside out, feeling what it is like to become the soft, blooming-out-of-the-air carnality of a pair of naked feet. They offer, in a few square inches, a prototype of his own style of brushy execution; and, at the same time, a vision of the other Juliette, the flirt who could pass to a man in a drawing room a note saying "Dare to love me." As it happens, I have always been interested in Juliette Récamier—especially in her friendship with Benjamin Constant—and I start to recall the bizarre controversy surrounding the "degree" of her

virginity. I wonder aloud if the term "extra virgin" would apply in her case, as it does to certain olive oils; or would "demi vierge"—that curious expression—be more appropriate here?

"I think the *appropriate expression*," Arikha says with the barest hint of sarcasm, "would be 'vestal.' Her husband was an old man, yet she remained quite chaste—despite the attentions of Lucien Bonaparte, Mathieu de Montmorency, and really almost every man who ever knew her. Very probably, David believed that her likeness could be a force for moral purity. He believed, like Poussin, that paintings could change men's lives."

I am beginning to wonder if there is anyone to whom the Old Masters and all their cast of characters minister with such angelic force as they do to Avigdor Arikha. For him, not one of them is dead: all are retrievable; everything that has ever happened is happening now. I almost regret mentioning Van Dyck to him in passing; he defends King Charles I at extraordinary length and heaps scorn on Cromwell the regicide. He reveals in his discussion of these ghosts a proprietary familiarity. For him, Rembrandt is a personal acquaintance, and one, moreover, whose morals are far from irreproachable: "But they were right, those Dutch burghers: c'était un personnage grossier!" There is about Arikha this little air of throwaway comedy. Often it is intentional, but sometimes it is not, and then it belongs to the sort of humor that arises from the disparity between a man's speech and his animal spirits. One hears in Arikha's voice the mixed rhythms of the Central European professor and the Hebrew exegete and the Paris intellectual, but his thoughts are filled with a passion in which logic has no part. Sometimes, as now, this passion drives him into such a state of aesthetic rapture that his whole body is possessed by a curious weaving or swaying motion. It is then that one begins to feel that he is actually a sort of dervish—a dervish of the art of painting. And one can only watch spellbound as his rhetoric whirls him into a strange, unguarded intensity.

At last, after discoursing on two or three more paintings encountered on the way to the Egyptian department, Arikha leads me at double time into the room where the Book of the Dead is usually displayed. But today it is absent, this book about absence; and the Louvre's closing bell is ringing.

"What a pity!" he exclaims. "I only wanted to make a point about this art that has no rounding of the human form, no *modelé* ..."

One afternoon, I joined Henri Cartier-Bresson at the Centre National de la Photographie, in the Palais de Tokïo, which had mounted a show of his India pictures. Henri has been a close friend of Arikha's since 1970, but the two men are very dissimilar. Henri is about twenty years older than Arikha, and he isn't intellectual in the way Arikha is-he doesn't need to turn his emotions into articulated thoughts. He also speaks more softly and hesitantly than Arikha, whose native tempo is distinctly staccato. The two men have some interesting things in common, however. Henri, if not exactly an "adventurer," is an obviously adventurous man; Arikha has also led an adventurous life, though all too many of his adventures have been visited upon him. Both men saw, between 1939 and 1950, the fragmentation of a world once open and traversable into pairs of hostile, mutually sealed blocs; both have a vocation for the most time-stabilizing capabilities of their respective arts. For Henri, this has meant the snapshot; for Arikha, the quick sketch and the rapidly painted oil. "Avigdor," said Henri, "is a rather daunting fellow, and I myself am on the timid side, yet we're extremely close all the same. I know he seems somewhat high-strung, but that's only because of what they did to him as a child." Henri told me that Arikha's concentration-camp experience had probably been much worse than he had indicated. He also told me about the incident that led to the death of Arikha's father, which Arikha himself hadn't cared to relate. Apparently, Rumanian troops had gathered two thousand Jews in the marketplace of Luchinets, and Arikha's father had approached the officer in charge and asked to see his written orders. An altercation had ensued, and then Arikha's father had slowly drawn on his glove presumably so as not to defile his hand—and slapped the officer in the face. It was this that prompted the beating from which he died eight days later.

"Arikha," said Henri, "is literally atremble with sensibility, and as intelligent as they come. Underneath his elitist demeanor, he's a very warm and tender-hearted person.

"Some years ago, when I took up drawing, it was Avigdor's draw-

ings that prompted me to meet him." Henri explained in detail just what it was that he admired about Arikha's drawings, stressing their "immediacy." "Like me, Avigdor has been greatly influenced by Eastern philosophy," he added. "He's always teaching himself how to make subtler and subtler distinctions. That's one reason that he loves wine and is a great wine connoisseur. He also loves beer and tea and coffee, and can tell you in some detail what distinguishes the water of one city from that of another."

Soon October was almost over. The sky was usually gray, and the trees in the Luxembourg Gardens wore the color of tarnished brass. One morning, I wandered into Arikha's studio, which seemed darker and stiller now, and we agreed that he would draw me. I sat down in a chair in the middle of the room, facing the big north window. About two yards away, he positioned his easel so the light would fall over his left shoulder. He scrutinized me for a moment, then snapped a cassette into his tape deck: a Schubert quartet. Sitting there listening, gazing at the sky through the round-arched window, I recalled something else that Cartier-Bresson had told me about Arikha's way of drawing: that when he sketched with a stick of charcoal he pressed it against the paper with such deliberation that it made a sound "like a cricket's chirp." And, sure enough, presently this chirping sound mingled with the strains of the quartet. Every now and then, as he drew, Arikha stretched out his free hand as if to direct me in some way, and I began to wonder if I was slouching or fidgeting, but soon I realized that this hand reappeared, outstretched and palm down, every time there was a rallentando in the music. Perched on the edge of a high stool, Arikha hovered at his easel, wholly swept up in his dervish mode, swivelling his head continuously back and forth between me and his drawing, unwilling to let the subject unravel in his mind. This, then, was the explosive approach to picturemaking that Cartier-Bresson had so vividly described: "Pan, la tête! Pan, les mains! Pan-pan, la Reine-Mère!" In an hour or so, I, too, was pan-panned into potential immortality on quite a large sheet of paper, to boot. Then Arikha turned the easel around, and together we looked at the drawing, he through a diminishing glass. He made a few small changes, and-despite a degree of

dissatisfaction—announced that the portrait was done. (It is at this point that he must routinely exercise a willpower, a restraint, that is comparable to a perpetual Lenten abstinence. Yet the truth is that this sort of drawing does not admit of correction; if he'd wanted to study my nose any further, he would have had to start a new portrait.)

We considered some other recent drawings for a while, and then Arikha began to riffle through a pile of worn folders and portfolios of old sketches. He seemed a little embarrassed by these early efforts; when he feared that they might have no aesthetic value, he cited their interest as documentation, and in this way he gradually slipped into a sort of visual presentation of his life. He brought out a large cloth-bound volume bearing, on the title page, the inscription:

AVIGDOR ARIKHA BOYHOOD DRAWINGS MADE IN DEPORTATION PARIS MCMLXXI

This book, printed in three hundred copies by the Youth Aliyah, an agency responsible for the immigration of young people to Israel, contained a portfolio of seven drawings made by the artist when he was thirteen and fourteen. Up to now, Arikha had been rather reluctant to discuss this period of his life, and I began to leaf through the book with considerable curiosity. The preface, written by Arikha himself, recounted the deportation, in the autumn of 1941, of Communists and Jews to a group of concentration camps set up between the Dniester and the Dnieper in the Rumanian-occupied sector of the Ukraine. Many of these prisoners were exterminated; others were left to starve to death; still others were forced by the Gestapo into slave labor. Arikha, who had been recaptured after his father's death, was in the last group; he worked in an iron foundry guarded by a dozen S.S. men. The preface said:

The following drawings formed part of a child's sketch-book provided by a Rumanian soldier containing some thirty leaves on which events were "related." Those representing S.S. bru-

talities or massacres were destroyed by order of a conscientious overseer with the remark "Kind spielst mit Feuer." ["Child, you're playing with fire."] The book thus censored [was] deposited at the labor center for eventual inspection by the Red Cross Commission which was to visit these camps in December, 1943. The drawings were remarked by the delegates of the Relief Committee for "Transnistrian" deportees, which had obtained [permission from the Axis to liberate and evacuate] 1,400 children bereft of both parents. One of these orphans having died before liberation, his name was transferred to the author of these drawings on the day of departure, March 6, 1944, and it was this false identity that made possible his removal to Israel, then Palestine, together with 120 other children, under the protection of the International Red Cross and through the agency of the Youth Aliyah.

Captions were provided to explain the drawings:

Frontispiece: Ukrainian militiamen shooting fugitives.

- (1) Escorted by a soldier two kapos drag toward the cattle trucks two prisoners "selected" for extermination camp.
- (2) Starving fugitives knock on the door of a house be longing to Ukrainians. These usually denounce them and they were shot.
- (3) Work lasted from dawn to nightfall under the supervision of guards, militiamen, and soldiers. In the background, militiamen beating prisoners.
- (4) The soup never varied—a few lentils and water—and was distributed once a day.
- (5) Another work scene—those no longer able to work were in danger of selection and so hid their weaknesses as best they could.
- (6) Burial—the corpses were loaded on carts, and ditches dug to receive them.

The drawings were quite objective. The handling did not suggest that the young draftsman had treated his subjects differently from the way he would have treated other, more tranquil motifs. A fondness

for incidents at the picture's edge (still noticeable in Arikha's work) was apparent. In one of the forced-labor scenes, an arm holding a club projected into the picture from the right, suggesting something that I'd never heard maintained: namely, that the victim may as readily see the oppressor as thinglike or mindless as the other way around. This drawing had a strange dignity. When we came to the picture of starving fugitives begging for bread from a woman in a house, Arikha glared at it coldly. "And she didn't give *anything*," he said with a snort. "The Israeli Foreign Ministry sent me back the original sketchbook in 1960, and I was eager to look at it again. I hadn't seen it in over fifteen years. But when I opened it I had to ask my wife to take it away. It wasn't the drawings themselves, it was that smell: you know—well, perhaps you don't—the horrible odor of corpses. The notebook reeked of it, or that's what I thought till Anne told me that it had no smell at all. The stench was in my mind."

I made a helpless remark about how terrible it must have been for a young boy to experience all this.

"Yes, terrible, but the strange thing is that I was not unhappy when I was deported. I felt the exhilaration of the new. My child's sense of wonder was justified. Later, of course, I realized how terrible it had been. But for many who grew up in the camps the horror came to seem normal. That is why it was so hard to survive—if you survived at all—with your humanity intact. And many people didn't.

"Aha! Now, these," said Arikha, opening another portfolio, "are from my years at the Bezalel School, in Jerusalem. Academic training. Here, on this sheet, an obligatory still life in the style of Cézanne. And here, on this other sheet, is how it actually *looked* to me when I drew it later, by myself. This is all still very crude, of course—not yet *cooked*. And here: *Gebrauchsgraphik!*—most of our teachers were from the Bauhaus. This is the head of a combatant in the '48 war, the Israeli War of Independence. My Soviet submachine gun. Piled Canadian rifles. This was during a bombardment—we'd been shooting out of a bunker window. Perhaps I understood even then: if you don't draw from life, why do it?"

The next morning, I packed my bags to leave Paris. As I was waiting for Arikha to join me at my hotel, I found myself mulling over

some of the perplexities suggested by our conversations. I'd begun to feel that there was about him a smidgen of the revenant's aura—the aura of Lazarus. Though he talked as matter-of-factly of hell ("the idea was simply to march us to death") as he did of the antecedent world ("the easternmost province of the Austro-Hungarian Empire"), it was hardly as if he talked just like anyone else. I was struck, for instance, by how often he slipped, in discussing the practice of art, into an apocalyptic or Manichaean mode of discourse—one that pitted life and the continuity of free response against dead forms and dead observances. He also lacked a certain imaginative leniency toward most other people's ideas, and he relished intellectual combat in a way that suggested that talk could really solve a lot of the world's problems. He had the revenant's faith that everything comes to rights in the end.

Then he was knocking on my door, and we went downstairs and walked around the corner into the rue de Fleurus. Not far from Gertrude Stein's old home, we found an odd, seedy-looking café and ordered two espressos. When the coffee arrived, Arikha sniffed at his, sipped it, and reeled violently backward.

"It's the beans!" he exclaimed. "Scorched during the roasting!" A pall fell over his features. I was beginning to think him unsinkable, and here he was, defeated by a cup of coffee.

"Why don't we walk over to Saint-Placide," he said sulkily. "I think there's a decent café there. Oh, but we haven't much time. Let's stay here, it's all right, really; anyway, I should like to insist that I am actually a tea drinker, not a coffee drinker at all."

He looked at me miserably. "Listen," he said, "there's someone I wanted to tell you about. Have I mentioned the Georgian commissar yet?"

I assured him that he hadn't. The defeat slowly vanished from his face; it was suffused now with a hectic glow.

"Well, listen. This was in Soviet Czernowitz. The summer after the Nazi-Soviet Pact, Stalin occupied Bukovina; it didn't last long, this occupation, but the Soviets ran everything for about a year. In my new Soviet school, my best subject was art. I was asked to paint decorations and portraits on the walls—I painted a picture of Marshal Voroshilov!—and the school administration decided to send

me to Moscow and enter me in a state-run academy. At this period, my father became very friendly with a certain Soviet commissar. He was a political commissar with the rank of colonel in the Red Army, and he must have been of Tatar descent—he looked quite Asiatic. I don't remember if I've mentioned to you yet that my father had once been an enthusiastic supporter of the Soviet Union; when the Soviets occupied Czernowitz, they made him the accountant at one of their state-run factories. Everything they got their hands on was soon in a dreadful mess and my poor father was wretchedly disappointed. Well, one day I came home from school with a chromo of Stalin, which I was supposed to hang over my bed. The Georgian commissar happened to be there—he often stopped by—and he said, 'Oh, no! You're not going to put that up?' The next day, he returned with a beautiful gray clothbound copy of the Christian Bible for me. Do you realize what this means? We children were being incited by the Soviets to denounce family and friends. He could have been shot for fostering religion. Well, he opened it to the Apocalypse and asked me to read, and soon we all got so caught up in the words that I continued reading for some time, and I remember my father sitting in his chair, eyes half closed, listening to the words of Saint John and nodding ves. yes. 'You think of the Apocalypse as coming at the end of time,' the commissar said, 'but these are the days we are now living through.' And it was true: on the twenty-second of June, the Germans attacked Russia and bombed Czernowitz. On that same day, I was discharged from the children's hospital, where I'd been under treatment for scarlet fever. Soon afterward, the Soviet front broke. There was a train ready to head east, and the commissar pleaded with us, 'Come with me!' It was the last train out, but my father declined. Maybe he felt that I wasn't well enough to leave yet; certainly he wished to show his solidarity with the Jews who would have to remain. So we didn't go, and that was lucky for us, because the commissar's train was bombed totally to pieces. It's a strange thought, but if we had managed to escape to the East I'd be a Soviet citizen today. A Soviet painter! Can you imagine? If our fate had been just a little different. Instead—this was around Yom Kippur—we were deported by Rumanian troops. Eighty to a hundred people in these—what do you call them?—

cattle cars! And the upshot, of course, was that I wound up not in the Soviet Union but here, in Paris."

During the whole time he told this story, Arikha's face had been radiant; now he fixed upon me a peculiarly communicative look. But what did it communicate? I wasn't sure; perhaps sadness, half submerged in a burlesque expression of make-believe submission to fate. Yet when I thought of fate, Arikha seemed a distant figure, as if reduced in scale by a diminishing glass; and it occurred to me that his pride in *not* submitting to fate (in proving, even as a child in captivity, that he was a doer, a creator, and not a victim of history) had probably been secured only at the cost of continual propitiation. His entire ethic of painting, whatever else it was, seemed essentially propitiatory, though just what inner voice-what "deity"-was being appeased I could not directly say. In his roles as dervish, pilgrim, prophet, and kvetch, Arikha followed a draconian code; what distinguished his way of painting was not so much his sincerity (there are, after all, other sincere practitioners around, good, bad, and indifferent) as his need to finish every picture on the day it is started. For a painter to abandon the possibility of working further—to discard tomorrow, so to speak is to renounce a vital support in life; it's like throwing away one's shoes. But imagine for a moment what it would be like to go about all your business in your stocking feet—the sheer, giddy audacity of it. I supposed that Arikha felt much the same way as he coped with his selfimposed handicap. Somehow, paradoxically, it set him free.

Dungeon Masters

R. B. Kitaj, Leon Kossoff, and Others

In the fall of 1989 R. B. Kitaj was recovering from a heart attack, and had yet to work out a form of sociability that would suit his new predicament. Should he brush off inquiries about his health, snubbing concern and thwarting compassion? Or should he offer the boring, medically complicated, and inevitably plaintive replies that a lot of people wouldn't have the patience to hear? His plight, after all, was perfectly ordinary: for years engrossed in the subtler sort of pains and perplexities, he had suddenly been obliged to confront the brute imperatives of survival. This simplification was summary and bewildering, and since the heart attack he had become rather quiet, refraining from those intense conversations about art and culture on which he had formerly thrived.

Fifteen years earlier Kitaj had coined the expression "School of London," which ended up confusing a great many people. The occasion was a show titled "The Human Clay," which he organized at the behest of the Arts Council of Great Britain for a public gallery in London. In considering this commission he informed the council that he felt himself "a poor judge of abstraction" and so would prefer to limit his selection to pictures of people; he then composed a catalogue

essay that briefly set forth what he regarded as the enduring claims of figurative art. The show itself gave rise to a number of disputes. There were the predictable complaints about who had or hadn't been included, and the understandable reservations about whether figure drawing should be accorded so central a place in the artistic life of the capital. The chief bone of contention, however, was over the "school" that Kitaj had assembled in his essay—a personal selection of artists who had chosen to live in the city—and almost at once his coinage was subjected to a barrage of semantic quibbling which has not ceased to this day. Wearisome debating points abounded. Did all the members of the School of London have to represent a similar philosophy? Was the School of London a rival to the New York School, or the principal heir to the School of Paris? Did it advocate, like the schools of the Italian Renaissance, some particular sort of coloring or composition? And what about David Hockney, a Londoner who now spent most of his time in California, or Kitaj himself, who was so deeply American that almost no trace of a local accent could be detected in his work? Were they true members of the School of London? The continuing controversy left Kitaj in a state of bemused frustration. "To my way of thinking," he once told me, "any city that has a number of serious artists working in it at the same time may be said to have a 'school'—it's just that most of these schools don't attract notice."

All the arguments about the so-called School of London and its putative members load the dice: they depend on one's definition of the term. Yet most of the more eminent painters of the older generation do share certain circumstances and habits of thought. The art life of London is a matter not only of achievements and failures but also of attachments and habits, of hatreds and vices, of contagious obsessions and public-house fiefdoms. Where things are—the geography of art—can be as important as what they are. Colleagues live separated by daunting distances, in a far-flung accretion of urban villages so dissimilar and introverted that they had no common electrical current until well within living memory. Chelsea, Hampstead, Camden Town, Islington, Bloomsbury, Whitechapel and the East End, Soho and its onetime northern extension, Fitzrovia—each name offers a distinct bouquet of artistic associations. It may be that to speak of a central

DUNGEON MASTERS

group of London artists is to knuckle under to journalistic oversimplification, to capitulate to just the sort of boosterism that these artists themselves despise (or affect to despise). There is little difference, though, between the perception of influence and influence itself, and in this sense a few painters remain paramount. With Hockney gone, Francis Bacon reigns, the dirty granddad of British art; Lucian Freud has acquired a reputation as our time's foremost observer of the human countenance; Frank Auerbach, Leon Kossoff, Michael Andrews, and Howard Hodgkin have all won considerable attention for achieving some sort of personal expression within the traditional medium of paint on canvas or panel.

These artists have a long and complex history of acquaintanceship. One's eyes linger over the famous photograph of Bacon, Freud, Auerbach, and Andrews drinking champagne at Wheeler's, in Soho. They look like mates on a spree, but it seems that the shot was contrived and they did not compose a cohesive social set. Nowadays, these old acquaintances seem to be travelling steadily away from one another, like galaxies in the cosmos. Though they never congregate, they all keep in touch with certain people (one of them is Catherine Lampert, the director of the Whitechapel Art Gallery), and a few old ties have remained unbroken. Freud no longer sees Bacon, but Auerbach does see Freud; Kossoff, who went to art school with Auerbach, still cherishes a great admiration for his old comrade, though he has tired of the fruitless comparisons that people are always making between their very different kinds of work. A good book remains to be written about the London world of painting since 1945; its author would have to be some snoop in his seventies who never missed a party in his life. This imaginary chronicler would have to take into account the change in British sexual mores after the war, and the resultant emergence of homosexual culture heroes, like Bacon and John Minton. He would have to explain the persistence of an archaic bohemian outlook, the often squalid living conditions, and the contempt, real or feigned, for self-promotion, journalism, and vogue. He would have to clarify the territorial impulse—the way proprietary sentiment condenses around St. Paul's, or the docklands, or the obelisk at Mornington Crescent and he would have to tell us why it is that the cult of pourriture noble,

or noble rot (grapes bursting on the vine, pheasants going high, titled belles in the spoilage of middle age), still has such a firm grip on certain imaginations. He would also have to point out that the ranks of the London painters are ruled over not by living people but by a few paintings in public collections whose authority no one gainsays. Such pictures—among them the Poussins and Titians in the National Gallery—exert an almost talismanic attraction: there is a general belief in the spiritual power of flesh painting, a sense that any new finding about the figurative potential of oil paint is also a finding about flesh, about life.

Kitaj, the American, stands a little outside this milieu both in the nature of his painting, which has been more open to the winds of Paris and New York, and in his social position, which is that of the selfappointed guide. Like the dragoman waiting by the tourist steamer, he will take you to whatever you want to see, though always along the route that suits his own idiosyncratic purposes. He also likes to write and receive letters, and that autumn of 1989, when I often saw him in Chelsea, we would exchange wads of foolscap; he thought it perfectly natural to correspond with someone in the same city, or even in the next room. Some of his letters were very long, and I found myself rereading them as I rode around on the tube, scanning his tight handwriting for clues to his mood whenever I approached his stop. An excitable correspondent, Kitaj has a way of reaching for stylistic effects; yet his prose, like his accent, would be quite at home in Cleveland, Ohio, where he grew up. In a way, he isn't a Londoner. After years of living in Europe, he has never come to feel much at home anywhere, only a little more at home everywhere. He misses his friends, who are scattered all over, and he calls them often. He is planning to move away and planning to stay put.

"Un-at-homeness and assimilation don't marry too well," he confided in one of his letters. "The mixture has been explosive for me and my poor pictures. . . . I do like to watch people who are un-athome. Is that not a possible subject or trait in pictures as in people? I don't leave London easily, nor do I stay here with any ease. . . . Bacon lives near me, and Freud not far away, and, yes, I feel the spirit, in my neck of London, of those American ghosts—Whistler, Sargent,

DUNGEON MASTERS

James, Pound. Just before I arrived in England . . . I read Will Rothenstein's *Men and Memories*, a very good chronicle of English art life, and I live in a sea of those blue plaques in my very streets—Turner, Whistler, Tonks, John, Steer, and all the others. Even Sickert opened his first art school in Chelsea, with Whistler as patron. But no, I don't feel safe anywhere . . . maybe a *little* here"—"here" meant a table in his favorite café—"where I'm writing you."

I asked him once why he continued to live in England.

"Live in England?" he replied. "I haven't lived in the real England since I had a house in Dulwich Village. Then I had real English neighbors and my children went to real English schools. Now I don't know where I live, I really don't. I do like to work by the London light, though I'm not sure that explains anything. But I will admit that there is something in the air here. Bacon has been painting in the same room for over thirty years—a room so tiny it would fit in Julian Schnabel's bathroom. Freud and Kossoff and Auerbach have been in the same small rooms for years, working and working, rarely stopping. Auerbach's studio looks like a dungeon, with that one barred window way up near the ceiling. They hardly ever leave London—I don't think they often cross London. "I have come to think—though with certain reservations—that the real divide in art is between mainstream artists and marginal artists, and that the mainstream has nothing to do with modernism or any other ism, but simply with paint. If it is true, as some people say, that any habit can become addictive, then the greatest of all addictions is to paint itself—to its colors, its consistencies, its smells, its drying times. The real mainstream painters may very well be the ones like Auerbach and Kossoff and Freud, who have completely given in to their addiction, who paint only in order to paint some more. I've lost that addiction myself. I used to have it, but I've lost it."

Kitaj is a man of middle height, fifty-eight years old, with a shock of nearly white hair, and high, almost Asiatic, cheekbones. His original name was Ronald Brooks; when he was nine, his mother married Dr. Walter Kitaj, a research chemist and a refugee from Hitler's Vienna. Before coming to London, in 1959, the younger Kitaj had been a seaman and a soldier, and had studied art in New York, Vienna, and Oxford. A thoroughly assimilated Jew, he took no great

interest in his ethnic background until about 1970, but since then he has proclaimed himself a specifically Jewish artist, and his pictures have been tenanted by increasing numbers of Jewish refugees. In one large painting, now in the Tate, the artist has represented himself in a dream, recumbent before the entrance to Cecil Court; his brush has transformed this well-known alley of booksellers into a sort of émigré theatre, presided over by the late Mr. Seligman, an antiquarian bookseller of Central European extraction. Such displaced persons seem to embody the displacement of Kitaj's own thoughts, which range restlessly over London and the whole Western world, mixing up politics and baseball with countless spectres from old French and Italian art.

Kitai first attracted notice in New York in the sixties, when Alfred H. Barr, Jr., bought a big canvas of his for the Museum of Modern Art, and his current way of working is still recognizably related to the loose, subjective manner embodied in that picture. He uses collage and free association to coax his feelings into imagery, but he also defines that imagery with a brand of strong contour drawing that harks back to the Quattrocento. Over the years, both his wife, Sandra Fisher, who is a painter and an accomplished draftsman, and his close friend David Hockney have encouraged him to pursue his interest in figure drawing, at which he has come to excel. He is also an avid reader and bibliophile: he lives surrounded by tall bookshelves lined with volumes on art, iconography, literature, and philosophy, and he has developed a gaudily argumentative writing style of his own. He writes to defend life drawing, to champion artists whose work he likes, and also to explain, if that is possible, the "integrally Jewish" imagery of his own pictures. He likes to say that there are "moments where words flourish as secret agents for painting," an idea that offends those purists who believe that artists should refrain from interpreting their finished work; in reply, he will devote page upon page to a species of rambling and morbidly sensitive self-vindication. At times, he seems to be ambivalent about the very fact that his thoughts are private and inaudible: he is sociable to the marrow, and if he has an idea, he wants the world's reaction to it, though when the reaction comes and is perhaps less than welcoming he may be profoundly distressed.

DUNGEON MASTERS

Kitaj's painting has always looked unmistakably his, and perhaps out of the sheer abundance of his originality a spring of admiration flows: he plumps unstintingly for his colleagues' work. Some painters are grateful for his support, while others are merely embarrassed, but all agree that he is genuinely trying to be helpful. It is extraordinary how he refuses to permit anyone in his presence to criticize a painter whom he likes: this seems to pain or alarm him so much that he breaks in before the would-be critic can finish airing his opinion. Of course, one can read such advocacy as a form of patronization, just as one can read it as a plea for mutual aid, or as an attempt to turn London art society into an admiration bee. But at bottom it is probably just plain old Midwestern generosity, a sentiment that the English commonly fail to recognize.

During the autumn of 1989, when Kitaj was recovering from his heart attack, I would poke every now and then into a café he frequented in the Fulham Road, near Onslow Square, to see how he was doing. The café had Muzak, cane chairs, tables with plastic tops, ceiling fans, a framed glass advertisement for Dunville's, a neon Schlitz sign. It was a café like many the world over—not a home away from home but a place where anyone from anywhere could feel perfectly rootless and disoriented. In one corner was a blackboard scrawled with the day's specials, and under this board Kitaj could often be found, scribbling away on a yellow pad or sketching the other customers—"observing the un-at-home," as he might put it. Each time as I sat down I would tell him, quite truthfully, that he was looking a little better.

"Better? I feel finished," he would invariably reply. "Jesus, how can you say I look better? I don't understand how you can say a thing like that." But even as he spoke his face would brighten, and he would look up with those strange eyes of his, which seemed to have pupils like mismatched buttons, one slightly smaller than the other—the effect of dissimilar eyeglass lenses. Then he would slump back into a forlorn posture and work very slowly at his food. Having lost a lot of weight, as his doctors had ordered, he was swimming in the clothes of a former self, and was to all intents and purposes tethered to the Royal Brompton Hospital, a few blocks away, where he went for checkups. A strict regimen of exercise had set him circling through Chelsea several times

daily, strengthening his heart tissue, building up his stamina, hoping to shake off a terrible despondency.

"I am going to retire," he announced to me one day over a plate of chicken salad. He seemed pleased to have hit on the idea. "Most people think that painters never retire, but some actually have, you know. And I'm not talking about some fifth-rate schmearers, either. La Tour retired, Cuyp retired, so why shouldn't I? I'm lost, I'm dead already, and what I should do, really, is to hand on my wife to somebody else, the way what's his name, that musician, bequeathed his wife to that other musician. But here I go complaining again. Don't listen. I always blot my copybook, as the English say." For a moment his voice sank beneath the Muzak. Why, he murmured—he was always brooding on this-did so many people reject his interpretations of his pictures? Why did they reject even the idea that he was entitled to offer such interpretations? Carefully, point by point, he explained to me the intentions behind his more recent paintings, until it began to seem that his sheer refusal to let go of them was the real content of his mental efforts.

One afternoon, after lunch in his café, we decided to run an errand or two in the neighborhood. Kitaj's part of Chelsea lies between the Thames and South Kensington Station, and whenever we went walking there we'd forget why we'd ever started out. The place itself (or was it the warm autumn light?) induced a sort of dreamy dislocation. We would wander in the shadow of cornices and crowstepped gables, trying to hold a course through what seemed a vast, scrambled atlas of ornament, until gradually our errands slipped our minds. The cafés, pubs, and bookshops, the bending streets that closed off any view of what lay behind or ahead—these seemed a way of saying that distraction itself might be the best reason for being there. The rows of identical Victorian façades resembled vertical moraines or upended brickfields, each one a jaunty tryout of some historicizing style; it was as if times and places were being whimsically whisked about.

We walked until we came to a handsome house in The Vale; it was empty, in the process of redecoration. The brickwork was nicely repointed and, to judge by its various colors, had recently been repaired. In front was a moss-covered annex that must once have been used as a

DUNGEON MASTERS

studio, since its roof had a large skylight. "This is where Walter Sickert had his first school in London," Kitaj said. The soft sunlight played over the gardens that lay between Sickert's schoolhouse and the backs of the white terrace houses on Elm Park Road. Farther on, a round blue plaque announced, "This House Was Built for Augustus John." The little structure—a virtual cottage—had three dormer windows and a big chimney. Opposite was the house of A. A. Milne. "What's the name of this street, anyway?" Kitaj asked, looking about in a daze, though we were two blocks from his own house, where he had lived for twenty years.

Continuing our circuit, we passed a corner building with its angle sheared off, Paris-style, so that a narrow façade looked out obliquely onto the crossing. The little façade had one big window on the ground floor and one up above. A moat guarded by a high iron fence ran along the house. "Bacon had that once," Kitaj said, pointing toward a small studio just discernible inside the house. "Bacon used to acquire rooms, the way Sickert did. Sickert would get a room somewhere to put his etching press in, and then a room in some other street for painting the model, and then a third room in a square in some other part of town for doing something else—maybe near one of those music halls he was always sketching. Bacon would take rooms here and there, too, but, unlike Sickert, he'd never actually use them, and they'd just stand empty."

We passed the house of William De Morgan, the Victorian ceramics man and novelist, which had a studio window in a notch between two squat towers. We passed the long white modern house that the German architect Erich Mendelsohn built for himself when he came to Britain in the thirties. We crossed the Fulham Road and then the Old Brompton Road. "Here, on this corner, is where I usually run into Bacon," Kitaj said. "At the age of eighty, he dresses as if he were going to a leather bar." We turned into a mews that looked newly spiffed up. "Bacon's door is open, so we won't go in," he said.

"Why not, if it's open?"

"It means he's working."

We continued walking, and after a long silence Kitaj said, "There used to be wonderful brothel life around here, but soon after I

arrived, in the fifties, they passed the Street Offenses Act. Before that, I knew some marvelous whores here. Down that street, I think—yes, *way* down that street—there was a wonderful whore I used to visit pretty often."

I looked down the street and saw nothing but shadows falling across it, marking it off into the distance.

"One day I called that whore up," said Kitaj in a furry voice, "and her maid answered the phone. She said, 'Denise has retired,' and it was like a blow to my stomach."

Once a place of rooming houses and crotchety old souls, Kitaj's borough of leafy streets and quite gardens was by now an exclusive precinct. Most secretive of all were its great squares, with their full-crowned chestnuts and limes. Screened by hedges and low-springing boughs, and protected by tall, spiked grilles, they formed shadowy pastoral islets within the stream of the traffic. Sometimes, walking by one of these squares in a sunny spell between showers, we would catch sight of a keyholder in the exercise of his proprietary right. Slipping through a gate in the grille, the keyholder would lock it carefully behind him and disappear into the dripping glade. In a way, I began to think, the painters of London were like those keyholders, for each was ensconced in a place where no one could follow.

Until around forty years ago, there was something oxymoronic, even to many British people, about the idea of a British pictorial art. As a distinct phenomenon, it came about very late, in the Georgian period, when a world of surpassing loveliness was already in place in the British Isles. This world consisted of architecture, furnishings, interior design, bookwork, and species of idyllic landscape, deeply impregnated with human thought, that Wordsworth's phrase "the spiritual music of the hill" perfectly describes. Most English art simply illustrates this realm, instead of embodying truths of its own, but some of it has great charm. The English understood Arcadia and its uses, both ideal and material; they reinvented the portrait, as they had reinvented biography; and they saw that animals were a suitable subject for high art. The problem was that each of these fascinations brought with it a certain peril. Portraiture, for example, which sprang from the British sense of the uniqueness of the individual, gave rise to a

DUNGEON MASTERS

kind of radiative pictorial arrangement in which nothing but a single head might be of interest, and the British hypersensitivity to nature all but precluded that power of generalization, of willed abstract design, which had carried French art to predominance. Whereas the Frenchman, in Bonnard's phrase, was "heavily armed against nature," the Englishman often became a mere conduit for it. Yet the best English art always transcended these limitations, and in our own century the whole issue has been redefined by the internationalization of art. A large rôle has been played by London's increasingly cosmopolitan composition: it is significant that the two artists chiefly responsible for introducing Continental painting ideas into Britain—Walter Sickert and David Bomberg—were both of foreign origin (respectively, Danish and Galician-Jewish).

What has come about in London since the war, however, is not really a variant of European modernism, and much of it remains profoundly alien to Americans brought up in the appreciation of classic Parisian art. London is a place of extreme privacy, and something of this has rubbed off on the local artists, who are often reserved, and even secretive. Whereas New York artists usually seem ready to assassinate their grandmothers to attract attention, their London counterparts tend to dodge the limelight and to regard even the briefest meeting with a client, curator, admirer, well-disposed journalist, or potential benefactor as a miserable penance. What the principal interpreter of contemporary English painting, Sir Lawrence Gowing, has written of Lucian Freud's working method might be applied to the practice of many others as well: that it has the character of a solitary and ravenous appetite. Subjects tend to be very personal, and as jealously possessed as a lover; high style is suspect, as if it were a form of vanity; good paintings are assumed to be the rarest of things, invariably rescued by their makers from the jaws of failure; and self-confinement in a tiny cell, perhaps before a single, compulsively reworked canvas, is a routine mode of existence. There is a high-minded crankiness to the whole mentality.

This curious hair-shirt ethic derives in part from the remarkable example of David Bomberg: if there is such a thing as a London School, he would have to be seen as one of its precursors. Bomberg was not

a great painter, but he was, as Kitaj once remarked to me, "the last major artist, or the last one we know of, to work in relative obscurity." Bomberg died in poverty, in St. Thomas's Hospital, in 1957; the neglect that he endured makes the saddest and most controversial story in the annals of modern British art. In his youth, before the First World War, Bomberg was a leading light of the London avant-garde, but he found scant support in his last thirty years. Reappraisal began almost immediately after his death, and has since acquired increased cultural weight. As a teacher at Borough Polytechnic, a public college in South London, from 1945 to 1953, Bomberg encouraged several artists who later rose to prominence, including Leon Kossoff and Frank Auerbach, and since he himself studied with Walter Sickert he can be seen as a link in a pedagogic chain stretching back to Sickert's teacher James McNeill Whistler and to Whistler's own master, Courbet.

The general public knew little of Bomberg's life until 1987, when Richard Cork published his monumental biography, David Bomberg. Cork is The Listener's art critic and one of England's most gifted historians of modern art, and if his huge book only demonstrates in the end that Bomberg was an interesting but distinctly minor painter, his scholarship has nonetheless rescued a fascinating career from oblivion. Cork relates, among many other details, the story of how Bomberg, then a seventeen-year-old printer's apprentice from the East End, was discovered, in the Victoria and Albert Museum, by none other than John Singer Sargent. Bomberg was working on a drawing in the museum's cast court—which, with its crowding of unrelated plaster reproductions, was the perfect venue for this improbable encounter when Sargent happened by, on his way out from the restaurant. He stopped to admire Bomberg's effort, and as Bomberg appeared to be powerfully built Sargent later invited him to pose in his Fulham Road studio. There, during several sessions, Bomberg was able to observe an accomplished draftsman at work, but he also soon realized that Sargent's current project was defectively imagined—"a very ill-conceived emulation of the Florentine" was how he later put it.

With the assistance of a Jewish educational fund, Bomberg began attending the Slade, London University's art school. He also joined Sickert's classes, and Cork notes that it was probably from this genial

mentor that he learned to disdain visual clichés, and to seek his subject matter in the rowdy social centers of popular London. As he began to explore the art world, he made friends with some of the most brilliant talents of the day, among them the poet Isaac Rosenberg and the painter Mark Gertler, both East End boys like him. He also met the painter and writer Wyndham Lewis, with whom he maintained a tense but mutually beneficial connection.

Bomberg was a man of total integrity and fierce candor. He was also one of those people whose names enact their characters: a friend of his youth, Joseph Leftwich, once described him as "very 'blasty'-'pugnacious' is too mild a word," and added, "He wanted to dynamite the whole of English painting." Brought up in the overcrowded Jewish slum of Whitechapel, Bomberg felt a deep kinship with the scruffy world of popular democracy, the old London of cold-water flats and smoke-palled streets, and to many his views on the relation between life drawing and liberal society have come to seem vitally relevant. For Bomberg, life drawing entailed a kind of faith or abandon; he taught primarily by example, searching, with his clumsy dark line, for what he called "the spirit in the mass." In a number of tracts, still largely unpublished, he used an exalted Blakean rhetoric to stress the centrality of life drawing to art and to democracy: he sensed that a man before a drawing board is in some ways like a man at the polls—equal at that moment to all others, free of the weight of authority and money, and without audience. He believed that the fate of life drawing was linked to that of a free citizenry, for "drawing demands freedom" and "good draughtsmanship is Democracy's visual sign."

It took many years of labor, however, for Bomberg to gain his singular insights; his early work reveals a somewhat contradictory temperament. Despite his exceptional powers of realistic observation, he was attracted to the rather naïve machine aesthetic represented by Wyndham Lewis and the Vorticists, and he visited Picasso in Paris, though he never really comprehended the nature of Cubism. While executing elegant illustrations and strong modernist pictures, he discovered what became his only truly personal theme—the labyrinth. His imagination was essentially architectural; if the figure played a meaningful role in his paintings, it was largely as a sort of Meccano

contraption lurching about in the vast maze of the metropolis. At first, like the Futurists, he revelled in the dynamism of modern life; and in such pictures as *Jewish Theatre*, *In the Hold*, and *The Mud Bath*—all based on East End sights—he reduced his characters to a tangle of shafts and arcs that boldly "scythe" (to use Cork's metaphor) across the canvas.

But Bomberg's participation in the mechanical mowing down of soldiers at the Western Front radically changed his views about man, art, and nature: in 1915, he enlisted in the Royal Engineers and was sent to fight in Flanders, where he rapidly sank into a depression. Trench warfare filled him with a terrible dread. Like many of the young men one encounters in the memoirs of the period, Bomberg came to feel that the carnage served no earthly purpose and would probably go on forever. At one point, he shot himself in the foot and defiantly proclaimed this deed to a superior officer; for this he could have been executed, but self-inflicted wounds had become so common at the front that the officer merely docked his pay for a few weeks.

Bomberg saw the war as the first attempted suicide of mankind; the role played by technology distressed him deeply, and it also contributed to his loss of interest in the sort of chugging imagery, full of moving parts and machine-looking edges, that had characterized his earlier pictures. For a while, his direction seemed uncertain, and he would probably have found little patronage if a painter friend, Muirhead Bone, had not suggested that he apply to the Zionist Organization for support in painting a set of pictures depicting the fledgling Jewish homeland. Bomberg was not a Zionist—his experience at the front had disabused him of any faith he might have had in the value of nationalism-but the idea of a long sojourn in Palestine, where the sunlight would be strong and the architecture vaguely Cubistic, appealed to his artistic instincts. He arrived there in 1923, and had the good fortune to find a notable patron in Sir Ronald Storrs, the military governor of Jerusalem. Storrs was a highly cultivated and engaging man, a holdover from an earlier era in his antiquarian and preservationist sentiments, and he devoted unsparing efforts toward the restoration of Jerusalem as a city of architectural beauty and civilized piety. Storrs wanted old-fashioned topographical paintings that would

record his restoration of Jerusalem; in his view, it would be Bomberg's task to "walk about Zion and go round about her: and tell the towers thereof." Bomberg was a modern artist, and the production of glorified architectural renderings was not at all in his line, yet almost at once his aesthetic self took on a waxy pliancy in the hands of the amiable Storrs.

In the Palestine pictures he ricocheted between a fairly conventional sort of view painting and a more expressive treatment of space and atmosphere. Anticipating some of the most venturesome representational work of the nineteen-fifties, he found that remarkably broad and loose paint patches sitting on the canvas weave could account for perceived structure and atmosphere while frankly declaring their own physical presence. In the sweeping Mediterranean townscape he also rediscovered the theme of the labyrinth, his standing obsession. Jerusalem appears in his canvases as an inhabited ruin, an elaborate system of oubliettes, and a reminder, in its multiplicity of boxy shapes, that the things man has made are beyond reckoning. There is something parched and desertlike about this imagery, yet also something English in the calm enumeration of roofs and windows and towers. Some of the bolder paintings look almost like geometrical puzzles, but the Capitoline accent of a dome against the horizon—usually that of the Muristan or the Church of the Holy Sepulchre—tells us that some points of the compass are sacred, that here there is more than color and form, there are also angels and djinn. This vision of the Holy Land delighted Storrs, who later, in his memoirs, wrote excitedly of Bomberg's "cosmic stare."

In rural Spain between 1929 and 1933, Bomberg discovered that intricate human nesting patterns could reflect the romantic past. Playing on the British tradition of the tourist landscape, he managed to convey encyclopedic amounts of geographical information while putting oil paint through a new set of expressive paces. Yet these glaring, hypnotic pictures attracted little favor back in England, and he fell into such despondency that he produced no paintings at all between 1938 and 1941. He hit a low point in 1939, when the newly formed War Artists' Advisory Committee rejected his job application. Three years later, however, the committee relented and the virtually destitute

painter was dispatched to Burton-on-Trent to execute a set of pictures of an underground munitions magazine situated nearby.

Serving as a London fire watcher during the Blitz, Bomberg wandered hawk-eyed amid the shattered buildings and smoldering cinders of the City. It was here, in the late seventeenth century, after the Great Fire, that Christopher Wren and his associates labored to build a "New Jerusalem," a precinct of Christian prayer on British soil, and the sight of St. Paul's rising over the devastation must have reminded Bomberg of the domes of Jerusalem itself. In a series of charcoal sketches that he made of St. Paul's and the City, which are possibly the most original British drawings of our century, the labyrinth motif reappears with a ghastly beauty. One of the best of these drawings hangs in the Imperial War Museum: it shows what can only be called a London bombed into abstraction.

When written surveys of contemporary British art appeared after the war, Bomberg did not figure in them, and he was miserably represented in a 1956 Vorticism show at the Tate. Various explanations have been offered. Had his visual ideas, as seems most likely, been simply too advanced for his audience? Had he put too much faith in his versatility and shifted styles too often, so that many otherwise welldisposed people couldn't figure out who he was? Had he painted too exuberantly in a culture that preferred a certain muffled reserve, so that, despite his adherence to representation, his work looked brash and foreign? He was certainly abrasive to picture merchants, and fearlessly blunt in the expression of his preferences. His East End manner was particularly offensive to people who were prejudiced against Jews, and he applied unsuccessfully for scores of jobs, including many for which he was thoroughly unfitted in the first place. Worst of all, he was plagued by doubts, and would stop painting for several years running, so that even dealers who admired him might well have wondered whether he could reliably provide them with product. At last, worn out by struggle and defeat, he died-and became famous. In 1958, the Arts Council Gallery put on an exhibition of his work, accompanied by a catalogue with an essay by Andrew Forge, and in 1967 the Tate mounted an even larger retrospective, whose catalogue contained a ringing defense of his achievement by David Sylvester. In 1987, Rich-

ard Cork published his biography, and a full-scale Bomberg retrospective, arranged by Cork, came to the Tate the following year.

Across the street from Christ Church, off Commercial Street in the East End, is an old pub called the Ten Bells, with a highly ornate entrance—a big lamp, fussy ironwork, pilasters encrusted with gilded masks. Inside, one afternoon, amid a jungle of Victorian tiles and a display of framed photographs relating to Jack the Ripper, Leon Kossoff—a short, dark-eyed, sallow-complexioned man—sat on a red banquette and talked to me about his painting. A few days before meeting him, I had seen, in the basement of the Tate, a picture of his that had fascinated me. This painting shows a huge public swimming pool near Willesden, in North London, where he has lived since 1970. Scores of children frolic about, brushed in with a kind of painterly shorthand suggesting that a single glance has somehow caught the future of an entire democratic population.

I believe I'm not alone in thinking that Kossoff's paint handling often has a childlike quality. As in many early modern figure pictures, his imagery grows clumsy or contorted under the pressure of emotions that leave no time for measured delineation, and fresh impulses keep forcing him to restate his shapes. If he has not achieved what he wants by the end of a painting session, he'll scrape down the whole picture and reëxecute it on the next working day. Painting largely from memory, he sets up an implicit analogy between the visual recovery of something recently seen and the redemption of past time, and what his turbulent images forfeit in verisimilitude they make up for in poetic density. Kossoff's work isn't hard to understand-in fact, it's rather old-fashioned—but quite a few London viewers are disconcerted by it. They seem to look *into* his pictures, to see whether the objects there are substantially like the objects in the world; but if one glances slowly across his surfaces one begins to see things of greater significance. One notes the struggle of impulse against counter-impulse, the survival of awkward yet expressive passages, the bluntly carven quality of the handling, the grotesquerie.

It was a brilliant Indian-summer day, and Kossoff had just been drawing Christ Church for about three hours. He grew up in the East

End, in Bethnal Green, and as a boy he trudged up and down Commercial Street almost every day, often stopping to look up at the great church; later, as a grownup, he twice tried to paint it. Neither of those attempts succeeded, and he came to the conclusion that certain motifs had to age in his mind—had to acquire a patina of remembrance before he could tackle them with any hope of success. At last, the right moment had arrived, and more and more Christ Church paintings were springing to life in his studio. He felt that the building itself was strange, a little tortured, especially when seen from the rear. For him it was a repository not only of visual sensations but also of uneasy memories. It was probably these, he explained, that had welled up during his earlier attempts to draw the church, almost physically staying his hand; though it was also possible, he added, with a concessive smile, that he might simply have botched the execution, proved unequal to the task of fitting "all that"—his hands sketched a tall churchly presence in the air—onto his sheet of paper. As he talked on, he grew fantastically careful with his phrases; sometimes he inclined his head and rested it in the palm of his hand, half muzzling his speech; at the other moments, gesturing with the same hand, he would hide his mouth as if to repent of something he had just said. It was an English gesture, deeply reticent, foreign to an American.

"You work not because you know but because you don't know," he said. "Every day, I get up knowing I can't draw and hoping that this day I'll learn."

I protested that there were different ways of knowing how to draw, but he waved my objection aside. He wasn't voicing some rarefied, philosophical conception of drawing, he insisted, and he wasn't denigrating his abilities; he was just making a brute statement of fact. As a student, he had never shown the slightest facility—he had even failed the Government Art Schools' drawing examination—and every one of his drawings, whatever else it might be, was a coming to terms with the unyielding truth that he just did not know how to do it. Color, too, was a mystery to him. "I just start off with the most obvious local colors," he said. "Whatever will do—like pale yellow for the church, or pink for a person's face. What I'm trying to do is to draw with the color—to get the drawing right." All his paint marks were really a hunting for the

right drawing, which he discovered not at the beginning of a picture, as other painters might, but at the end, in the last few hours; there was no conscious construction to anything he did—it was all a succession of "crises," of constant reseeings of the subject. As he explained that these crises were fraught with intense anxiety and totally devoid of any romantic exhilaration, I recalled that in previous communications with me he had described his work as undergoing an "upheaval." Possibly he lived in a permanent upheaval, though his appearance fell short of the seismic. His clothes were nondescript—neither painters' duds nor mufti-and his gestures were inscribed within an arc of restraint. He had the slope shoulders, the disabused air, and the obliging manner of an old-time London tradesman, and his dark-circled eyes emanated a sort of oysterish resignation. He clearly had no desire to talk to a journalist; he seemed indeed to regard all interest in his work as a dangerous blandishment, a poisoned chalice. Once, when I had announced myself on the phone, he had replied, "Oh, hello, I'm sorry," and then repeated "I'm sorry" in a fainter voice, and then he had hung up.

We decided to go out and sit in the Christ Church close. The church, built in the early eighteenth century to drawings by Nicholas Hawksmoor, is generally regarded as a masterpiece of the Baroque. Its steeple, faced in white Portland stone, rises serenely into the rushing London sky; by a trick of design, large parts of it seem to have been scalloped out, and its curious concave bays enforce a remarkable sense of weightless monumentality. One thing seems to menace the church, and that is the encroachment of high rises. From in front of the building we could see Broadgate, a huge business complex then under construction both beside and directly over Liverpool Street Station; it was the largest building site in London after Canary Wharf, in the docklands. Like Christ Church, Broadgate is largely a composition in curves, but in much of its design and detailing, its postmodernist stairways and balusters and lamps, it lapses into slick, movie-palace elegance. It looms over the entire East End-all those half-repaired roads, all that Urdu graffiti—like a tantalizing, unfulfillable promise.

Half a dozen derelicts were sharing a bottle in the garbage-strewn area in front of Christ Church. The close turned out to be locked,

and Kossoff suggested that we try the grounds of St. Matthew's, nearer the heart of Bethnal Green. As we started off, he confessed to despising the Broadgate development. It wasn't so much a matter of its parvenu architecture or of its belittling of the East End as of its raw physical threat. Buildings like Christ Church and St. Anne Limehouse, Hawksmoor's other great church in the eastern part of London, needed space around them for their lines to be seen. It wasn't enough just to let them be: look at what had happened to Wren's City churches, which had survived the depredations of the Luftwaffe only to be dwarfed by office buildings and tower blocks. In fact, Kossoff said, his feelings of urgency about painting the church had to do not only with the persistence of memory and with his own aging but also with the doom—the callous entombment—that almost certainly awaited Hawksmoor's creation.

Kossoff was born off the City Road, which starts behind Liverpool Street Station and curves miles north to Angel Centre, in Finsbury. His parents had emigrated from Kiev. His father, who for some years worked as a baker's deliveryman, eventually owned a small chain of bakeries in the northeastern borough of Hackney. The household was dominated by the stern demands of the trade—the early rising, the unrelenting hours—and the young Kossoff was viewed as the heir to his parents' productive way of life, though by the age of twelve he was spending a good deal of time drawing. Between 1945 and 1949, he did his military service, which included tours of duty in several European countries, and after demobilization he entered St. Martin's School of Art. This was clearly an act of rebellion against his father's wishes, and I gathered from Kossoff's conversation that his parents were upset by his decision to stray so far from the path they had beaten. At St. Martin's, Kossoff became friends with Frank Auerbach, who, like him, was Jewish but of a wholly different background: the child of a wealthy Berlin family that was later annihilated by the Nazis, he had been sent to Britain at the age of eight and educated at a Quaker boarding school. Auerbach, five years younger than Kossoff, was also enrolled as a student in David Bomberg's evening class at Borough Polytechnic, and he persuaded Kossoff to join him there. Kossoff remained in the class for two years, while continuing his studies at St. Martin's,

and then put in three years at the Royal College of Art. In those days, Auerbach and Kossoff often posed for each other, and their common use of a heavy impasto—their reliance on painterly "attack" as a means of slamming the image across the surface of the panel—has caused them to be flippantly conjoined in the chatter of the London world of painting.

Kossoff had his first one-man show in 1957, at the Beaux Arts Gallery, a major showcase of London talent. (The gallery was run by the painter Helen Lessore, who was Walter Sickert's sister-in-law.) By then, he had fastened on many of the subjects that still preoccupy him—views of the northern and eastern inner suburbs, demolition and building sites, street and crowd scenes, railway cuts and junctions, his parents, his wife, his two brothers. He also did a series of studies of St. Paul's—the same Capitoline theme that had fascinated Bomberg—and later came an interest in the children's swimming pool near Willesden. Kossoff's imagery evokes the populist atmosphere of much twentieth-century British art: looking at his cityscapes, one can almost smell the steam of marshalling yards and the lime's breath of cellars and alleys in winter.

Heading now toward Bethnal Green, we passed between the famous rows of Queen Anne houses in Fournier Street, formerly dilapidated and currently in the process of gentrification; at the end of the block was the local mosque, the Jamme Masjid, housed in a Georgian building that bore the faded inscription "1773 UMBRA SUMUS" high in its wall, over a faded sundial. Around the corner, in Brick Lane, men were pouring out of the mosque—swarthy, paunchy fellows, many of them elderly, with tufts of white hair flying out from under their white knit skullcaps.

First the Huguenots, then the Jews, and now the Asians—all had come directly from debarkation to the slum of Brick Lane. During Kossoff's childhood, an enormous number of impoverished Jewish immigrants—perhaps as many as a hundred thousand—lived in the area; they were mostly survivors (or descendants of survivors) of the Russian pogroms of the period between 1881 and 1914. (In 1914, Bomberg had painted a famous picture of the bathhouse here.) Kossoff spoke of the overcrowded Brick Lane of the Depression era with

a sort of casual sadness in which no trace of either humor or nostalgia could be detected, and though his reminiscences conjured up a street of drapers' shops and shaggy, disputatious men in gabardines, what we actually saw was a pair of bent Asians in dhotis, who moved slowly forward ahead of us through the perfume of the cookshops and the knots of chatting loiterers. At length, we reached St. Matthew's Church, a duncolored edifice with a wooden crucifix over its portal. We entered the close and sat down on a wooden bench across from two tall poplars.

In the near-medieval Jewish world of his childhood, Kossoff said, there had been no such thing as painting. Unlike writers, who were people of the book, painters were not held in esteem; to many they were cringers, schnorrers, almost beggars. Yet from his mother, who worked near Christ Church and had occasion to meet many people and also from Joseph Leftwich, who was friendly with his father-Kossoff had heard about the Jewish artists of Whitechapel, including David Bomberg. "So, even as a youngster, I knew about Bomberg, though I never thought I was committed or talented enough to associate with him," Kossoff said. "Much later—when I got out of the Army, and Frank Auerbach persuaded me to join Bomberg's class—I learned more about him, though I was never really a member of his inner group. For all his talent, he never made one feel like a student but almost like an equal. His actual teaching didn't affect me that much. What did affect me was that he was a survivor. He had survived as a painter, and so I might, too." Yet Kossoff told me that he had declined to exhibit with Bomberg and his students. He didn't believe in groups and labels, and he reminded me of what Gustave Moreau, the teacher of Matisse and Rouault, once told his students: "You will not be my equal until vou deny me."

When I raised the question of the neglect of Bomberg, Kossoff replied that the English just weren't pictorial-minded—at least, not in Bomberg's day. What they liked—what they had always liked—was illustration, in one form or another. They weren't interested, he said, in serious painting: as late as the nineteen-forties, one could still pick up Pissarros in the London galleries for a hundred guineas or so. And then there was the issue of snobbery, which Richard Cork's biography

had skirted. Kossoff spoke with barely concealed scorn of the hypocrisy—or was it sheer lack of nerve?—with which such matters as class and racial prejudice were still passed over in England; the presumption that a genteel anti-Semitism, mingled with a squeamish distaste for Bomberg's back-street manners, had played no role in the London art community's rejection of him was simply ridiculous. Of course, Bomberg's conduct had often been appalling; he had behaved with art dealers in a way that was so belligerent, so intimidating, that they had been quite put off by the idea of working with him. Kossoff recalled one dealer who had been terribly upset by Bomberg's adamant insistence that his pictures be shown according to his precise instructions. But all this was beside the point. Nobody had ever claimed that painters were easy to get on with, and the sheer strength of Bomberg's ability—especially in the talent-poor English art world of those days certainly outweighed all other considerations. Yet Kossoff also noted that Bomberg was a man so cussedly principled that his dukes were always up, and that it was easy to imagine him rankled by slights that a person of greater poise might have absorbed more easily. There was the example of Mark Gertler, Bloomsbury's "Jewish painter," who, with his exceptional talent and almost girlish beauty, had become a lion in the salon of Lady Ottoline Morrell. Gertler, too, was a Whitechapel boy and the child of Galician immigrants who had lived on the edge of starvation. To make money, his father had at one time hawked buttons and at another time sanded walking sticks. Gertler left the East End in 1915, at the age of twenty-four, but not before executing a number of brilliant paintings that translated his down-at-heel Jewish and bohemian experiences into a vivid personal idiom. Unlike Bomberg, Gertler got on well in society-for a while, at least. What troubled Kossoff about Gertler's trajectory, however, was his gradual estrangement from his roots, and his eventual espousal of a sort of blue-rinsed Parisian modernism. Gertler lost his way, and ended up a suicide at the age of forty-eight; though Kossoff ventured no explanation for this, he implied that any attempt to escape from the gross data of one's existence could only lead to an empty, unfelt art.

For Kossoff, apparently, being a painter meant examining one's own immediate surroundings, however unpleasant. In stray phrases

and glints of images, he portrayed himself as a plodder, a stoic, a Sisyphus of art, and something in his choice of words suggested a distinct fondness for his plight, a coziness with his personal boulder. His apprehension lest his work be accepted in the wrong way—as a set of mere illustrations of his life—was strong enough to argue a surreptitious wish that it not be accepted at all. Clearly, he relished his outsider status; while conceding that he had enjoyed a certain local recognition for over two decades, he insisted that this was success of a very limited order and might easily have continued unchanged for two more decades had a certain collector not happened on the scene. This collector was Charles Saatchi, the founder, with his brother, Maurice, of the mammoth advertising firm of Saatchi & Saatchi.

Charles Saatchi was rapidly assembling one of Britain's largest collections of contemporary art; for the past few years, he had been buying Kossoff's paintings en bloc, and now he owned fifteen major pieces. There was an obvious financial reason for Saatchi to be interested in acquiring a group of Kossoffs—he had a fine nose for major, or potentially major, artists whose prices hadn't yet peaked—but his personal interest in these pictures rather unsettled their creator, who recalled that when Saatchi came to his studio to look at some work he had turned out to be disarmingly modest and candidly curious, like a person who had a genuine love for painting. The whole thing utterly stumped Kossoff. Why, he wondered, would a man like Saatchi—an entrepreneur, a figure from the world of marketing, promotion, and chic design—take an interest in his work, which was manifestly unchic and had nothing in common with most of what Saatchi was buying?

I had noticed that whenever Londoners discussed Charles Saatchi there were these worries, these doubts. Was he a true collector, with the collector's inspired cupidity, his compulsion to accumulate some particular sort of object? Or was he merely a glorified trader, who was prepared to dispose of his holdings under the right conditions? Certainly Kossoff had no way of knowing—though he was aware that Saatchi had already got rid of a few expensive pictures. At the same time, it was Saatchi who had yanked him out of the shadows and into the limelight of high prices and journalistic hoopla. "Saatchi changed my life," Kossoff said flatly. His expression was so quizzical that I couldn't

tell whether the change had brought him pleasure or pain or only some final sense of life's preposterousness.

I had by now acquired the habit of asking everyone I met in the London world of painting how he or she felt about the fate of David Bomberg. The neglect of Bomberg was a distressing reminder that every age—including, doubtless, our own—banishes some of its ablest talents to limbo. As I studied Cork's book, however, I began to feel that Bomberg's claim on the reader's sympathy was somewhat weaker than it had at first appeared. There was a sense, of course, in which the whole tragic story defied rational understanding, but an artist's best work often plays Jekyll to the Hyde of his private personality, and this seemed to have been the case with David Bomberg. Whatever in his nature was fractious or imbalanced did not show up in his teaching or in his more exemplary pictures, and thus all the tributes of his admiring students-which Cork quotes at length-did not really help to elucidate his plight. Yet within the tale of what was done to Bomberg lies embedded the smaller tale of what he did to other people, which, it turns out, was often rather disagreeable. Cork's narrative contains a long train of snarling, Hollywood-style metamorphoses, in which our hero's darker self blackens a fellow-student's eye; brains a certain Professor Brown with a palette; organizes a revolt within the Omega Workshops; tries to provoke a fistfight between his brother, who was a professional boxer, and Wyndham Lewis; earns the enduring hatred of Henri Gaudier-Brzeska; so infuriates Ben Nicholson on a painting trip to Lugano that Nicholson buys him a ticket home to England; falls afoul of the very Zionist cultural institutions on whose patronage he subsists; antagonizes a detachment of Bedouin guards; alienates his friend Muirhead Bone; obliges his family to live in a tent; and, in a particularly absurd incident, throws a pile of baby clothes out the window. As spectators, we may find all this quite rollicking, but nothing suggests that either of his two wives found it especially entertaining. "He seems to have suffered," Cork writes, "from a deep-seated emotional insecurity which impelled him to cloak it in arrogance."

In Brighton, one misty, salty morning, I rang Dennis Creffield's bell. From the flight of steps in front of his building, on Marine Parade,

I could see Brighton Pier and, farther off, in a shimmer of sunlight, the ruined beauty of West Pier. Creffield is one of those lesser-known English artists whom Kitaj frequently praises. He was born in London in 1931, and in his late teens he, too, studied with David Bomberg at Borough Polytechnic. After three years there, he went on to the Slade, where he won the Tonks prize for life drawing, and later he taught at the University of Leeds and Brighton Polytechnic. Creffield has had one-man shows at a number of important places, including the Leeds City Art Gallery and the Serpentine Gallery, in Hyde Park. I had seen some photographs of his drawings in the magazine Modern Painters, and though photographs often fail to capture the spirit of drawings, these had interested me. This was the same Creffield who was a source for the penultimate chapter of the Cork biography, in which he had borne witness to Bomberg's generosity and lofty sense of purpose. So by coming to Brighton I was seeking to kill two birds with one stone: to look at Creffield's drawings for whatever pleasure they might afford and to put a few questions to him about the neglect of Bomberg.

In a photograph of Bomberg's students in the book, Creffield appeared as a beardless, childish-looking seventeen-year-old with unruly fair lamb's-wool curls. Now, more than forty years later, he was a shortish, slender man in a pink Henley shirt, with a domed brow and thinning hair worn long in back. He showed me upstairs to a flat in a house that had obviously always been divided into flats, and his own instantly revealed that he either had no money or was totally uninterested in money or in any veneer of elegance. It was the apartment of an old-fashioned bohemian who lived and breathed art, with reproductions and sketches and knickknacks piled up everywhere and proliferating over the walls and tables. At the front was his studio, in which piles of big charcoal drawings, about a yard square, lay on the floor. The studio was painted entirely white and lit by a blaze of watery sunshine; a large bay window gave the impression of bellying out over the Channel. Through its panes little was visible but the sea itself, a broad expanse of rippling gray, surmounted by pewter-and-foam clouds.

Creffield had barely introduced himself when he began to explain why living in Brighton suited his character: despite certain novel vulgarities that threatened to drown out the associations proper to the

place—those grand old memories of dirty weekends, private detectives, co-respondents, and Graham Greene crooks—Brighton, he said, was still a fine, seedy, romantic place to dwell. This had to do partly with the light, which was positively Mediterranean, and partly with the town's climate of truancy. It still was a spot to visit not with the wife and kiddies but rather with a secret sweetheart, and if one happened to end up working here—over this seafront heaving with kissing couples and screeching with penny arcades—one's labors derived a certain benefit from it. They took on a larky, picnicky quality that nicely counterbalanced the vast moral imperative of the sea and sky, which were constantly urging one to get on with it and make something of one's moment on earth.

Creffield's big charcoal drawings were all of churches. He explained that in 1987 the Arts Council had commissioned him to draw the twenty-six medieval monastic cathedrals of England, and that he had since drawn other cathedrals-including St. Paul's-that do not belong to this category. It was a project dear to his heart, he said, for ever since the age of seventeen, when Bomberg set him to drawing the cloisters of Westminster Abbey, he had wanted to tackle all the great Norman and Gothic basilicas as a unified theme. He explained that he was a Catholic, and that his religious beliefs had contributed to this ambition. From February to November, 1987, he wandered about with a trailer, applying to the appropriate ecclesiastical authorities to gain access to closes, naves, apses, and choirs. Since he hated to be observed while drawing, he executed most of the work in the very early morning or in the late afternoon and the evening. The project yielded hundreds of drawings, many of which were currently on tour all over England, but Creffield had gone right on drawing cathedrals, and there was unfinished work on the walls.

"I conceived of my tour as a sort of course in drawing," he said. "I wanted each cathedral almost to make the drawing by itself, and when things were going well I would leave off working not when I'd achieved some structure or definition but just when the drawing felt 'said'—technically, it could have been quite incomplete. My drawings have nothing to do with transferring a retinal image onto a piece of paper, but rather with recording an emotional experience, which

could include a purely mental image of a building, or a sensation of length or vastness that would never have fit on my paper if I'd rendered it topographically."

Creffield had a knack for juxtaposing the cursory and the highly detailed. He could casually hit the stride of Gothic tracery, converting it into something like the brilliant dashes on painted pottery, and he liked laying fretworks and filigrees next to staid black shapes. He used flying buttresses to get a diagonal, skipping movement that energized the whole page, but he could suddenly downshift into wariness, abandoning all his shoulder and elbow jive in favor of a tense wristy caution. He would do careful fan vaulting, like the patterns of foam the tide leaves on a beach; then, a moment later, within a broad gloom of nearly undifferentiated charcoal soot, he would float a single slot of white so cannily into place that a whole Norman crossing, with all its shafts and ribs, swam into the imagination. It was a sociable appeal to the viewer's habits of visual inference: a lighthearted flick of his crayon, pinning down the odd crocket or finial, summoned up in one's mind half-forgotten images of architectural elevations, or caused drowned memories of an evensong at Ely to rise to the surface of awareness. There was a classic, European sense of shared heritage to the whole endeavor. Creffield seemed to have learned from all the master masons of medieval England, and perhaps he belonged to the last generation that had the training—or the mere sense of connectedness—to do so. He knew his cathedrals the way older people know Shakespeare, and, in fact, he was eager to point out the similarity between the churches and the plays. "It's that medieval aspect of Shakespeare," he said. "The ebullience, the cosmoslike vastness! And then there is the anonymity, the suppression of ego. We don't really know who Shakespeare was, just the way we don't really know who built the cathedrals. And this isn't 'a regrettable lacuna in the information at our disposal"—he mimicked a pedant's diction—"it's part of the whole idea. Nowadays so much art is only ego, yet that's just what we've got to get rid of."

He plucked some photographs off a table. "Have you been to Southwell?" he asked. "It's in Nottinghamshire. Has a large thirteenth-century chapter house—octagonal. All around the capitals, gables, and moldings of the stalls are these wonderful leaves, the so-called

leaves of Southwell. A triumph of English carving. Look at these curiously realistic heads poking out from the springing of the gables. Look at the oddly swollen cheeks of that damsel with the chaplet. Splendid, eh? Here's Jack-in-the-Green, an ancient English tree spirit who looks out from among the fronds." He held up the photograph and communed with Jack for a moment, then peered at me suspiciously. There was something wild or woodsy, something Druidical, about him. His features seemed to gather themselves into a knot at the center of his face, from which they bristled in my direction.

"What, actually, are you writing about?" he asked curtly.

I had already told him over the telephone, but I reiterated my interests: Bomberg, Kossoff, himself, and so on.

"Kossoff, eh? We were in Bomberg's class together. Let me tell you something—you mustn't pay any attention to those boys Kossoff and Auerbach when they start to go on about difficulty and struggle, and all that rubbish. Those boys have always been incredibly ambitious. Those boys were showing in their teens."

Creffield insisted that he respected Kossoff and Auerbach as artists, but that they had always been great successes, had always taken the high road to acclaim. The most infuriating thing about them was that they were widely regarded as the inheritors of David Bomberg, whereas, in reality, during Bomberg's lifetime they had refused to join any of his groups and had gone their separate ways. Creffield launched into a brief version of the saga of Bomberg's last years—the Borough Group, the Borough Bottega Group, the synods, the excommunications, the schisms, the ecumenical reconciliations—and of how "those boys," as he kept on referring to Kossoff and Auerbach, had never really grasped Bomberg's teaching in the first place, whereas he himself had held the Master's banner aloft. In fact—he saw no reason to deny it—he was Bomberg's spiritual son. Like Bomberg, he had always tried, inch by inch and second by second, to keep his painting open to the impress of his feelings, and, like Bomberg, he had been repaid for his pains with a total absence of worldly success. Yet his very failure had kept him mobile and elastic, unlike Kossoff and Auerbach, who, being tied to smart galleries, had sunk into self-repetition. They had every right, of course. To whom did it matter-certainly not to Cref-

field—that some people bartered their freedom for a monstrous visibility and stood about like giants in fetters, blocking everyone's way? He, at least, who was undiscovered (the fact that Anglia TV had just completed a film on him apparently counted for nothing), had used his obscurity to protect his independence, and so to this day made strictly voluntary decisions in the practice of his art.

Creffield might have gone on like this for some time had a young woman not entered the room. She was pretty and blond and seemed hesitant to intrude, though it was perfectly clear that she lived there. Creffield radiantly introduced her as his "sweetie," and in a soft, perturbed voice she said something about a baby asleep in the stairwell outside, who shouldn't be wakened if possible, and how there wasn't much of anything for lunch. She must have been at least thirty years younger than Creffield, who had several times morosely described himself to me as a sixty-year-old, though in fact he was fifty-eight.

In the kitchen, we fixed ourselves some bread and cheese and wine, and then we went back into the studio. We sat down across from each other at a table by the big bay window, and I asked Creffield to give me his impressions of Bomberg.

"Well, when I came to Borough Polytechnic he was already quite ill," Creffield replied, "and he sensed that his work would not be accepted in his lifetime. So he conceived of his students as being able to take up what he wouldn't be able to do. He was handing on the torch, so to speak, and he treated his students like colleagues. Can you imagine a man of his achievement putting his paintings on a railing in the Victoria Embankment Gardens next to the work of a little boy like me? Yet that's just what he did once, in the days when public shows were authorized there."

"And was he as difficult as he seems to have been?"

"Of course he was difficult," Creffield said, impatiently. "He was difficult because he had standards! The one word I remember his using over and over was 'integrity." Creffield went on to recall an incident in which the painter Josef Herman—an artist who had settled in South Wales, where he created a group of pictures based on the life of a mining village—had once sent a potential buyer to Bomberg's studio. "Bomberg eventually threw this buyer out," Creffield said. "Even

though Bomberg badly needed to sell, he wouldn't sell to someone buying in the wrong way. Bomberg was the sort of person who would hang a whole exhibition and then take it down because something about it bothered him aesthetically."

"What about the fact that he was Jewish and of lower-class origin?" I asked. "Did that contribute to his neglect?"

"I very much doubt it," Creffield said. "In fact, all that may well have satisfied the English idea of the artist as a colorful oddball—a Gulley Jimson, if you will. Even for conventionally prejudiced people, the Jewish peculiarity was eminently acceptable in an artist. The problem was that Bomberg simply wouldn't compromise on his standards. He had deep puritanical anxieties about that sort of thing. Well, you might say that he was difficult, but you really don't have to be very difficult to be difficult, if you know what I mean. In the backward English art world of those days, Bomberg just didn't fit in. My God, man, for fifty years this great artist wasn't even mentioned in a foot-bloodynote! He just didn't fit in!"

Creffield paused to eat some bread and cheddar. Then he said, "Another student of Bomberg's told me that Bomberg tried to help a refugee painter, who was apparently having a hard time, to get a job at Borough Polytechnic. He spoke to the principal about this painter, and the principal said, 'Well, send him along. I'll see what I can do.' A little while later, the principal got in touch with Bomberg and told him, 'The fellow has some very interesting ideas.' 'Really?' said Bomberg. 'What are those ideas?' The principal explained them to Bomberg, and Bomberg replied, 'If you employ that man, then I'm resigning."

Creffield concluded on a triumphant note, yet it struck me that he had just weakened his case. There is, to be sure, a kind of easy sociability, a good-natured tendency to yield or agree, to which serious artists will not stoop when aesthetic judgments are in play. Creffield was all primed up on this ethic, which had clearly been Bomberg's as well; the hitch was that the ethic did not seem to fit the situation. The principal's judgment might well have been deplorable, but the refugee had initially been Bomberg's candidate, so Bomberg had been under some obligation to vet him before proposing him for a job. Failing that, he was surely entitled to reverse his opinion, but to accompany

the reversal with a threat was to exceed the norms of civilized conduct. Of course, neither Creffield nor I would ever really know the details of the case, but I couldn't help being impressed by the sheer cantanker-ousness of the brief that Creffield was holding for his former master.

Something in Creffield shied at being asked all these questions about Bomberg, and as he answered them his voice seemed to stifle some question of his own. "Now I'm going to ask you something," he said, finally. "Are you interested in Bomberg, or are you interested in me?"

I put down my glass of wine and swallowed my bread and cheese. "Both," I said. "I'm interested in both Bomberg and you."

"I've noticed that all your questions are about Bomberg," he snapped. "You've asked me far fewer questions about myself. And what I want to know is just what I asked. Why did you come down here, anyway? Are you interested in Bomberg, or are you interested in me?"

Just then the sun came out over the Channel, lighting up half of Creffield's face, while the other half sank into darkness. The waves of the sea were tiny and innumerable, and seemed to move very slowly, like waves of mercury. Above them, the clouds rearranged themselves. It was a moment of pure embarrassment.

I said, "I'm interested in both Bomberg and you."

"Well, I think you should have told me that before you came down here," he replied sharply.

"I did tell you," I said.

"No, you did not."

I said very slowly to Creffield that I distinctly remembered calling him and telling him what my purposes were. At first, he recalled none of this, but after a moment his memory quickened, and he conceded that it was true. He fell silent, and disappointment shadowed his brow, for evidently I had failed to manifest that exclusivity of adherence—that heraldic allegiance to some person or camp—which he presumably required in people.

We lingered for a while over the wine and cheese, and then decided to go out for a walk on Brighton Pier. On the way downstairs, we passed Creffield's baby daughter asleep in a pram on a landing. The light was

so finely filtered that the beautiful child's face seemed chiselled out of the air itself, and the angelic sight, like Creffield's intelligent drawings, belied the dark picture of his life that he had so strenuously created for me. Apparently, he no longer saw me as an enemy or an interloper, and our chat, rid of contention, continued in a pacific vein that transparently bored him. Yet, after all the evasiveness and insincerity that I'd encountered in the London art world, I found Creffield's frankness refreshing. Bravely uncharitable, blithely unconcerned if he seemed envious of other artists whom he didn't admire anyway, he was big enough not to mind if he made himself seem small.

By this time, it was certain that Charles Saatchi was going to give Leon Kossoff a major exhibition in November, and it was equally certain that Kossoff wasn't going to have anything to do with it. Saatchi already owned the paintings in question, so technically he didn't need Kossoff, and Kossoff had decided to avoid all social functions related to the show, and even to shun the premises of the Saatchi Collection. He never told me his reasons for this decision, but two suggested themselves. One was that he didn't feel that he was ready. The other was a spectacular disclosure by Andrew Graham-Dixon, The *Independent's* art critic, that Saatchi had in the past six months sold off between seventy and a hundred paintings, or between ten and twelve per cent of his holdings. This huge divestment, with all that it implied about Saatchi's fickleness as a collector, had dismayed a lot of people in the London art world, and perhaps Kossoff was among them. In a sense, Saatchi stood to a painter like Kossoff in much the same way that the Broadgate complex stood to Christ Church, and the parallel was more than metaphorical: he was friendly with one of the directors of Broadgate, whose wife helped to handle public relations for the Saatchi Collection. The irony of the situation was that Kossoff, in the end, was indebted to Saatchi: though he might wish to avoid publicity, his paintings were meant to be shown, and Saatchi, whatever his failings, was showing them to the greatest advantage.

As the exhibition drew near, I kept in touch with Kossoff. It was clear that he was not disposed to meet with me again. Still, I wanted to see him—I was curious about his way of working—so I wrote him

a letter in which I confessed that I had not completely understood what he had told me so far. This seemed to mollify him—to allay his standing mistrust of certitudes—and about two weeks before the show I received an invitation to his home.

Kossoff's street in Willesden is lined with houses of the "stockbroker Tudor" type, habitations for the most middle of middle-class people, but all the gentility stopped short of his foyer, which was barren of furniture and hung with pictures in progress. The ground floor of his house had been given over to painting, but the stacks of big, heavily reworked panels leaning against the soiled walls could not disguise the original identity of the rooms: there was a dusty pantry, a paint-besmirched sitting room, and so on. A defiantly anti-domestic air hung about the place, as if a rebellious son were methodically trashing a conventional suburban home. The sitting room, now Kossoff's studio, was breathtaking. Everything in this smallish lair—the panels, the floor, the tables, the buckets, rags, newspapers, palettes, even parts of the walls themselves—was so thickly covered with dark, glistening, clammy paint that the whole chamber resembled a mud man's cavern. I had already seen one photograph of it in a newspaper and another in a catalogue—in fact, it ranks as one of the London art world's more notorious sights—but I still couldn't prevent an exclamation from escaping my lips. Kossoff's reproving eyes bore down on me. "Too much has been made of this," he said briskly (though, obviously, only he could have authorized the photographs).

An easy chair in a particularly gloomy corner was reserved for his models. It was only about eleven in the morning, but one of them, he told me, had already come, posed, and gone. He evidently had the habit of rising very early and driving himself relentlessly till night-fall—a perseverance that smacked of the old-time family bakery. His labors seemed to entail the same tedium as a baker's, the same forced unsociability, the same anxiety over a life pursued at hours contrary to those observed by the rest of humanity. The whole point about bread, as he must have learned from his father, is that people want it every day: there is no possibility of missing a few hours of work, for a bakery that can't turn out bread with clockwork efficiency is really no bakery at all. Whatever the nature of his long and taxing relationship with

his parents, Kossoff seemed to have carried this baking ethic into his production of paintings, and with it the baker's self-hectoring tempo, helpless belief in work for its own sake, and knowledge that he is both the slave of his mastery and the master of his slavery.

Together we scrutinized his recent efforts, making our way back into the shadowy recesses of the house until we came to a little room against whose walls four or five paintings of Christ Church were leaning, shouldering each other so closely that it was very hard to tell where one composition ended and another began. Clearly, Kossoff had finally got hold of his enigmatic subject and was knocking out one impassioned depiction after another. Though art writers tend to portray him as a dour, unhappy man, these paintings didn't seem sad at all; on the contrary, as I remarked to him, they emanated a naïve ebullience and humor.

"It's probably true that I used to be unhappy," he replied, "but that doesn't mean my pictures are about unhappiness. I think my pictures are about light—something that many people just don't seem to realize. They're about the outer light—the light of London, which I am trying to capture quite objectively—and also about an inner light. I'm trying, in a way, to light up the internalized parents within me, to empty myself of what was making me self-destructive."

His work did indeed gleam with the light of London—that shifty gray lustre that gnaws at the edges of things. But it also seemed to be about the power of line, a broad impulsive line that darted about the canvas trying to prove that the world could be summed up in a single long fidgety gesture.

"Well, I half hope one doesn't see any lines," he said, looking at me with vague horror. "Let's say marks, not lines!"

This wasn't very persuasive—his work was full of lines—but what did seem to be happening in the paintings of Christ Church was that the search for an adequate drawing had by dint of dragging paint through paint produced a grainy luminescence. The paintings looked good to me, but they abutted each other in such an optically frustrating way that I just stood there squinting and cocking my head. "Oh, I've confused you with all my talk," Kossoff said, mistaking the cause of my perplexity. "I can see you're getting more and more confused."

After we had looked at the paintings for a while, he invited me upstairs for a cup of tea. The top floor of the house was a normal suburban interior, with scarcely anything—except for a few pictures—to betray a life spent in art. In a bookshelf beside the tea table I discovered a copy of the new Saatchi catalogue, with reproductions of Kossoff's paintings, among others. I asked him in what spirit he had managed to impose the final, triumphant coat on some of the bigger pictures, and how many hours of compositional invention they had required. But Kossoff had no idea how long they had taken him, since he generally worked in fits of desperation. "You have to understand that I simply don't know how I did those paintings," he said. "If I knew how to make more like that, I would." While he was talking, I handed him the catalogue, but he held it with perceptible reluctance, as though it might burn his fingers. He started to thumb through it but soon jibbed at this task and let its covers fly shut, with an exclamation of disgust.

We chatted for a while longer, but he refused to be further tempted into articulating his artistic aims. "Just try to be as brave in looking at my paintings as I try to be when I'm making them," he said. The words sounded pious, but he didn't look pious as he said them. He looked like someone with a hidden ailment who regrets having revealed the extent of his pain.

He saw me to the front door. "I expect you're totally confused now," he said contentedly. But very early the next morning—at just the hour when a baker might start to feel a little heavy on his feet—Kossoff called me on the telephone. "Just forget everything I said," he told me. "Talking about myself like that was dreadfully self-indulgent. Please forget everything."

One of the people I happened to quiz about David Bomberg was Sir Lawrence Gowing, who lives in a cluttered house in Fulham. Gowing is a tall, stuttering, bent figure in steel-rimmed glasses, with a pendulous lower lip and vividly veined large hands; he is also a superb writer on modern British painting and other aspects of art. A draper's son from the run-down borough of Hackney, he made a name for himself in the thirties as a talented tonal painter, and he has brought a painter's experience to the scrutiny of contemporary art. Gowing's insights are

invariably so interesting—they draw one's eye to such crucial things—that it scarcely matters whether he is right or wrong, a fact of which he himself is probably not unaware. He writes of London painting with a heady enthusiasm, which does not carry over into his conversation. In person, he may rapidly grow reserved about a work he has praised in print—not, one suspects, out of meanness but out of a suddenly descending, slightly comical sobriety, like that of a man shaking off the effect of a good bottle of wine.

"Bombergism," he stammered out in his throaty voice, "has to do with instilling feeling into the paint patch, which is a confusion. There are few more dreadful reminders of mortality than the heavy Bombergian paint surface about a year after execution. There was a time, rather recently, when Bombergism reached epidemic proportions in our art schools, and with it came a strong dose of the Bombergian paranoia, which, like all paranoia, is contagious. I believe that any inquirer could soon satisfy himself that Bomberg was not in fact murdered by the English art world—this happened only in his imagination. It is true that his application to teach at one of our leading academies was turned down by its director—a sensitive man whom nobody ever accused of unkindness. During his last days, Bomberg summoned this director to his bed and said to him, 'I am the greatest painter in England. You have contrived my neglect, and now I am going to die.' The man was deeply upset by this, and was always overfair to Bomberg's students thereafter."

Later, sifting through the Bomberg correspondence in the Tate Archive, I discovered, to my surprise, abundant evidence of the keen interest that many discriminating persons had taken in Bomberg's work. The loyalty of his friend the academic painter Muirhead Bone was particularly touching—though one could sense Bone's growing weariness with Bomberg's hopeless inability to get on in the world—and there were others who had given him moral support, and, at times, money. Kenneth Clark, first as the director of the National Gallery and then as the chairman of the War Artists' Advisory Committee, had turned down his appeals for patronage, but not even Clark's letters seemed unsympathetic. In May of 1938, he wrote Bomberg, who was then unemployed and without a gallery, "I am very sorry to know you

have had such a long run of ill-luck. I wish I could help you more than I do, but as I have told you I feel bound to help other artists whose work appeals to me more strongly." The same day, Clark addressed a letter to the Artists' General Benevolent Association urging that relief be provided for Bomberg, "the merits of whose work have been generally allowed by all those capable of judging." When Bomberg applied for a job as a war artist, Clark—this time backed up by a committee—again turned him down, but probably on the ground that Bomberg's work was too subjective in style to aid in the documentation of the war effort; many distinguished nonillustrative artists, including Ivon Hitchens, Ben Nicholson, and Victor Pasmore, went unrepresented in the War Artists collection. In retrospect, the whole unhappy episode seems an everyday failure of connection, from which neither Clark nor Bomberg emerges with much egg on his face. (And, of course, the committee did eventually relent.)

Bomberg seems to have lacked any of the routine skills and wiles necessary to secure a job. At times, he applied to absurdly inappropriate employers, like Smith's Motor Accessories Works, the University of Pennsylvania, Alexander Korda, and Walter Gropius (who advised him to include pictures of his work with such applications). When one of his students provided him with a considerable sum to launch a high-class inn in the London neighborhood of Rosslyn Hill, he wasted months of precious painting time refurbishing a house, then left it one weekend in the care of an apparently pleasant couple, who stripped it. Such fecklessness boggles the mind, and suggests that Bomberg's vaunted moral refinement was allied to a hidden juvenility. A close friend once said of him, "One of the most characteristic things David ever told me was that he lacked ambition. He said he didn't need it; he knew success and acclaim were his due." In these words we hear unworldliness shading into vainglory: Bomberg evidently labored under the delusion, common among artists and the young at heart generally, that gifted people can sidestep necessity, while other, weaker souls are chained to their fates. Devoid of any Machiavellian perception of how society actually works, Bomberg seemed to believe that patronage runs, or might be expected to run, on the merit system, and thus fell into dejection when the art-world powers refused to accord him his just deserts. One is not surprised to

discover that as a boy he was terrorized by his father, a compulsive gambler who suffered from paranoid delusions and would assault his wife and children when his luck was low. There is no need to enlist Freudian verities—or clichés, whichever they may be—to demonstrate the parallel between the little Bomberg's natural and never satisfied need for an unconditional paternal love and the grownup Bomberg's pathetic claim to a surpassing entitlement.

As Gowing suggested to me, there are problems with the best of Bomberg's art. Though his drawing was superb, his painting was hampered by a very limited repertory of marks, and his handling was often leaden in the shadows. His color ran toward meaninglessly overheated madders and oranges, yielding no signs that he had understood Matisse or any of the great twentieth-century French colorists. With such limitations, he was unwise to indulge his dream of greatness; lacking self-knowledge, he often wasted his talent and subjected his family to wretched tests of endurance. Yet Bomberg's brand of virtuous bloody-mindedness represented a common behavioral pattern: it seemed to break out not only among his followers but also among a great many artistic types who had never had anything to do with him and could, indeed, be living anywhere in Britain—or on earth. In such people, the cult of "standards"—which claims to transcend individual ambition, and can even inspire a splendid self-sacrifice, like stalking off a job-masks a boundless and ruthless self-love. The standards invoked seem always to confirm one's own ideas and one's own work, and to uphold them is usually to throw oneself grandly into relief or to impugn the motives of a colleague.

But if Bomberg had clearly contributed to his own ruin, that was a far cry from saying he had caused it. There were, after all, his pictures, which, despite their failings, were superior to those of most of his contemporaries. There was something, too, in his very rebelliousness, his relentless contumacy, that compelled a grudging assent. It was an integral part of his artistic temperament, as diffidence was a part of Kossoff's and irascibility a part of Creffield's, and only a prig would be put off by what made them creative people. In the end, I began to feel, it would be impossible to arrive at a definitive explanation of Bomberg's neglect. For one thing, there is no commonly accepted notion of what

neglect—which is, after all, the absence of something—concretely consists of. If you don't much care for Bomberg's work, for instance, then there was really no neglect at all. Gowing's response was of this order: he was an artist himself, and, as such, he happened to be viscerally repelled by Bomberg's handling of oil paint. Kossoff's view was quite different: though he plainly took Bomberg's part against the establishment, he had also felt obliged to resist and, later, to deny the influence of his former teacher. Creffield, for his part, nursed a personal rancor against the malignant forces that had betrayed his spiritual father. From Creffield son-of-Bomberg to Kossoff the Apostate, the various accounts of David Bomberg's martyrdom held all the makings of a permanent theological dispute.

In the meantime, sitting in some stale-smelling pub or run-down railway coach, I would mull over Kitaj's latest sheaf of yellow foolscap pages. "There is the looming question of *Silence*," one letter announced portentously. "I'm looking for a more modest life now . . . maybe a silent one. Of those 3 great Joycean attributes—I think I know something about exile, but silence and cunning have always eluded me." Yet the more Kitaj found words to talk about depression, the less depressed he really seemed to be; at the same time, his bottomless capacity for self-justification began to seem every bit as Sisyphean as Kossoff's struggle with the impossibility of art. "Writing," he confessed in the same letter,

may be a kind of almost casual compromise notation (I may now discontinue) . . . I have just painted a kind of meditation on Dürer's great Melancholia engraving. I had to *read* Panofsky before I knew what's going down in the Dürer. If we now have the vast (visual-textual-oral) experience of these thousands of pictures from Giotto to Picasso, why should a modern, dissident painter *not* break ranks and challenge the precious autonomy of picture-making? Why should a Jew *not* be attracted by exegesis in its often contradictory and mysterious forms? Why does an analogy have to "hold" or a painting to "work." Fuck that; Life and Poetry are not like that!

The whole letter was a treadmill of rhetoric and braggadocio—by turns poetic, informative, outrageous, and silly—and it was as exhausting to read as it must have been to write.

One was bound to discover that Kitaj, with his doubts about the central place of abstraction in contemporary art and his belief in the anthropological or ethnic specificity of modern painting, was fighting the battles of the past. He may have been right, he may have been wrong, but nobody in London seemed to care much about his ideas anymore. It was always possible, of course, that the mere venting of these obsessions somehow helped him to paint; it was also possible that all the cerebration simply muddied his mind.

One afternoon, I poked into Kitaj's café, and, sure enough, there he was, sitting under the specials board, scribbling on a yellow pad. He had on a blue-and-white checked shirt, in which he looked remarkably youthful, and his skin had assumed a rosy bloom, but he replied to my greeting with his usual litany: he was finished, lost, half dead, etc. Then I mentioned that I'd seen Kossoff, and he leaned forward expectantly. I told him about Kossoff slogging through the East End with the world on his shoulders. I told him about Kossoff slaving away in his grotto up in Willesden.

"Yes, well, these London guys have a certain aura," Kitaj said, in a tempo rather less halting than it had been a few weeks earlier. "I think that that aura comes in part from Giacometti. The circumstances of Giacometti's life are one of the sources—or, rather, the examples—of this behavior. It's the idea of the dungeon—to work all your life in a dungeon, even if you wind up being pretty successful. I myself used to be relatively unaffected by this. I wasn't as alone as these other guys are. I was the one person who tried to keep in touch with all the others in this strange London of ours. The rest of them pretty much stopped seeing one another. Maybe they felt they were growing older and couldn't spare the time, and there were various personal strains. But now I don't get out much anymore, either. Now I, too, keep to myself." He mused for a moment. "That dungeon thing—it's starting to happen to me," he said.

He stared into the middle distance and fetched a deep sigh. "I'm trying to paint my depression," he continued. "I think I told you about

my version of Dürer's Melancholia engraving—well, my interpretation is a kind of self-portrait in which I'm holding my brush upside down. I even reread Panofsky on Dürer, but now I've forgotten what he said. Something about Dürer breaking away from the whole previous history of representing that illness."

Kitaj had remembered right. Some weeks later, when it had become clear that he was not only painting his depression but painting his way out of it, I looked up the famous engraving, along with Professor Erwin Panofsky's commentary. The picture shows a winged allegorical figure, her head propped dejectedly against one hand, surrounded by scientific tools and solid-geometry models; at her feet crouches the gruesome Black Dog whose name has passed into British English as a synonym for depression. In his text Panofsky explains that Dürer was the first to treat the figure of Melancholia as a thinker, an artist, a person whose awareness of unreachable truths causes him spiritual affliction. The melancholic lives on a treadmill, searching and searching for answers that are not to be had.

Several months after that meeting with Kitaj, I received a letter from him. "I've been O.K. since Xmas," he wrote. "I've been working on a few pictures which are better than what you saw. They got more 'pictorial structure,' man! Hope that don't kill 'em. One is called *The Heart Attack*. Maybe it's the first heart attack in the history of art! You ask: Am I addicted to paint once more? I think yes—something is starting up in these new pictures."

On November 1st, the Kossoff show opened at the Saatchi Collection, together with an exhibition of the work of the sculptor Bill Woodrow. The Saatchi Collection is managed with integrity and efficiency by a professionally trained curator, but, as its name suggests, it isn't exactly a museum: it has no permanent installation, no explicit commitment to the public interest, and no trustees. Since its shows may be expected to boost the value of its holdings, it could be classified as an exalted art gallery, but such a view would be unjust, because there is no real evidence that Charles Saatchi's intentions are primarily mercenary. The Saatchi Collection is simply a vehicle sui generis for art display, and part of its novelty lies in difficulty of access, for it is situated far

from the center of London, in a remodelled warehouse off Boundary Road, in the posh inner suburb of St. John's Wood. It is not listed in the phone book, and its very entrance would be unposted but for a tiny nameplate beside a nondescript door. Passing through this door, and then a forecourt and another door, one enters a vast, airy, skylighted set of white halls. The transition is striking, and intentionally so: like some stuffy, self-sequestered noble household, the Saatchi Collection wants to proclaim its restraint, its indifference to the hurly-burly of competition. But, of course, this wish is duplicitous. In reality, the visitor feels that his pseudo-museum ostentatiously overobserves a propriety: knowing that everywhere, and especially in London, the best way to court publicity is to shun it, the Saatchi Collection makes a point of its reticence. It represents an advertising man's conception of how not to advertise oneself.

Kossoff's paintings were hung in three huge rooms at the rear. I was the first to arrive at the exhibition's press preview, so I was alone with three black-clad servitors, who coasted toward me, each listing under the weight of his tray of champagne flutes and canapés. Laden with offerings, I began trying to connect Kossoff's pictures with their labels, each of which was distant from its painting by five or six yards. There were fifteen paintings, hung so far apart that they totally failed to possess the allotted space; all of them could have been adequately displayed in any one of the three rooms. In Willesden, I had seen Kossoff's pictures edge to edge and could hardly make visual sense of them, but here his work was so sparsely sown on the staring white walls that the walls seemed to take precedence, reminding the viewer of the price of space in London and how the Saatchi Collection was wallowing in it.

Yet the pieces represented a sensitive selection of his work. The most striking was a figure picture from 1983, more than eight feet long, titled *Family Party*. It showed a cluster of people in an arrangement resembling one of those arrays of carved apostles over a church portal, except that these folks were decidedly secular. At the center, where on a medieval tympanum Christ would have been enthroned, two children were petting a dog; above them a woman served snacks to a row of party zombies lolling in boredom. The image was linear,

graphic, very English in its wry observations; it appeared to embody some reaction to the ennui of a family gathering—some fear, or wish, that a moment of total mortification might lie just ahead. Kossoff's way of putting it all together was riveting. His paint was like lava in playback—a substance that started out seeming viscous and clayey and then grew fiery as you looked at it. Thick skeins of paint lassoed the figures with breathtaking nonchalance, and one could feel how difficult it must have been for him to keep all the calligraphic and spatial invention going: any hesitancy in the interweaving of the various passages would have wholly disjointed the composition. It was a performance that edged right up next to the abyss of classic bad painting, and part of the flair and the fun of it lay in Kossoff's teetering attempts to keep it from degenerating into a slab of well-meaning mud.

Before leaving the Saatchi Collection, I lingered for a while in front of Kossoff's *Double Self-Portrait*, which consisted of a pair of square panels painted in lime green, gray, dull mauve, and black. The panels appeared to represent two discrete moments in their creator's existence: reading from left to right (as one inevitably did), one observed a rather cheery-looking fellow slumping into a posture of rodentlike confusion. The twitchy paint was so inventively brushed on that not one stroke followed any conventional or intellectual notion of form, and in each case one could not have said how such a clutter of pigment had ended up looking like a face at all. It was just following its own loopy logic; yet there, twice, was a man, looking out.

The double self-portrait was so alive that it seemed for a moment that Kossoff himself must be somewhere in the room, which had by now filled up with people. But, of course, that was impossible. Artists do not generally attend press previews of their work, and, in any case, Kossoff had declared his intention to stay clear of the exhibition.

No, he wasn't here—that much was certain. He was probably off in his dungeon, doing whatever it was that dungeon people did, and doubtless having a grand old miserable time of it.

Mark Rothko, Talker

Richard Diebenkorn

 ${f M}$ ark Rothko liked to hold forth. As a listener, you might have found his harangues enlightening, infuriating, or "banal," as Clement Greenberg did, but never funny. They weren't stand-up. I first went to see Rothko in, I believe, the late spring of 1966, in his last studio, a former gymnasium, on East 69th Street in Manhattan. The place itself had a typical mid-century, New York city gym atmosphere, a dusty half-light, which has pretty much disappeared since then. It still seemed a little odd anyway for a painter to move into a gym, a theater of muscularity, but Rothko's tenancy did evoke the sheer strenuousness of the work that he and like-minded artists had been carrying out for more than a decade: pulleys dangled, huge canvases loomed in the shadows. Manhattan school gyms in that era, those of parochial schools and shabby-genteel Protestant church schools and even many public schools, were often cramped, and dark, and grimy. Cinderblocks predominated; exposed pipes ran riot. Those gyms were relics of an antecedent world in which dodgeball and gymkhanas and prize-distributions had been inflicted year after year on throngs of kids with sniffles and jumbled-up Latin in their heads—I had been one of them. So the presence of a meditative

avant-garde painter like Rothko in such a setting struck me as weird and awe-inspiring.

I was not his friend; I was a brat admirer, one of many youngsters (I assume) who now and then visited him, and I did not converse with him but listened, and asked occasional questions. I came a number of times, and there were always others present—I recall a particularly lively conversation with Ray Parker, who I believe had recently had a one-man show. Rothko was heavy-set, properly-dressed, dignified, and a little somber, with—it seems to me now—a barely perceptible tendency to dentalize his Ts in the classic Jewish immigrant fashion—we kids called it "tantalizing your Ts." On several occasions he expressed to me his contempt for somebody called Emily Genauer— "that idiot Emily Genauer"—and seeing that I did not recognize the name he brightened perceptibly when addressing me. I did not read art reviews, but even if I had, I was still too young to know that the lady in question had called his paintings vapid—exclusively decorative—some years earlier in the *New York Herald Tribune*.

My memories of Rothko, long dormant, were reawakened by seeing John Logan's play Red in the spring of 2010. The play is about Rothko: he is seen in late 1958, at work on a set of paintings for the Four Seasons Restaurant in the Seagram Building, in Manhattan pieces that he eventually refused to deliver and that ended up in London and Japan instead. In many ways the chief virtue of the dialogue is that the artist's patter—the most telling lines of which were lifted from James L. Breslin's distinguished biography, Mark Rothko-comes across as hilarious, just as I do not remember it. Alfred Molina, in his scariest role since Spider-Man 2, created a self-engrossed, choleric, bullying Rothko, not at all the figure I recall but one surely better suited for the stage; playing opposite him was Eddie Redmayne, who superbly incarnated an increasingly wounded and rebellious assistant. Red's real theme. I felt, was the abrasion between artists of different generations, Rothko versus the older Cubists and Surrealists, his young acolyte versus himself, and what it added to this old-chestnut of an idea was a shrewd sense for the way that formerly crucial ideas and bitter conflicts between aesthetic creeds, perceived in retrospect, begin to seem silly, even downright ridiculous. It was unsettling how

MARK ROTHKO, TALKER

Logan's play suggested that out of all those screaming postwar arguments about Nietzsche and Kierkegaard and Camus in the Café de Flore and the Deux Magots and every smoke-filled den from the Bay Area to Budapest, nothing in the way of good dialogue can be woven today but farce. At one moment in *Red*, the Rothko character angrily asked who would remember Andy Warhol's soup cans in a hundred years, and all of us in the audience laughed knowingly. Yet the play surely hints that the last laugh is on us, even if we will not be around to see future comedies that make sport of our own superficial taste, our own pretentious ideas.

In *Red*, the fictionalized Rothko dismisses the young Frank Stella as a trashy upstart, but when I visited the real Rothko sometime later (That summer? The summer after?) at a grandiose villa he had rented in Berkeley, California—on this occasion he was conferring with his restorer, Dan Goldreyer, about the unconscionable damage sustained by the canvases he had painted for Harvard's Holyoke Center—he spoke to me appreciatively of Stella's color. That Rothko's attention to others, his kindliness, is obscurely present even in Molina's raging Rothko seemed to me a warrant of that actor's talent.

A word Rothko used that still hangs in my memory is "mysterious." "It's very mysterious, very beautiful," he might say of another painter's work, perhaps adding, "It owes a lot to me, of course." That final blessing was bestowed without a smile—without a hint of vanity, of ironic self-deflation, or any sort of humor. It was a statement of fact and, as far as I could see, it was always true. Rothko's own masterpieces, those astonishingly inventive juxtapositions of colors, shifting tones, and ragged edges, are themselves mysteries that never yield up their secrets.

Rothko could get pretty angry sometimes and I saw it happen, though not in the way that Molina's fictionalized Rothko made it happen onstage. One felt that he got angry with his friends and even casual acquaintances precisely because he took them so seriously—the cynical discounting of friendship so common in contemporary urban social life was wholly alien to him. Anything said in conversation was at once taken up at face value. No opinion was allowed to pass—it might be seconded, it might be countered, but no error or foolishness

ever offered, as far as I could see, a pretext for a display of wit or decorative sarcasm. Every idea was respectfully met, head-on.

Many grandiloquent pronouncements about Rothko's painting have been floated at one time or another by the artist himself, by his patron Dominique de Menil (a sanctimonious champion of the religious nature of art), and by other commentators. But his paintings, exceedingly inventive around the year 1949 and for a while thereafter, did not remain uniformly inventive as he continued to mine a rather limited vein. And Rothko the talker liked to claim for his art certain aesthetic qualities that I could not, even as a very young person, perceive in the work itself. His earlier, surrealist output had perhaps embodied some of these qualities, but in taking up abstraction he had been obliged to abandon them. He could talk a blue streak about "drama," for instance. He loved Aeschylus' tragedies and Nietzsche's conception of the origin of tragedy, and because the act of painting put high drama in his life—all serious art is hard to pull off—he insisted that we see his paintings as dramatic. And some of them could be dramatic, of course, in the colloquial sense of "exciting." But true drama is a narrative structure involving the reversal of fortune, or at least some sense that this reversal has happened or can happen, and though drama is possible in an abstract painting, I felt obscurely, as I stood there listening to him, that it required certain very specific elements. In a canvas by Picasso or Juan Gris, for instance, a play of forms is set in motion across the picture plane, and as in a jazz improvisation we perceive in the evolving dynamic the standing peril of failure, of a collapse of integration, and we're thrilled when the composition succeeds. In fact, it is practically impossible to create a sense of drama in a painting with few relational forms and no strong diagonals, or at least no stepwise elements suggesting diagonal motion, and Rothko's work is among the most static ever created. That does not mean that Rothko painted poorly—I felt in 1966 that he had painted as beautifully as anyone in New York off and on during the previous two decades—but for me those veils of color were essentially contemplative, devoid of the narrative vigor he ascribed to them.

Distressingly, during the course of that spring I came to a conclusion hard for me to swallow as an admirer. For as I hung out in

MARK ROTHKO, TALKER

Rothko's gym I felt more and more that all his talk about drama was not only misleading, it was actually a defensive smokescreen. The tragic sense of life was something he craved for a kind of painting that had forfeited such transcendent meanings, and now the oratory supplied what had been exiled from the canvases. Though I didn't have an ear sophisticated enough to detect it at the time, his speechifying, as Logan's play suggests, was merely one riff, one litany, in a world-wide existentialist bull session.

It also is true, I think, that a certain melancholia pervaded that studio, and Rothko's black paintings are sometimes seen as a premonition of his suicide in 1970. Unhappily for this theory, they were executed long before the aneurysm that deprived him of the ability to paint and probably occasioned his final depression; and, in any case, the black painting as a sub-genre already had a well-established pedigree in art, not at all associated with death. No, the problem with Rothko's black paintings is not any putative morbidity but their stolidly presentational nature, and in order to come to terms with this misfortune one has to understand that there were purely aesthetic, non-social reasons that prevented Rothko from developing beyond a certain point. During the "hinge" period of the late '40s, when he was discovering his mature style in that group of delightfully improvisatory paintings called the "multiforms," and later, during the early '50s, when he had already created his trademark image of stacked, usually scumbled veils, he maintained what his friend Robert Motherwell would later call a "living collaboration" with the canvas. By refusing to envision a "predetermined end," Motherwell explained, an artist might allow the unfinished painting to "come to one's aid," like a friend, with unpredictable solutions. At this period both the color choices and the "color volumes"—the densities of hue, value, and saturation relative to rectangle size—are often surprising, unpredictable, and joyful, and conform to no logic, as in the best work of Milton Avery, Rothko's early mentor. And it may be that all this is just a potential definition of that term "mysterious" he was so fond of. But though Rothko justifiably painted big canvases—his colors had a natural reach, a large expansive pulse—his visual idea was fairly circumscribed: he made big paintings on the basis of a small idea. And in attempting to repeat what was

clearly a success, in strictly aesthetic terms, he began to repeat not the experience that had generated that success but rather the hard-won trademark image. He found a "way," and he overproduced. Mystery vanished; formulaic solutions abounded: harmonies of adjacent hues on the color wheel, dulcet wooings of scarlet and maroon, pseudodaring blacks.

And of course there were social pressures, such as being thought of as vapid, and financial temptations, too. Rothko, embattled, became super-conscious of all the people out there. He came to conceive of the big painting as a kind of grand tragic statement vis-à-vis the audience and the national cultural amphitheater: the mere format of the canvas (itself over-scaled by now, a sufferer from its own hypertrophy) virtually dictated where to shift a color-value in the interest of graphic impact. Disconcertingly, even fans like myself began to perceive a bastard cousinship between this so-called advanced painting and various forms of good design. In this new, presentational work, a kind of rhetoric or bombast—getting an idea across to the multitudes—took the place of spontaneity and surprise.

One of Mark Rothko's most famous sayings, worthy of a Pre-Socratic philosopher, is "Silence is so accurate." He had a way not only of haranguing people but also of being very quiet for a longish spell, perhaps taking a pull on his cigarette, while he considered what they'd said or what he was about to say. His finest paintings reveal a superb sense of hesitation, of steps not taken, of where to leave things patchy or shabby, just where a lesser artist might have done something eyecatching. But these silences in his talk, these moments when he and the other grown-ups just sort of sat there, gave me the opportunity to look around at what was going on. About the time that I visited Rothko in his gymnasium studio, and later on, in Berkeley, a certain group of paintings, all rather dark, of a similar, vertical format, and featuring minimal surface incident, was beginning to proliferate, exerting an appeal at once genuinely contemplative and terribly public; and I felt, uncomfortably, that these were the works, no longer of a master exactly, but of an expert.

Acknowledgments

Many thanks are due to the magazine *Art and Antiques* for gracious permission to reprint from its pages, in somewhat altered form, "H.C.-B. Postscript," and "Mark Rothko, Talker"; also to the Estate of Henri Cartier-Bresson and the Magnum Agency, for the rights to the photograph "Our cat Ulysses and Martine's shadow" (1989) shown on the cover of this edition.

CPSIA information can be obtained at www.ICGtesting.com Printed in the USA BVHW030818230419 546269BV00001B/39/P